KU-377-990

PHOTOJOURNALISM
An Ethical Approach

COMMUNICATION
TEXTBOOK SERIES
Jennings Bryant—Editor

Journalism
Maxwell McCombs—Advisor

PHOTOJOURNALISM
An Ethical Approach

Paul Lester
California State University, Fullerton

LEA LAWRENCE ERLBAUM ASSOCIATES, PUBLISHERS
1991 Hillsdale, New Jersey, Hove and London

On the cover . *Pack journalism then and now. (Top) News photographers
in 1911 cover* a dynamite explosion in Communipaw, New Jersey. (James
Hare/Photography Collection/Harry Ransom Humanities Research Cen-
ter/The University of Texas.)*
*News photographers in 1984 cover the finish line at a track event of the
Olympic Games. (Anacleto Rapping/The Los Angeles Times.)*

Portions of Chapter 8 and Appendix B
originally appeared in Lester, P. (Ed.).
(1990). *NPPA Special report: The
ethics of Photojournalism.* Durham,
NC: NPPA. Reprinted by permission.

Lawrence Erlbaum Associates, Inc., Publishers
365 Broadway
Hillsdale, New Jersey 07642

Library of Congress Cataloging-in-Publication Data

Lester, Paul.
 Photojournalism : an ethical approach / Paul Lester.
 p. cm. — (Communication textbook series. Journalism.)
 Includes bibliographical references and indexes.
 ISBN 0-8058-0671-7. — ISBN --8058-0672-5 (pbk.)
 1. Photojournalism. I. Title. II. Series.
 TR820.L46 1991
 778.9'907049—dc20 90-21824
 CIP

Printed in the United States of America
10 9 8 7 6 5 4 3 2

Contents

Preface

There has been little mention of photojournalism ethics in textbooks designed for undergraduate journalism students. In fact, throughout the many years of journalism text publishing, only one book has been devoted entirely to the subject of photojournalism ethics.

A typical view of photographers was expressed in a 1932 textbook, *Ethics and Practices in Journalism* by Albert Henning. He wrote, "Newspaper photographers can scarcely be considered journalists. . . . They do not come into contact with the problems that daily face the man or woman who goes forth to gather facts. . . . It is difficult to see wherein the education required of a news or editorial writer would be necessary preparation for the class of work photographers are required to do" (pp. 61–62).

Some years later, a few pages in the text, *The Press and Its Problems*, by Curtis MacDougall (1964), gave advice for budding photographers that would be considered unethical today. If a subject constantly hides his face, MacDougall suggested that "a cry of 'fire' often will cause persons . . . to uncover long enough for a speed flash" (p. 342). Mothers with children or single women can be persuaded to pose if a photographer tells "them they are to be entered in beauty or intelligence contests" (p. 342).

Wilson Hicks (1973), in his textbook, *Words and Pictures*, argued strongly that photographs and photographers should have the same respect as words and writers. Yet Hicks had no specific section on ethics and admitted that some situations need to be re-enacted for the camera or "require a certain amount of setting up, rearranging and direction" (pp. 128–132).

Several more recent mass media and photojournalism textbooks, fortunately, contain brief discussions of photojournalism ethics. In Eugene Goodwin's (1983), *Groping for Ethics*, hidden cameras, posed or re-enacted shots, shockingly gruesome pictures, sexually offensive images, invasions of privacy, and whether to

take a picture or help a subject in trouble are discussed. *The Messenger's Motives* (Hulteng, 1984) has one chapter devoted to the newsworthiness of pictures, dead victims of disasters or violence and their grieving survivors, the right to privacy, photographic harassment of famous people, camera and darkroom manipulations, and set up and re-enacted situations.

Photojournalism textbooks, for the most part, have had shorter discussions on photojournalism ethics than mass media textbooks. Cliff Edom (1980) in his second edition of *Photojournalism* has ethics writer Dr. John Merrill discuss philosophical perspectives of picture-taking ethics. Edom gave a brief history of photojournalism ethics and warned editors not to manipulate images because credibility will suffer. Edom also wrote that photographers should serve the profession "with good taste," must photograph "only the truth," and that photographers do not "accept free tickets, free transportation, free samples . . . " so that objectivity can be maintained while covering a subject or event. *Pictures on a Page,* Harold Evans' (1978) classic textbook for photojournalism editing instruction, devotes two pages to "four areas of sensitivity: violence; intrusions into privacy; sex and public decency; and faking" (pp. 285–286). Another addition to photojournalism is the technically useful and visually pleasing, *Photojournalism: The Professionals' Approach* by Ken Kobre (1980). Similar to Edom's work, Kobre mixed history with camera and assignment techniques to produce a textbook that is used by many instructors who teach beginning photojournalism. Kobre wrote that photographers should not set up pictures. Photographs, he added, should not add to the suffering of survivors of a tragedy. In a new edition, Kobre devoted an entire chapter to the subject of photojournalism ethics.

Frank Hoy in 1986 devoted a chapter on ethics in his textbook, *Photojournalism, The Visual Approach.* Hoy's work provides one of the best general discussions on photojournalism ethics. It was disappointing, however, when he asserted that photographers should not worry with ethical issues when shooting. Problems can occur when photojournalists blindly adopt a shoot first and ask questions afterwards policy.

There has been one undergraduate textbook that concentrated on photojournalism ethics. Published in 1971, Curtis MacDougall's, *Pictures Fit to Print? . . . Or Are They?* was not widely distributed. The book is filled with many controversial and disturbing images in several sections. Chapters include "Good Taste and Bad," "Indecency, Obscenity," "Invasions of Privacy," "Crime," and "The National Image." However, the discussion included with the images is superficial and without a philosophical base. The semi-annual Journal of *Mass Media Ethics* began publication in 1986. The Spring/Summer 1987 edition was a special issue devoted to photojournalism ethics (see Appendix B for a detailed discussion). The newest addition to a photojournalism ethics library is *NPPA Special Report: The Ethics of Photojournalism* (Lester, 1990). Newspaper and television professionals and academics commented on a variety of ethical issues.

The idea of photojournalism as a profession is only a few decades old. Undergraduate textbooks in the field of journalism are beginning to reflect the change in attitudes among photographers, reporters, editors, and journalism educators toward the photojournalism profession. In its small way, hopefully, this work will continue that positive push forward.

ACKNOWLEDGMENTS

This work would not be possible without the direct help of Dr. Jim Welke, Director of the School of Communication at the University of Central Florida. He had the wisdom to give me a computer so that I might work more efficiently and stop bothering the secretaries.

My editor at LEA, Jack Burton was always there for me when I had a question or a problem. His enthusiasm for this project helped me through many long nights of frustration. Max McCombs in Texas also offered insightful support.

Jim Gordon, editor of *News Photographer* magazine, quickly and cheerfully loaned many pictures I could use for this text despite his overwhelmingly busy schedule. Jim gets my vote as photojournalism teacher of the year.

I spoke with many photographers and editors who contributed stories and pictures for this work. Particularly, Rich Beckman contributed a fine synopsis of the research on photojournalism ethics. To all those who helped, thank you for your effort. The success of this text is largely due to all of your concern and love for the photojournalism profession.

But my biggest thanks, so much that it seems absurd to write these inadequate words, goes to my photo researcher, Carla Hotvedt of Silver Image in Gainesville, Florida. She volunteered to take on the frustrating job of securing pictures and permission forms from photographers and picture agents for this textbook simply because she believes undergraduate students can be helped. Please see Carla for all your stock photo needs.

Ethics is a life-long process shaped by what you experience, what you read and who you know. I have been blessed with many teachers in my life. All of my friends/teachers have helped shape my personal ethical code.

Steve Altman, my first photography teacher at a junior college in Dallas taught me how exciting photography can be.

At the University of Texas, Larry Schaaf taught me the importance of technical concerns and J. B. Colson taught me to care enough about my photographic subjects to include their words with the images.

At the University of Minnesota, George Hage and Hal Wilson taught me to love and respect my students. Everette Dennis taught me to work hard for a project I believe in. Dick Foushee taught me that photojournalism is never really separate from whom I am.

At Indiana University, my dissertation committee, John Ahlhauser, Jim Brown, Will Counts, and George Maccia taught me the value of accuracy and a love for teaching photojournalism. Jim Brown, a trusted friend and mentor, is especially helpful in my continuing ethical growth.

At *The Times-Picayune* in New Orleans staff photographers G. E., Mike, Bryan, Andy, Lionel, Ronnie, Jerry, Pat, Pete, Burt, Bobby, Don, Ralph, and Tony, writers Millie, Loyce, John, and Chris, and especially, photo editor Jim Pitts, all taught me so many lessons that if each one were listed, another volume of this textbook would be required.

Clarence John Laughlin taught me to see the magical light around us all. Nancy

Pierce taught me to care deeply for whatever it is I do. Janice, Aaron, and Ian taught me that distance is a state of mind. Jack Gibbs taught me that a Krylie should never eat beans when the Orkin man is around. Paul "Zuke" Bibbo taught me a brother's love. Donna "Turk" Terek taught me to never lose sight of a goal. Katie Lloyd taught me to be honest with myself. Chris Maron taught me to "Just say yes." Marvin Cortner taught me to laugh at myself.

My father, Tom and my brother, Carl taught me to value every day because life is short. Elaine and Wally MacPhee taught me that "family" is not confined to a blood relative. My mother, Jody taught me that love is infinite and never judgmental.

And finally, my wife Roseanna and my 25-month-old daughter Allison teach me that life is filled with love and joy that is beyond measure.

Chapter 1
The Merger of
Photojournalism and Ethics

Civilization is a stream with banks. The stream is sometimes filled, with blood from people killing, stealing, shouting and doing things historians usually record, while on the banks, unnoticed, people build homes, make love, raise children, sing songs, write poetry. The story of civilization is the story of what happened on the banks. . . .
—Will Durant

In a fitting tribute to the power and prevalence of photojournalism images, *Time* magazine recently produced the first issue in its history on a single topic with a single advertiser. Measured from the dual technological achievements announced in 1839 of Louis Daguerre's daguerreotype and Henry Talbot's calotype, the 150th year of photography has been celebrated throughout the world with gallery exhibitions and feature articles in all manner of media.

Life magazine, a publication responsible for photojournalism's rise in respect, published an anniversary issue titled, "150 Years of Photography: Pictures that Made a Difference" (1989). *American Photographer* (Squires, 1988), a magazine that regularly features works by newspaper and magazine photojournalists, devoted its cover and over 30 pages to the subject of photojournalism. Marianne Fulton (1989), associate curator of photographic collections at the International Museum of Photography at the George Eastman House in Rochester, New York, was the editor of a well-researched and richly illustrated book on photojournalism, *Eyes of Time: Photojournalism in America.*

Jim Dooley, photography editor and chief for the Long Island newspaper, *Newsday,* remarked that "newspaper photojournalism is in its heyday. It's going through a tremendous renewal" (cited in Fitzgerald, 1988, p. 35). Professor of Photojournalism at the University of Missouri, Bill Kuykendall, also feels that there is now a photojournalism renaissance. "I think there has been a rebirth," said Kuykendall, "of interest in candid . . . photojournalism" (cited in Fitzgerald, 1988, p. 35).

Just as discussions of photojournalism have received an abundance of media

treatment, professional ethics has also received widespread attention in magazines, books and from experts in the field (see Barrett, 1988; "Pentagon Probing," 1988; "What ever happened," 1987).

Ethical issues are hot topics in today's media-conscious society. Questions currently debated in formats that vary from newspaper articles to public forums broadcast on public television stations include: Is insider trading a result of greedy individuals or does it foretell a problem with the entire system of business? Are the temptations from profit motives too great for government employees to manage without outside monitoring? Should the organs from aborted fetuses be used for medical purposes? Does the media concentrate too much on scandals or other sensational events and miss the underlying issues that may be ultimately more important?

ICONS WITH ETHICAL PROBLEMS

When photojournalism and ethics are combined as a topic for discussion, *Time* magazine's, "150 Years of Photojournalism" issue should be analyzed in a more critical manner. After consulting with experts in the field, the editors of the photojournalism issue reproduced in the introduction, "The Ten Greatest Images of Photojournalism."

"There are hundreds of unforgettable news pictures," the subhead explains. "Some record great events, others the small but resonant ones. In our view these ten—images of war and peace, love and hate, poverty and triumph—are the ones indelibly pressed upon the mind and heart" ("150 years of photojournalism," 1989, p. 2).

Ironically, 8 of the 10 photographs have ethical problems associated with them or the photographer. Another "unforgettable news picture" is made more unforgettable through computer digital manipulation.

Civil War photographer Alexander Gardner moved a corpse to illustrate, in separate images, a Union and a Confederate soldier. Robert Capa and Joe Rosenthal were accused of stage managing their famous photographs. Dorothea Lange and Alfred Eisenstaedt were criticized by their subjects for not paying them for their famous poses. The pictures of Bob Jackson and Eddie Adams were considered too gruesome by many members of the general public. Gene Smith regularly posed his subjects and manipulated his prints with a variety of techniques that included double printing. And finally, in a demonstration of the manipulative potential of computer technology, a photograph of the solitary moonscape portrait of Edwin Aldrin by fellow astronaut Neil Armstrong is transformed at the end of the issue to an invasion of the moon by a platoon of moon-walkers.

There is no doubt that for older Americans, the 10 images are among the strongest and most visually memorable icons of the 20th century. A committee from Britain or France might not have seven American-related images. A group of younger students of photography might include photographs more recent than 1971. Another panel might not have five pictures that are war-related, a portrait of a destitute family, an international disaster, a political assassination and a mercury-deformed child.

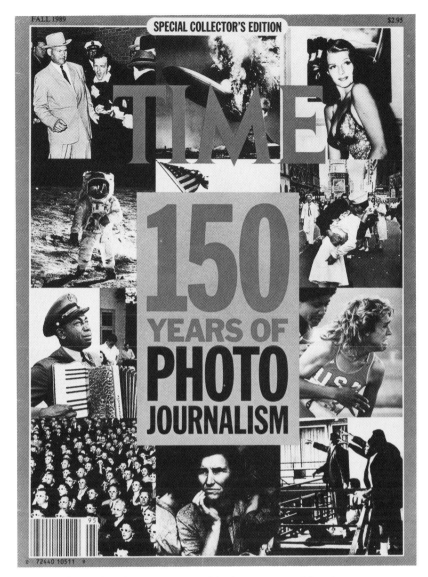

In 1989, 150 years since the announcements of the daguerreotype and the calotype processes, Time Inc. published an anniversary issue on photojournalism sponsored by a single advertiser, Kodak. (Copyright © 1989 The Time Inc. Magazine Company. Reprinted with permission).

Perspective. A top-10 list is shaped by a judge's perspective. Ethical determinations are shaped by perspective as well. Past experiences, present concerns, and emotions are some of the factors that shape your response to a photograph. Your perspective, your 10 greatest images, will differ from another's. And when you see a picture on the front page of your local newspaper of a mother crying over the death of her son, you will either be moved or offended by the image because of your perspective.

Ethical arguments are usually unsatisfying. There is no clear winner or loser when perspective guides a determination. But there must be some way to defend your action to a reader who does not share your personal perspective.

Writers and photographers for newspapers follow the same ethical principle of truthfulness outlined in ethics codes. Journalists would view as unethical a reporter who fabricated quotations. Likewise, a photographer who uses darkroom tricks to make a false image would probably be fired. The principle of truthfulness is easily defended by both writers and photographers.

IT IS HARD TO HIDE A CAMERA

Ethical worlds often collide, however, because of the fundamental techniques the two reporters use to gather information. During a controversial news event, when a father grieves visibly over the loss of a drowned child, a writer can stay behind the scenes with pen and paper hidden. Facts are gathered quietly and anonymously. A photographer is tied to a machine that must be out in the open and obvious to all who are present. A videographer during the 1967 riots in Newark, New Jersey said, "a newspaper guy can huddle in a doorway or get it over the phone. But we've got to be in it to get it" ("The riot beat," 1976, p. 78).

Long lenses or hidden camera techniques can be used, but the results are usually unsatisfactory. Focus, exposure, and composition problems are increased with the use of telephoto lenses or hiding a camera. Besides being on ethically shaky ground, the use of hidden cameras is illegal in Delaware, Georgia, Hawaii, Maine, Michigan, New Hampshire, South Dakota, and Utah.

The photographer, unlike the hidden writer, can be the target of policemen, family members, and onlookers who vent their anger and grief on the one with the camera. No call to journalistic principles of truthfulness will convince a mob not to attack a photographer in such an emotionally charged situation.

Because photographers must be out in the open to take pictures, the photographer's ethical orientation must be more clearly defined than with writers who can report over the telephone. A photographer must have a clear reason why an image of a grieving parent is necessary.

PHOTOJOURNALISM AS A PROFESSION

Although photojournalism is filled with many dark moments, the history of the field is also rich with pride and professionalism. Cliff Edom (1976), one of the most well-respected photojournalism educators in the country, credited Frank Mott, dean of the Journalism School at the University of Missouri, with inventing the term, *photojournalism*. In 1942, Mott helped establish a separate academic sequence for photojournalism instruction. For the first time, photojournalism was considered "as important to the field of communication" as its word equivalent.

In 1946, Joseph Costa, staff photographer for the New York *Daily News,* was elected president of the first national organization for newspaper photographers, the

National Press Photographers Association (NPPA). *Editor & Publisher* magazine at the time wrote that the aim of the new organization was "to combine all elements of the working photographic press in America to raise and maintain the high levels of photography necessary to the advancement of pictorial journalism." Shortly thereafter, the first issue of *News Photographer,* the official publication of the NPPA, was printed (Faber, 1977, p. 27).

Academic standing, professional membership, and literature unique to the organization are fundamental criteria for the definition of a professional group. Since the early days of the NPPA, members of the photojournalism profession have seen academic sequences begun at universities across the country. NPPA membership has grown from a handful at their first meeting in Atlantic City to more than 9,000. *News Photographer* magazine has grown in coverage and stature to become one of the leading trade publications in the business.

Another standard of professionalism is the amount of self-criticism that occurs within the organization for the betterment of its members. From the first issue of *News Photographer,* articles have been written, not simply to introduce technical advances, but to critically examine the ethical behavior of press photographers. From relations with the police to the coverage of tragic events, ethical issues get a fair hearing within the pages of *News Photographer.*

Reactions to controversial issues is a result of the underlying principles that guide a person. Many times photographers and the general public are on opposite sides of a philosophical wall. As part of the journalism community, photographers see their role as providing readers with a record of each day's events. The community at large is benefited. That mission often leads to the taking and printing of disturbing, graphically violent images. Such an underlying philosophy at work for journalists could be interpreted as a form of Utilitarianism. Many members of the general public, however, are disturbed by such images. Readers often complain that they either do not wish to see such gruesome photographs in their morning newspaper or are concerned that the pictures will contribute to the grief of the victim's family and friends. The underlying philosophy for those letter writers is most probably the Golden Rule. It is important to understand that the two conflicting philosophies have long been debated by philosophers without a satisfactory resolution. Emotional issues find little room for compromise. Again, a person's perspective guides a response to a controversial photograph.

The main concern of this textbook, the workbook, and the computer program is to help you learn your own ethical perspective. Such an insight will help you understand the various perspectives in use by photojournalists, their editors, their subjects, and their readers. As photojournalism heads into the next sesquicentennial, the ethical principles photographers rely on, as never before, will be challenged. It is vitally important, as you start your career, that you consider being an ethical photojournalist. The photojournalism profession demands nothing less.

Chapter 2
Photojournalism Assignments and Techniques

When asked to describe a photojournalist, most people would probably tell of a slightly disheveled, camera-weighted, young photographer who scurries to troubled areas anywhere in the world to produce images that capture people in crisis. Quite a romantic view. The reality is different.

Most photojournalists, according to a 1982 survey, work for a daily newspaper, are college-educated men, have families, own homes, are in their mid-30s, and make under $25,000 a year (Bethune, 1983).

Photojournalists should consider themselves to be on an equal status as word journalists. Photojournalists are reporters. But instead of pen, notebook, or tape recorders, these reporters use a camera and its accompanying selection of technical devices to record events for each day's printed record. As reporters, photojournalists must have a strong sense of the journalistic values that guide all reporters. Truthfulness, objectivity, and fairness are values that give the journalism profession credibility and respect. From getting the names spelled correctly in a group portrait to not misrepresenting yourself or a subject, truthfulness is a value that gives the public a reason to rely on the accuracy of the news they read and see in their newspaper. If you are economically, politically, or emotionally involved with a subject, your objectivity will be put into question. A photographer's credibility will suffer if free gifts from a subject are accepted or if political views or personal opinions cloud news judgments. To be fair, a journalist tries to show both sides of a controversial issue, prints stories and photographs proportionate to their importance, and if mistakes are made, prints immediate, clear, and easily found corrections.

A photojournalist, from experience and education, must know what is and what is not news. The media are often criticized for concentrating their efforts on negative, often tragic events in their community. Journalism professors Ted Glasser and Jim Ettema (1989) reviewed the most commonly held news values: "prominence, conflict, oddity, impact, proximity, and timeliness." In their article, Glasser and

Ettema argued that a journalist should also use common sense, taught in journalism schools or through work experiences, to decide what is news. Unfortunately, tragic events usually fit into most news value categories (pp. 18–25, 75).

Successful picture taking is a combination of a strong news and visual sense. It is no easy proposition. As reporters, photographers use their sense of news judgment to determine if a subject is worth coverage and to present a fresh or unusual angle to an ordinary event. As visual recorders, photographers must use their sense of visual composition to eliminate distracting and unnecessary elements in the frame. As technicians, they must have a high level of expertise to use their machine to expose correctly and in focus that peak news moment.

The French photojournalist Henri Cartier-Bresson used the phrase, "the decisive moment" to describe the same idea. The decisive moment is an instant when the subject and the compositional elements form a union. For a newspaper photographer, the moment may come when a subject expresses in a minor facial gesture or an overt action the essence of his or her situation and when the foreground and background visual elements contribute to a reader's understanding of that subject's emotional state.

A confident news and visual sense is essential when covering any of the many assignments a photographer may face. Photojournalistic maturity elevates an ordinary picture taker to a journalist with a clear communicative goal. Whether the assignment is a ground-breaking ceremony at a local high school or a five-alarm fire at a nursing home, a mature photojournalist will find a way to capture in photographs a fresh and decisive summation of the event.

There are six basic types of assignments a photographer faces. News, features, sports, portraits, illustrations, and picture stories each present a photographer with a different set of challenges.

NEWS ASSIGNMENTS

News is the assignment most people probably think of with the term *photojournalism*. Crossing police lines to get to the heart of a raging fire or head-on collision, photojournalists often risk physical harm with the news assignments they cover.

Types of News Assignments

News is actually divided into two parts: spot and general.

Spot News. Spot news is any unplanned event where little advanced planning is possible. Photographers will often learn of spot news events through a radio call from their photography editor or directly from a police and fire scanner in their car. Because photographers are often driving in their car, spot news is sometimes found through coincidental circumstances. Although emotions are high when driving to a spot news scene, special care must be taken to drive safely. Traffic laws must be obeyed. Most likely, arriving an extra minute sooner because of a high speed chase will not make a difference in capturing the most dramatic moments. Almost always, spot news is an assignment where subjects will be injured or in physical trouble. The

photographer must be prepared to help the injured if no rescue workers are on the scene. To get quickly through police lines, an identification card is usually connected to a small chain and hung around the neck. Police officials are supposed to allow news photographers access to news events. Understanding and tact are often necessary by photographers during heated emotional moments on both sides of the police line. A photographer who obstructs the work of the police or rescue workers runs the risk of arrest.

For news and most other assignments, a photographer must be prepared for any type of film, lighting, and lens requirement. One camera bag should contain two 35mm single lens reflex (SLR) camera bodies. At least one of the cameras should have a motor driven mechanism to automatically advance the film. The bag should contain at least three lenses (wide-angle, normal, and telephoto), a portable flash unit with a fully charged battery pack, a portable radio for communication to the photo editor, a pen and notebook for caption information, and a variety of 36-exposure film in an assortment of film speeds (100, 400, and 3200 ASA). Color or black-and-white film depends on the requirements of the individual newspaper.

Whenever possible, both cameras should be loaded with fresh film so that there are plenty of exposures for fast action. Depending on the situation, one camera should have a 35mm wide-angle lens and the other a 180mm or 300mm telephoto lens attached. Most photographers will take an initial wide-angle, scene-setting picture. After a few moments, an assessment of the salient elements of the event is made and the photographer switches to a telephoto lens for a close-up perspective.

There is a debate among photographers whether zoom lenses should be used. As opposed to fixed focal lenses, a photographer can move the focal length in or out for a variety of close-up and wide-angle views. Zoom lenses typically save a beginning photographer money because they can take the place of several lenses. Most professional newspaper photographers, however, do not use zoom lenses. Many find that zoom lenses do not focus as sharply as fixed focal lenses. With their typically small aperture openings they are not practical in low-lighting situations. Zoom lenses also make photographers worry about another technical consideration when shooting. While making aperture, shutter speed, and focus corrections, a photographer with a zoom lens must also decide whether to zoom in or out. A fleeting subject can be lost if valuable seconds are used to make those decisions.

For sensitive news situations, funerals, or courtroom scenes, where the photographer wants to remain as inconspicuous as possible, some photographers carry a small, rangefinder camera in their bag. A rangefinder, without the mirror mechanism of an SLR camera, is quiet and useful for low-light situations.

As with the other assignments, the best images will show the emotional struggle on the faces of those involved at the scene. Tired and dedicated rescue workers helping dazed and confused victims is a visual image that often shows more clearly than words ever can the emotions of concern and fear associated with spot news events.

Often, spot news assignments occur at night just before a press deadline. To get a picture quickly to the photo desk, some photographers will overexpose their images with their flash, underdevelop their film at drastically reduced times, print their negatives while they are wet, and turn in a print that has only slightly been fixed and washed. From unloading the film from the camera to turning in a print with caption information to the night city editor, the time can be cut by half. Afterward, the

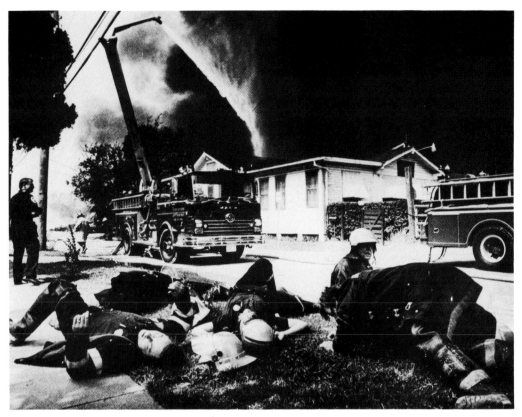

Spot News Assignment. Exhausted firemen rest after battling a five-alarm ware-
house fire (photo by Paul Lester/*Times-Picayune*).

photographer should fix and wash the film. The negatives should be carefully filed
and labeled within a protective sleeve.

General News. General news assignments give photographers a chance to prepare.
Special film, camera lenses, and lighting needs can be anticipated. General news
assignments usually take the form of a politician's press conference or a group of
donors to a local charity. A photographer's main concerns with such assignments are
typically arriving on time to get a good vantage point, making sure that names in a
group picture are spelled correctly, and having enough energy and curiosity to
produce an unusual, yet telling moment. A picture of a politician or lecturer will
always be more visually interesting if an emotional facial expression or hand gesture
is captured on film. A standing group of business persons all smiling at the camera,
a milk bottle picture as a photo editor used to say, is a visually dull image. Take care
to find angles or activities that will not only show the physical appearance of a
group, but will reveal their personalities.

Be on your toes. Even during the most banal news conference, strange events
happen. Still and video journalists covered the Dwyer news conference that sud-
denly turned tragic (the Dwyer news situation is detailed in chapter 4). A photojour-
nalist must always be prepared for the unusual and the newsworthy.

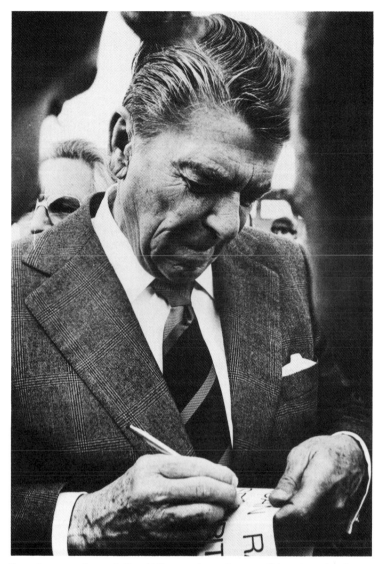

General news assignment. Ronald Reagan signs a bumper sticker at an airport political rally (photo by Paul Lester).

FEATURE ASSIGNMENTS

With feature assignments a photographer needs the sharp reflexes honed by spot news events. The trouble with features, however, is that a photographer usually cannot anticipate where the assignment will take place. It is no wonder that many undergraduate photography students often complain that they cannot find meaningful feature pictures to photograph.

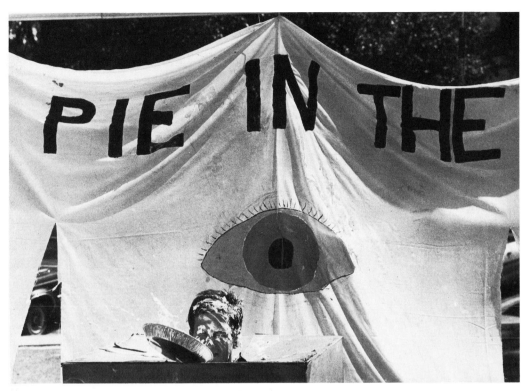

Feature assignments. A young man is the target of a shaving creme pie in this
human interest feature picture (photo by Paul Lester/*Times-Picayune*).

Feature assignments are usually self-generated ones. Photo editors, with no other
assignments, will tell the photographer to shoot "wild art" or "a colorful enterprise
picture for Page 1."

An ordinary photographer might drive to a public park and capture the usual
scenes: a child rides a swing, a young woman reads a book, two men talk on a
bench. These pictures are made to show readers nothing more than that the weather
was nice and people enjoyed the day.

A more mature photographer anticipates the need for a feature picture by the
photo editor and has already scouted an area of town or a particular subject that is
both visually interesting and filled with meaningful content.

Types of Feature Assignments

There are two types of feature assignments: human interest and pictorial.

Human Interest. These features show persons being natural and unique. The im-
ages cannot be anticipated. They are one of a kind moments that capture a person or
group being themselves: odd, humorous, and natural. Cute kids, animals, and nuns
are traditional subject clichés.

Features offer an opportunity for a page to be highlighted with a pleasant, happy picture that may offset the tragic events of the day. A photographer looking for human interest features thinks like a hunter. Keenly aware and observant, knowledgeable on matters of basic human nature, quiet and unassuming, and technically competent to capture quick and fleeting moments, the photographer stalks the city looking for pictures that go beyond the cliché.

Photographers have several techniques they use to take pictures of people. Some will use a 35mm wide-angle lens and get close to their subjects. Others use telephoto lenses to keep a far and undetected distance from their subjects. They will either identify themselves immediately or wait until the subject asks for an explanation. There are two things that happen when you ask a person if you can take their picture and both of them are bad. Either they say no and you don't get the picture or they say yes and stare and smile at you like they were posing for a snapshot. When you see some unusual action, get an initial picture. Afterward, you can identify yourself, get their names, and take addition photographs after they become accustomed to your presence.

Pictorials. The other type of feature picture is the much maligned pictorial. Traditionally, the pictorial is a silhouette of two standing, arm-in-arm lovers at sunset. Pictorials rely on the graphic elements of composition and lighting more than subject matter. Many times pictorial feature pictures, when combined with bold page layout design, can educate unsophisticated readers to the artistic forms and lighting characteristics within their world. A photojournalist should never become

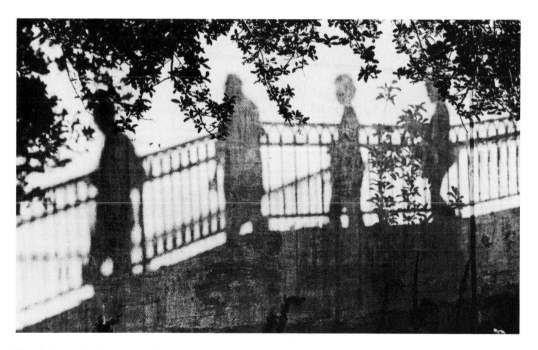

The shadows of tourists walk along a wall in New Orleans for this cliché-ridden pictorial feature picture (photo by Paul Lester/*Times-Picayune*).

distracted by shapes and shadows. Personal artistic expression in the form of pictorial feature pictures have a limited place in the photographer's portfolio. It is far better to take pictures that combine the striking visual qualities of the pictorial with human interest moments.

Because feature assignment photographers often are their own reporters, much of the responsibility for the caption is left to the photographer. Names and locations are a minimal requirement. Quotations from subjects bring more interest to an otherwise ordinary picture/caption package and increase the chances for larger, front-page treatment.

SPORTS ASSIGNMENTS

Although most persons would link photojournalism with news assignments, a recent survey of newspaper photographers revealed that the most common assignment is actually sports. Sports assignments combine the action and excitement of news within a clearly defined structure. The key for successful sports photography is to know that structure. You have to be familiar with the rules of the game to predict dramatic moments. You should also know the backgrounds of some of the key players and anticipate their contribution. If you know that a rookie kicker is about to attempt his first field goal for an NFL team you should concentrate your telephoto lens on his sideline preparations. In an instant, his face may reveal his nervousness that would make a good picture.

Types of Sports Assignments

Sports Action and Sports Feature are categories within the sports assignment. *Sports Action* is a photograph of any moment that occurs on the playing field during the run of the game. *Sports Feature* is a picture that shows anything else: an angry coach in the locker room, a frustrated player on the sideline, an anxious fan in the stands. As implied by the name, the same procedure applies to sports feature hunting as with human interest features. A photographer tries to capture a peak, dramatic event not happening on the playing field.

Most sports involve a ball and at least two opposing players. The best sports photographs not only show the ball, but reveal the determination in body language and facial expressions each player's struggle to out-perform the other. Readers are aware of the overhead perspective offered by television of the linebacker blitzing a quarterback. A successful sports photographer gets beyond the uniform and the helmet and into the eyes of the players. A reader should be able to see the passionate, determined eyes of that blitzing linebacker or the frustrated expression of the soon-to-be-sacked quarterback.

For most sports, long lenses are a necessity. Fast shutter speeds are also in order. Because many sports are played at night or indoors under artificial lighting, expensive telephoto lenses that let in as much light as possible are necessary. A fast ASA film or a film that is pushed to a higher ASA with high speed developer is as

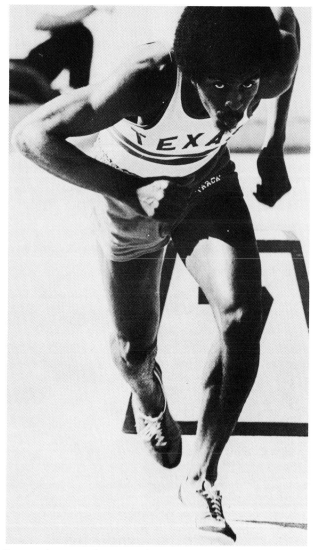

Sports assignments. A runner sprints toward the finish line in this sports action photograph (photo by Paul Lester/*The Daily Texan*).

necessary as a fast telephoto lens. These techniques are valuable because a photographer wants the most depth of field and the fastest shutter speed possible from a film and lens combination. Focus is a problem with fast moving players. If the lens is wide open, there is no room for focus error. Stopped action without blurring is almost mandatory for sports pictures.

Some photographers use an electronic flash on their cameras where it is permitted by sports officials. Players and television videographers may object to the flash as it causes a brief flash of light that may distract from the game. Flash, however, has been used successfully during basketball games when the electronic strobes are

mounted in the four corners of the arena and controlled through a radio frequency on the camera by the photographer at courtside. Of course the cost of such a system is prohibitive. When using flash, make sure that the power output dial is set low (1/16 of second on some units) and the portable battery pack is fully charged. Sports action happens quickly. A low power setting will make sure that the recycle time is quick enough to capture that action. A photographer should also use a camera that synchronizes its shutter with the flash at 1/250th of a second. *Ghosting,* an undesirable blurring effect, can occur when a player moves faster than a shutter speed can stop. For example, at 1/60th of a second, a common shutter to flash synchronization, ghosting would certainly occur with any player moving faster than a walk.

To round out a photographer's equipment list, cameras should include motor drives for fast film advancement, a unipod to help support the telephoto lens, and a players' roster for caption information. Many photographers keep track of key plays by shooting the scoreboard immediately afterward.

Tips for Shooting Various Sports

It is difficult to give guidelines for shooting sports because they are so different. Knowing the rules of the game will help you find a spot where the key action is most likely to occur. Here are some general rules, but always look for an unusual angle. Suggestions are included.

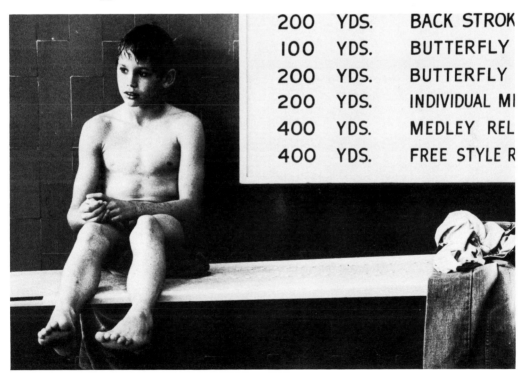

In this sports feature picture, a young boy rests between swim heats (photo by Paul Lester).

Football photographers usually squat about 5 yards either side of the line of scrimmage with a 300mm telephoto lens on a unipod. When a team is within 10 yards of the goal, photographers usually stand behind the outside boundary of the end zone. Another camera with a wide angle lens is ready for close-up, sideline action or features. To facilitate mobility, many shooters use a small, stomach bag to carry film, another lens, and a flash. Pay strict attention to the movement of the players. Several photographers have been hit and their equipment damaged by a 210-pound running back. Play your hunches. A quarterback may be ready to throw a "bomb." Get away from the pack and catch the reception.

Basketball photographers seldom locate themselves on the sidelines. They are most likely found on one side or the other of the net with a 35mm lens for close-up action and a 300mm lens for action farther down the court. Try an 85mm lens with a straight-ahead perspective. Or you might use a telephoto lens from a high, sideline position.

Baseball is a difficult sport to cover because the action is usually quick with long periods of undramatic innings. Photographers are usually confined in a special area behind first and third base. The usual equipment configuration is to have one camera on a tripod that is fixed on second base with a second camera around the neck. Pay attention. Foul balls can hurt if they are a surprise. Use your fixed position to take pictures with your wide angle lens of fans reacting to key plays.

Soccer photographers roam from the sidelines to the goal looking for headers. You may want to use an extreme low angle through the netting of the goalie attempting to stop a score.

Hockey photographers try to get high enough with long lenses to avoid the protective shield around the playing area. Use a wide angle lens up against the plastic protector to capture a hard check or scuffle.

Tennis is best photographed while kneeling at one side of the net. However, during professional matches photographers are limited to an area at a courtside location. As with baseball, try to get crowd feature pictures.

Swimming events are often photographed with a flash and a long lens with favorable results. Use an underwater camera to record the other side of a dive or turn.

Most track and field events require a long lens and knowledge of the individual event. You might use an extremely long telephoto lens and take close-ups of key actions—the relay hand-off, the pole vaulter's grip, or the shot put thrower's grimace.

Whenever there is doubt on how to cover an event, look at the positions and equipment of other, more experienced photographers. Then, think of a position based on your knowledge of the game. Above all, keep in focus, minimize blurring, and show the drama of competition in the players' eyes.

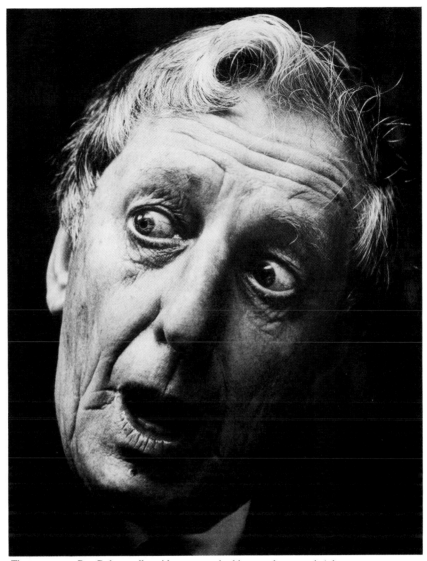

The scarecrow, Ray Bolger, talks with a reporter in this mug-shot portrait (photo by Paul Lester/*Times Picayune*).

PORTRAIT ASSIGNMENTS

Readers want to know what people in the news look like. The portrait assignment is an opportunity for photographers to capture a person's personality. It is no easy task. Important and ordinary newsmakers tend to hide behind a facade of friendliness. Seldom does a photographer get the luxury to spend long periods of time with a busy businessman. All the photographer's instincts and technical competence come into play to watch for a moment when the subject's personality is revealed.

Types of Portrait Assignments

There are two kinds of portrait pictures: mug and environmental. Mug shots, those little head and shoulder, close-up portraits, have staged a comeback on the pages of newspapers. A recent research study revealed that the front pages of five large circulation newspapers are filled with the tiny face photographs. It seems that photographers must learn to live with the small images (Lester, 1988).

Mug Shots. The term *mug shot* comes from the definition, "to make faces." The challenge for photographers is to make the mug shot more than a picture of a subject smiling for the camera. Despite its small size, the picture can and should be a telling record.

The portrait can be taken in the newspaper's studio where the lighting and background can be rigorously controlled or in the subject's office or home. A short telephoto lens, in the range between 85mm and 105mm, is the best choice for the close-up portrait. The subject is likely to be nervous. With a telephoto, the photographer need not get too close in order to fill the frame with the person's face. A telephoto also tends to have shallow depth of field. A close-up mug shot should not contain distracting background elements. Don't be hesitant to take pictures of hand gestures that occur close to the face. Unusual angles including a side view might be tried. Cropping on the face can also be tighter than normally expected to add interest to the portrait. Expect to take a 36 exposure roll of film for a variety of facial gestures. If a subject is outgoing, an editor may be convinced to print a series of three head portraits for a more interesting and revealing layout. Be sure to take pictures from each side and in front for a variety of views.

The Environmental Portrait. The environmental portrait not only shows what the subject looks like, but also reveals aspects of the sitter's personality by the foreground and background objects the person displays. Personal mementos on a desk or hung on a wall let the reader know more about the subject than a simple portrait can reveal. It is a picture of a person AND that person's environment—NOT simply a picture of a person in an environment. Some photographers specialize in the environmental portrait with wonderful results. Arnold Newman and John Loengard make photographs that reveal a subject's personality through facial expressions and background clues.

Because the environment in which a person lives, works, or plays is a necessary part of the photograph, a wider lens is needed than for a mug shot. The depth of field should be more extreme because the background needs to be in focus. A wide angle lens choice in a range from 20mm to 35mm is most preferred by photographers.

If a large, picture window is available, use that soft, natural light for the portrait. Often, however, the available lighting must be supplemented with electronic flash. A bare-bulb flash simulates soft, window light and is an excellent flash choice. If the ceiling is of moderate height and lightly colored, a flash head aimed at an angle will bounce the light off the ceiling and create a soft, even glow. If possible, a photographer may want to bring an umbrella or a light box and a stand for the flash. The photographer should try to avoid the flash mounted on the camera and pointed directly at the subject unless the personality of the subject warrants such a tech-

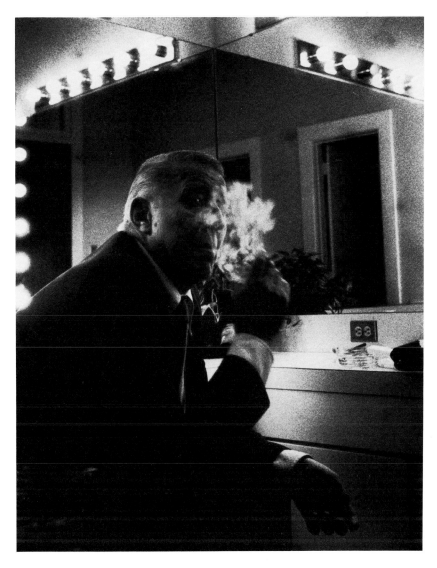

Portrait assignments. Bandleader Stan Kenton relaxes in his dressing room before a performance in this environmental portrait (photo by Paul Lester/*Times-Picayune*).

nique. Direct flash creates a bright, blinding light and harsh shadows that is inappropriate for most portraits.

Some photographers stage manage their environmental portrait subjects. They tell them where to sit or stand, whether to look at the camera or away, and to hold a prop. The cliché environmental business person's portrait always has the subject pretending to talk on the telephone. Such a picture always looks phoney and is a result of laziness or a photographer's much too prevalent ego who assumes he or she knows how the subject should look. The best method is to have plenty of time for picture taking, have a reporter interview the subject so that the photographer can work more freely, and if asked by the subject where to stand or what to do, simply tell him or her to decide. It is

always better to not create or stage manage a portrait session. Even if a pen and pencil set on a desk or a large, leafy, potted palm is in the way, avoid the temptation to move those objects. Part of the challenge of being a photojournalist is to work with the limitations that are presented during a shooting session. Distracting visual elements are a part of the subject's personality and should be left in the composition.

ILLUSTRATION ASSIGNMENTS

Consisting of food, fashion, and editorial subjects, the illustration assignment has come under criticism by leaders in the field who worry about the rise in the use of set up, contrived and computer manipulated images. The judges for the 47th Annual Pictures of the Year, one of the most prestigious photographic competitions in the world, announced that because of a concern for photographic credibility, the editorial illustration category would be eliminated. In addition, "photos that portray the subject realistically . . . will be preferred to those that illustrate a clever headline or concept" ("Contest Instructions," 1989).

Food illustration. For use with advertisements or editorial stories many photographers take food illustration pictures in the studio (photo by Allen Cheuvront/Silver Image).

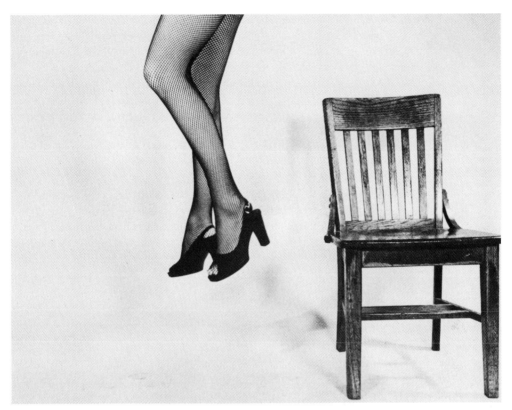

Manipulation techniques in the studio are used for a fashion illustration on women's hosiery (photo by Paul Lester).

Such trends have come and gone throughout the history of photojournalism. It is certainly hoped that a photographer who works on an illustration assignment does not carry those techniques to the other types of assignments. A fashion assignment, for example, lets the photographer work with an art director to create images that show models and clothing in pleasing compositions. The nature of an illustration is such that it demands much pre-planning. Locations, models, and clothing must be selected. During the shoot, poses must be managed. The ethical danger lies when the photographer, fresh from a fashion shoot, is asked to make an environmental portrait and uses those same techniques to manipulate the subject for an editorial story. The photographer's credibility may suffer. Readers who notice the name of a photographer who created an illustration may also see the same photographer taking pictures for other assignment categories and assume those pictures were set up as well.

The rise of the illustration assignment can be directly related to the rise in the use of color. Newspapers have invested heavily in color printing technology to attract readers and advertisers. Color printing in newspapers has increased steadily in quality and quantity to the point where readers expect to see color photographs and graphics everyday. To keep up with the demand, many photography staffs have switched to shooting all color negative film, bought color enlargers and film and

print processors, and purchased portable lighting equipment powerful enough to be used in poor lighting situations with low ASA color films. New films on the market, however, have made the shooting of color as easy and worry free as with black-and-white film products without complicated electronic flash techniques.

Some staffs have hired or made a photographer responsible for all the illustration assignments, thus avoiding an ethical conflict of interest. The photographer is trained in 120mm and large format color negative and transparency lighting and shooting techniques.

From an idea originated from a reporter or editor, the photographer is asked to illustrate a vague concept through an arrangement of props and models usually in a studio location. Many photographers enjoy the creative challenges offered by the illustration assignment. Problem solving is an absolute necessity as props get lost, food wilts or melts, and models complain.

The use of illustrations should be kept to a minimum by a newspaper. Whenever possible, illustrations should be made in realistic settings. Above all else, a photographic illustration should be clearly labeled as such in the caption and techniques that are special to the illustration should never carry over to another assignment category.

PICTURE STORY ASSIGNMENTS

With all other assignments, the pressure to produce pictures on a tight deadline sometimes causes photographers to hurry themselves through a shooting session. The picture story assignment gives a photographer a chance to slow down and produce a package of pictures over a longer period of time. Although not as numerous as some of the other assignments, picture stories should be essential components in a photographer's portfolio. At its best, a picture story illuminates a serious city-wide social problem through the telling in words and pictures a particular person's plight.

Picture story ideas come from an editor, a reporter, or a photographer. Gene Smith, one of the most respected photojournalists and producers of picture stories until his death in 1978, said that "The best way to find ideas for photo essays is to be immersed in enough activities and different people so that you keep your mind stimulated" (cited in Kobre, 1980, p. 288). A curious and energetic mind will always find stories worth telling.

There may be a pressing story in a foreign country with many of the newspaper readers concerned about the situation. An editor will send a reporter/photographer team to report their findings. Closer to home, a reporter or a photographer may have an idea for a story based on his or her own interests or previous assignments that warrant a longer treatment. In some cases, a photographer has the opportunity and the talent to produce both the words and the pictures.

Once a topic is decided upon, one of the first and crucial next steps is to conduct research on the topic. What has been written on the subject in the newspaper or in magazines and books? What can social workers, city officials, or persons in similar situations tell? Before contact is made with a subject, the photographer should read and talk to as many sources as possible in order to get as thorough an understanding as possible.

Part of the research process is to decide on the film and equipment that will be necessary for the completion of the assignment. Is the project a black-and-white or color film story? Will special lighting or camera equipment be required? Will permission from subjects be necessary?

Another crucial part of proper picture story planning and yet often overlooked is the deadline. There should be some kind of forced completion date for the project. Even if the story is self-imposed and the photographer shoots the pictures on his or her own time, a strictly enforced deadline upheld by a caring editor will prevent a photographer from spending too much time on the story. Many serious and professional photojournalists have sacrificed their careers because they became emotionally involved with the subject of a picture story. One photographer worked for over a year on a story of a little girl dying of cancer. When she died, the photographer decided to continue with the story and show how a family copes with the death of a child. The photographer could have used a strong editor to help manage the story and prevent the photographer from becoming obsessed.

The next step is to make contact with the subject. Some photographers do not bring cameras with them to the first meeting. Others take their cameras, but leave them in the trunk of their car. Most photographers will bring a camera with a 35mm lens on a strap around a shoulder to get the subject used to the picture taking process. Most persons think of photography as a means to prove they were at a famous landmark, to document the growth of a child, or to record the smiles of family members and friends. A photographer must take care to explain to the subject the purpose and intended outcome for the pictures. More importantly, the subject needs to understand that tiny, revealing moments only come if a subject is willing to be revealed and a photographer is willing to be a fly on the wall quietly observing and recording.

A picture story usually has five kinds of pictures: an overall scene-setter, a medium distance interaction, a portrait, a close-up, and an ending picture. The overall scene-setter describes in one picture the essence of the story. The photograph should readily place the main subject in the context for the reader. The medium distance interaction picture should show the subject communicating with some other person connected with the story. A portrait is usually a candid moment that reveals the subject's personality. The close-up photograph can be a tightly cropped detail of an object or a person that tends to symbolize the person's situation. Finally, the ending picture sums up and concludes the set of pictures. A photographer tells a story with words and pictures. There should be a logical beginning, middle, and end.

Once the pictures are taken, some photographers give contact sheets to an editor for the final decision. Others make 8×10 work prints of their favorites, called "selects" and let the editor chose from them. Many photographers work with an editor to produce a layout together. The editor concept, the idea that someone not emotionally involved in the story selects the pictures for the final layout, is a strong and valid one. An editor should keep the reader in mind. The photographer still has the subjects in mind. An editor should know from experience the pictures that best communicate a story. But a confident editor should never object to a photographer's input. Perhaps the best compromise is for a photographer to make prints of the favorites and for an editor to select from those images with a photographer's gentle prodding.

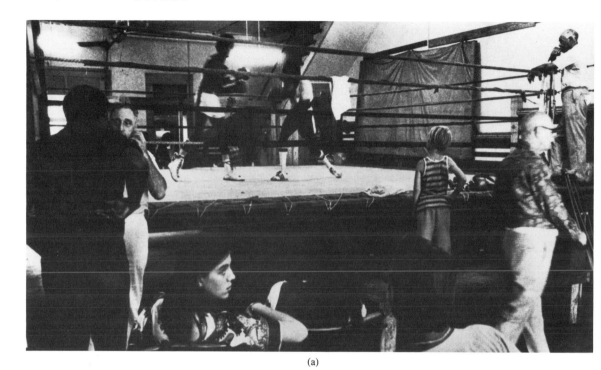

(a)

Picture story assignment. Athletes and spectators frequent an urban boxing gym.
(a) Overall, scene-setter. (b) Close-up portrait. (c) Close-up detail. (d) Medium-
distance picture. (e) Ending picture. (Photos by Paul Lester/*Times-Picayune*.)

(b)

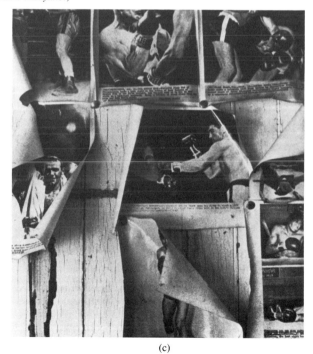

(c)

(d)

(e)

NEW TECHNOLOGICAL ADVANCES

Photojournalists are not only social historians with a camera, they are competent technicians who must keep abreast of the changing technology and the acceptable ethical considerations associated with that technology. In the 1940s, it was ethically acceptable to pose many subjects because the commonly accepted technology of the day, the awkward 4×5 press camera with a portable flash, was a poor recorder of the candid moment. Also, without a 36 exposure film cassette, photographers were forced to make every picture count.

Photographers commonly use cropping, exposure, contrast, dodging, and burning techniques in the darkroom to make the meaning of a picture more clear. Cropping can be accomplished during shooting by the choice of lens, distance from the subject or angle chosen, in the darkroom by changing the height of the enlarged image or moving the blades of an adjustable easel, or by marking the white borders of a print to show the area of the final, printed image. With manipulations in aperture and shutter speed combinations or the use of filters when shooting, times and temperatures when processing the film, aperture and time settings with an enlarger, and filter or paper grade selections in the darkroom, photographers can alter the original tones of the scene dramatically. By preventing light from exposing on a certain area of a print with a tool or by hand, the area can be "dodged" to appear to be lighter. Conversely, by adding more light to a specific area, the print appears to be darker or "burned." Dodging and burning can also be accomplished with concentrated developer or chemical bleaches.

Some photographers have resorted to a simple technique to manipulate an image—flopping. A negative is turned upside-down in the enlarger carrier to produce a picture that is reversed, or flopped. Sometimes the angle of a subject's face or hand fits a layout design more pleasingly if the angle is reversed as if viewed in a mirror. The practice is dangerous because right-handed people can be made to appear left-handed, a wedding ring is seen on a right hand, and words in the picture are reversed. Photographers should notice the best angles while shooting without resorting to flopping a negative.

With computer technology, the picture manipulations cited here are possible without ever entering a darkroom. Newspapers and national news bureaus are experimenting with technologies that in a few years will be commonly thought of as the industry standard. Whether a subject is photographed with negative film or by electronic still video cameras where photographers are able to record their images on a 2-inch floppy disk, the pictures can be converted to computerized, digital images. The photographer can then make exposure, color balance, and cropping adjustments on a television or computer screen, type caption information, and send their words and photographs via a telephone line to the photo editor's computer terminal. Once in the newsroom's computer, the pictures can be readied for the printing process. The photo editor can make exposure, color, and cropping correc-

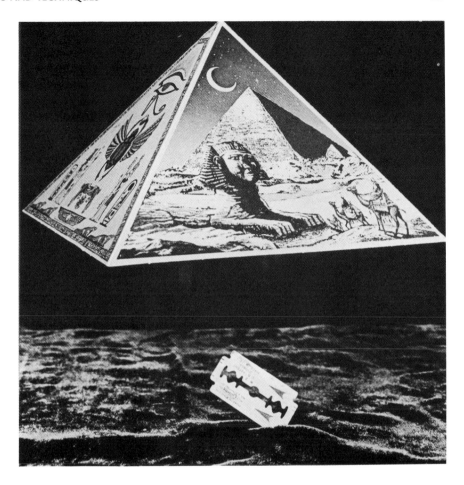

Marginal studio skills are employed to create an editorial illustration on the power
of pyramids to sharpen razor blades (photo by Paul Lester/*Times-Picayune*).

tions. Computer-controlled color separations are then automatically performed with
the pictures ready for the printing press. At the present time, the new technology
saves time, yet is expensive with the quality not as high as present, traditional
methods. But the day will come when the technology becomes affordable for even
university photojournalism programs.

There are certain principles that should remain constant despite technological
advances. The guiding principle for such manipulations should always be the con-
tent of the photograph. Is the content or intent of the image drastically altered by the
manipulation? Will an exposure adjustment, angle or perspective change, tight crop,
color correction, filter selection, flopped negative, or a dodged or burned area
mislead a reader? If the answer is yes, the manipulation should not occur. Whether

by traditional or new technological methods, the underlying principle of not fooling the public should never be compromised. Credibility forms the distinction between a respected chronicle of a community's best and worst moments and a supermarket tabloid.

A modern photojournalist is a mixture of reporter, artist, and craftsperson. A photographer is expected to determine in $\frac{1}{500}$th of a second, whether a subject is newsworthy, aesthetically pleasing, and technically possible to record on film. Assignments during any one shift can run from coverage of a five-alarm fire to a meeting with the governor. Consequently, photojournalists should be well-educated, curious, and cool under stressful situations. Photographers must also be humane, caring individuals aware of the many ethical concerns that are a part of any news assignment.

Chapter 3
Finding a Philosophical Perspective

The problem with photojournalism ethics is that answers are not easily found when they are most needed. What answers there are, are often derived from emotional outbursts rather than from the calm of reason. Surveys are mailed to photographers with situations detailed. Respondents are asked to rate the actions of photographers in hypothetical situations. For example, in one study, 38% of professional photographers in a national survey said the actions of a photographer during a specific situation is ethical. However, 34% rate the same action as unethical. Which group is right? Can the right answer ever be determined? How are right answers derived?

The introduction to *Approaches to Ethics* (Jones, Sontag, Beckner, & Fogelin, 1969), states, "Ethics is not primarily concerned with getting people to do what they believe to be right, but rather with helping them to decide what is right" (p. 8). Such a definition implies that there is an overall right thing to do regardless of a person's conflicts with values, principles, and loyalties. A photographer may have a very different ethical orientation than an editor or a reader depending on the situation. Taking a picture of a stressful subject is a photographer's choice. Printing the picture on the front page is an editor's choice. A reader may find such choices offensive if he or she is concerned with privacy rights and humanitarian ethics.

Can there be an ethic that will satisfy all groups involved? No. But ethics "is not concerned at all with what public opinion or moral matters actually happen to be, just as the scientist is not concerned with what people believe about the shape of the earth but with its actual shape" (Jones et al., 1969, p. 8). Yet photographers, particularly student photographers, frequently ask if an action during a specific situation is correct. There needs to be some method that solves the ethical dilemma.

To further complicate the issue, different philosophers and writers report different

definitions of ethical behavior. Some definitions are based on an ideal derived from general moral rules. Other definitions are interpreted as being specific guidelines of proper ethical behavior. Different ethical belief systems with their guiding values, principles, and loyalties are discussed later in a journalistic context. It should be made clear at the outset that no specific course of action will be right for every individual and for every situation. However, confronting general ethical principles is the first step when evaluating whether the shooting and publishing of a controversial situation was ethical.

Study Hypothetical Situations

There have been few studies specifically related to photojournalism ethics. Brink (1988), Hartley (1983), and Wilcox (1961) sent surveys to a large number of students, readers, photographers, editors, and educators. Respondents rated the situations described in those surveys as ethical, questionable, or unethical. The problem with the surveys was that one never knew why a respondent made a particular ethical judgment. An action was rated ethical, for example, but a reader of the survey never learned how the respondent came to that conclusion. Are upbringing, journalistic principles, reader concerns, newsroom pressures, or ethical orientation responsible for a survey subject's decision? The answer is not known.

Several other researchers have conducted studies of journalism ethics. For example, Barney (Barney, Black, Van Tuburgen, & Whitlow, 1980) focused on journalists' ethical orientations, moral development, and dogmatism as possible ethical decision makers. Mills (1982) discovered that a number of journalists use the conflicting principles of the public's right to know versus an individual's right to privacy as contributing factors. Izard (1985) found that journalists take into account readers' reactions more today than in the past. Weaver and Wilhoit (1986) reported that journalists are mostly influenced ethically by newsroom learning, senior editors, and co-workers.

Values, Principles, and Loyalties

The first step in determining an ethic for the field is to determine the values, principles, and loyalties at work. A journalist must be able to define these underlying factors in the decision-making process.

Ed Lambeth (1986) in his book, *Committed Journalism,* identified the values that are highly regarded by journalists: Newspaper journalists give readers information for their daily lives; information is published to help readers make decisions; information gives meaning to a complex world; newspaper reporters make sure that public and private institutions work fairly and without prejudice; newspapers publish information that help enrich the culture for individuals; finally, newspapers

publish information that helps others to distribute goods and services. These six journalistic values can be distilled, according to Lambeth, to:

- knowledgeability,
- usefulness,
- understanding,
- feedback,
- education, and
- entrepreneurship.

Lambeth also listed the principles that journalists stand by: truth telling, justice, freedom, humaneness, and stewardship. "Most fundamentally, the need is for a habit of accuracy . . ." (pp. 54–55). Truth, beyond all other principles, is the guiding guarantee for ethical journalism. The principle of justice is related to a reporter's preoccupation with fairness. A story should be complete, relevant, honest, and straightforward. The freedom principle refers to a journalist that is independent both politically and economically. A journalist should never compromise that independence by "the acceptance of gifts, free or reduced travel, outside employment, certain financial investments, political activity, participation in civic activity, or outside speaking engagements" (p. 34). Humaneness, as Lambeth (1986) wrote, is a principle that requires "a journalist to give assistance to another in need" (p. 35). Finally, the principle of stewardship is closely related to responsibility. A journalist is responsible for "the rights of others, the rights of the public, and the moral health of his own occupation" (p. 37).

Vague principles and values are the guiding foundations for the writing of professional ethics codes. For a photojournalist, the principles detailed in the NPPA "Code of Ethics" (see Appendix A) roughly follow the principles mentioned by Lambeth. Truth telling, justice, and freedom are principles covered by the NPPA Code when it asserts that "pictures should report truthfully, honestly, and objectively." The principle of humaneness is mentioned when photographers are asked to have "sympathy for our common humanity." Finally, the stewardship principle is invoked when photojournalists are told that their "chief thought shall be to . . . lift the level of human ideals and achievement higher than we found it."

Loyalties, as Christians (Christians, Rotzoll, & Fackler, 1983) wrote, identify "which parties will be influenced by it [a decision to photograph] and which ones we feel especially obligated to support" (p. 3). Loyalties to subjects, readers, society, the organization, the photographer, and the profession, need to be identified and weighed against each other. If a photographer, for example, is more loyal to him or herself, if he or she values winning contests, receiving peer acknowledgment, or pay raises over loyalty to his or her readers, that photographer is much more likely to have ethical problems.

In *Approaches to Ethics,* Jones et al. (1969) recommended that a person with an ethical dilemma first "ascertain the facts, sort and weigh the conflicting principles, apply partially indeterminate principles to the particular circumstances, and then, come to a decision" (p. 6).

Christians et al. used a variation of that ethical inquiry they called the "Potter's Box," named for Harvard Divinity School Professor, Dr. Ralph Potter. The box is used as a model for social ethics. For any situation, first define the circumstances as fully as possible. News values, principles, and loyalties that pertain to the specific situation are factored into the ethical equation. When all these considerations are within the "box," a course of action becomes more clear.

For example, suppose that the ethical dilemma in question is Hartley's (1982) first situation, "Klan Rally."

> A photographer is assigned to cover an anti-Ku Klux Klan demonstration in a city park. When he arrives, a police officer is speaking to a crowd of newsmen saying it would be a good idea if they left. He says, "Some Klansmen are going to be staging a counter-demonstration and we're afraid the presence of the press will encourage violence." Some of the newsmen leave but the photographer stays. Violence does erupt and the photographer is later awarded the Pulitzer Prize for his images depicting the fighting. (p. 24)

The first step in the "Potter's Box" analysis is to define the ethical question posed by the situation. An ethical question might be: Should a photographer stay at the scene of a demonstration despite his presence possibly inciting violence? Defined further the question becomes: Should a photographer give up news reporting responsibilities because of the recommendation of a police office? Defined further still and the ethical issue becomes: truth telling versus law and order.

All of the news values mentioned by Lambeth, except for entrepreneurship are invoked. If the photographer stays, readers will know about those involved with the demonstration. Readers will be able to make decisions about the different sides of the conflict. Understanding of the two sides may help give meaning to each cause. Police officials can be monitored so that justice is served fairly by government officials. The community is educated as the grievances are voiced by its members. In the face of all the values just presented, it is clear that the ethical position for a journalist to take is to stay at the scene to report the news.

The next phase in the Christians et al. method is to analyze and weigh the various principles at work. A photojournalist should always tell the truth fairly and objectively. Following such principles, the clear decision again is to stay and cover the demonstration.

Identifying loyalties is the next step. As Christians et al. (1983) noted, "ethical principles are crucial in the overall process of reaching a justified conclusion. However, in the pursuit of socially responsible media, clarity over ultimate loyalties is of paramount importance" (p. 6). A younger photographer's loyalties may be different from a photographer who has been at work for many years. A reader may certainly have a different set of loyalties than a reporter or editor. Loyalties help show why different individuals come to opposite conclusions about the use of a controversial photograph.

What loyalties are at work in the "Klan Rally" situation for a photographer? If loyalty is to *the subjects* then the photographer would stay at the scene in order to record faithfully the events at the demonstration. Another photographer would leave because participants may be hurt by the increased violence.

If loyalty is to *the readers* then the photographer would stay at the scene in order to inform them. Another photographer would leave because readers would not like a photographer who causes trouble.

If loyalty is to *society* then the photographer would stay in order to inform a larger public about conditions in the community. Another photographer would leave out of respect for police authority.

If loyalty is to *the organization* then the photographer would stay to prove that the newspaper is worthy of its watchdog function. Another photographer would leave so as not to cause problems for the newspaper.

If loyalty is to *the photographer* then the photographer would stay because the situation may get violent and result in dramatic pictures. Another photographer would leave to avoid any legal problems caused by additional violence.

If loyalty is to *the profession* then the photographer would stay and take pictures in a rational, objective and truthful manner. Another photographer would leave to avoid bringing disrespect upon all photojournalists if further violence erupted.

After a decision to stay at the scene has been made, values, principles, and loyalties alone will not tell a photographer how to take the pictures. For that answer, a photojournalist needs to identify the ethical guidelines he or she uses when covering a controversial assignment.

At a potentially violent demonstration, a photographer would probably use a 300mm telephoto lens and take pictures from a distance. Suppose, however, that a photographer is asked to photograph a protest rally for a political cause supported by the photographer. The photographer wants the protestors to look as complimentary as possible. At the scene, there are 10 protestors out of an expected 500. The photographer has two technical choices: use a wide-angle lens to show how few protestors are present or use a telephoto lens to focus on an individual who carries a sign. With such a technique, the size of the protest group in the photograph will be ambiguous.

Photographers are constantly defining reality. By selecting what stays in the tiny 35mm frame and becomes a picture, the photographer makes a conscious or unconscious decision to edit out a vast majority of the scene. Choices of film, camera, lens, aperture, shutter speed, angle of view, filters, lighting, and cropping can change a photograph's meaning. The reason why the principles of objectivity and truthfulness are so often stressed is because a photographer can easily lose his or her objectivity and not tell the truth.

When Norman Zeisloft was fired (see chapter 6) for stage managing a sports feature picture, his executive editor, Robert Haiman said, "I believe that a photographer is every bit as much a first-class citizen in this journalistic community as any reporter. And there is one thing about the journalistic community which is more important than in any other community and that is the obligation to tell the truth, the whole truth and nothing but the truth" (cited in Gordon, 1981, p. 34). Truthfulness is high on any ethical list of principles.

As John Hulteng (1984) wrote in his book on media ethics, *The Messenger's Motives,* "One of the least enviable situations in the debate over what is ethical and what is not in the handling of news photographs is that of the photographer" (p. 154). A writer can observe a news scene quietly and anonymously and report the facts back in the newsroom. A photographer is uniquely tied to a machine—the camera. There is little opportunity for concealment, nor are hidden techniques desirable.

Six Major Philosophies

Another method used to make and defend controversial decisions is to rely on ethical philosophies that have been established for many years. Six philosophies are discussed here. Along with the six philosophies are quotations from working news-paper photographers that show how each ethical philosophy is supported by different individuals. The quotations come from a special report in *News Photographer* magazine titled, "Bibliography of Grief: An analysis and description of tragic situations . . . over the past 15 years" (Sherer, 1986).

Although no one philosophy can always explain a person's motivation in supporting or rejecting a picture, generally speaking, a basic knowledge of the six ethical philosophies will help a photographer learn of his or her personal perspective.

The Categorical Imperative, Utilitarianism, and Hedonism philosophies are usually used to justify a photographer who takes a controversial picture or for an editor who prints it. However, the Categorical Imperative and the Utilitarianism approaches are most often at odds with the Hedonistic, self-centered philosophy. The Golden Mean philosophy can often be used by a photographer when shooting the assignment or by an editor when deciding how to print the image. The Veil of Ignorance and Golden Rule philosophies are most likely employed to justify a decision not to take a photograph or print a picture.

Categorical Imperative. Immanuel Kant, born in East Prussia in 1724, was a great influence on Western philosophy. Christians et al. (1983) noted that Kant's Categorical Imperative means that

> what is right for one is right for all. Check the underlying principle of your decision . . . and see whether you want it applied universally. The decision to perform an act must be based on a moral law no less binding than such laws of nature as gravity. "Categorical" here means unconditional, without any question of extenuating circumstances, without any exceptions. Right is right and must be done even under the most extreme conditions. (p. 11)

Lambeth (1986) elaborated on deontological ethics, Kant's emphasis on the nature of an act or a decision rather than the result of such an act or decision. Pure RULE deontology is a form of Kant's philosophy that says there are universal rules that all must follow "regardless of the good produced" (p. 21). In pure ACT deontology, on the other hand, it is admitted that firm rules or codes are not always possible. With such a belief, a person's instincts become more important in decision

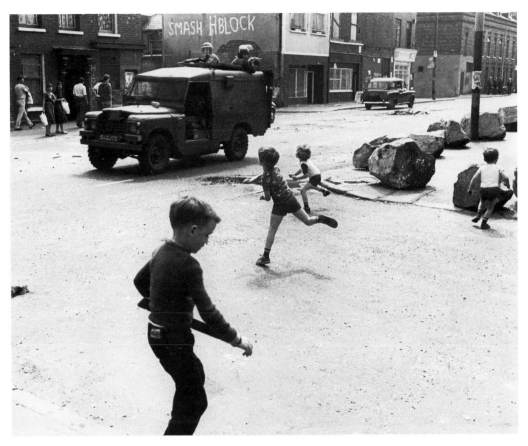

Categorical imperative. Children throwing stones at soldiers in Belfast, Northern
Ireland is a compelling news picture that should be printed (photo by Paul Lester).

making than logical reasons. Mixed act and rule deontology are compromises
between the extreme harshness of universal rules and the idea that emotions should
guide a decision. Both mixed act and rule deontology are guided by principle, but
the consequences of an act must be considered as well.

Two examples of Kant's Categorical Imperative can be found in writings by
photojournalists. Mary Lou Foy, former NPPA national secretary, invokes Kant
when she admitted, "I think religious services should be off limits . . . for funer-
als" (cited in Sherer, 1986, p. 27). For her, a universal rule of not adding grief to
family members during a funeral allows her to ban all photographers in all such
situations. Although her major concern is not to add additional suffering to a
victim's family, a Golden Rule influence, her unequivocal ban on all such photog-
raphy sides her with the Categorical Imperative philosophy. Conversely, David Nuss
of the *Statesman-Journal* in Salem, Oregon wrote that a newspaper's role is to cover
the news, "and sometimes that involves situations where there is also an issue of
taste, judgment, and the right to privacy" (cited in Sherer, 1986, pp. 28, 30). For
Nuss, the principle of reporting the news is a universal rule that must not be broken,
regardless of the consequences.

Utilitarianism. A popular ethical belief used by journalists is the philosophy of Utilitarianism outlined by British philosophers Jeremy Bentham and John Mill. Utilitarianism is the belief that tries to maximize the greatest good for the greatest number of people. A person wants to "maximize value or minimize loss" (cited in Christians et al., 1983, p. 13). In Utilitarianism, "various consequences are considered and the impact of the consequences of one action is weighed in relation to the consequences of another course of action" (Steele, 1987, pp. 10–11). Christians et al. (1983) use the Watergate scandal as an example. Reporting the story was certainly not beneficial to President Nixon, but the "overall consequences were of value to a great many people" (p. 13).

Reporters and photographers most likely use Utilitarianism when they justify complaints from readers who object to pictures of gruesome accidents with phrases such as, "People will drive more safely." A gripping interview with an accident victim is justified with, "Interviews act as a cathartic release for those under stress" (Steele, 1987, pp. 10–11). Peter Haley of the *Journal-American* in Bellevue, Washington and Gary Haynes, assistant managing editor of the *Philadelphia Inquirer,* use Utilitarianism to justify the publishing of gruesome accident photographs. About a series of drowning pictures Haley wrote, "at least a few parents could be moved by the photo to better train their children in water safety." Haynes wrote of Stan Forman's picture of victims of a fire escape collapse (see chapter 4) with, "and

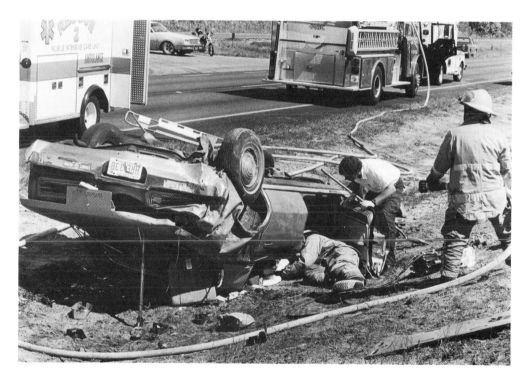

Utilitarianism. Many automobile accident photographs are published by editors with the belief that such pictures might make readers drive more carefully (photo by Larry Behnke/Silver Image).

in some cities [where the photographs were published], codes were quietly re-viewed . . . to be certain Boston's tragedy couldn't be repeated locally" (cited in Sherer, 1986, p. 28).

When a drowning victim's photographs were printed in a small-town newspaper, the journalists involved probably used the Utilitarianism philosophy to justify publication after a storm of protest was received by readers. The photographer "pointed out that his photos are under study . . . by the local fire department . . . with an eye toward improving swift-water rescue techniques."

Editors expressed the belief "that the paper's photo coverage has made . . . residents much more mindful of the area's hazards than mere words could have." And the executive editor "plans to promote better relations between the paper and the public with a series of columns he will write . . . explaining how and why certain editorial judgments are made" (Moore, 1978, p. 54). Seeing the drowning pictures on the front page of the local newspaper may have upset the victim's family, but from their publication and the controversy that surrounded them, many positive outcomes for many persons occurred.

Hedonism. Hedonism, unfortunately, has gained in popularity in recent years. Hedonism comes from the Greek word for pleasure and is closely related to the philosophies of Nihilism and Narcissism. Aristippus, who died in Athens in 366

Hedonism. Whenever a photographer has a personal reason for manipulating or publishing a picture, the Hedonism philosophy is at work. Chris Maron was told to stand behind an American flag in Park City, Utah. The picture was used in this textbook because Chris is a friend of the author (photo by Paul Lester).

B.C., a student of Socrates, was the founder of the ethics of pleasure. Aristippus believed that persons should "Act to maximize pleasure now and not worry about the future." Aristippus, however, referred to pleasures of the mind—intellectual pleasures. "While he believed that men should dedicate their lives to pleasure, he also believed that they should use good judgment and exercise self-control." His famous phrase is: I possess, I am not possessed. Modern usage of the Hedonism philosophy, however, has ignored his original intent. Phrases such as, "Eat, drink, and be merry, for tomorrow we die," "Live for today," and "Don't worry-Be happy," are present examples of the Hedonism philosophy (Edwards, 1979, pp. 24–25.

Dr. George Padgett, assistant professor of communication at Illinois State University, is sure of the motivation for printing graphically violent images. "They were printed," wrote Padgett, "for no other reason than that they were sensational and would sell newspapers—the same reason the supermarket tabloids give their readers a steady diet of Siamese twins and babies with three legs" ("Tasteless breach," 1986, p. 27). Roy Clark (1987), instructor at the Poynter Institute for Media Studies in St. Petersburg, Florida, disagrees with Padgett's explanation. "The real reasons for publication of these photos," wrote Clark, "are not economic, but aesthetic. They involve questions of personal ambition and peer approval. The photographer desires to get his or her best work, a memorable photo, on the front page" (p. D-1). Both explanations describe Hedonism as the justifying philosophy.

Golden Mean. Aristotle's Golden Mean philosophy refers to finding a middle ground, a compromise between two extreme points of view or actions. Formulated around the 4th Century B.C. in Greece, taking the middle way does not involve a precisely mathematical average, but is an action that approximately fits that situation at the time. As Christians et al. (1983) wrote, "The mean is not only the right quantity, but at the right time, toward the right people, for the right reason, and the right manner" (pp. 9–10).

In a funeral situation, an uncomfortable assignment for a photographer, one extreme action might be for a photographer to walk boldly up to the grieving family during the service, shoot with a wide-angle lens, motor drive, electronic flash, and leave without a thought of adding to the family's discomfort. The opposite extreme might be a photographer who is so concerned for the family that he or she refuses to take any pictures during the service. Such a photographer might even refuse to go to the site of the service against the wishes of the editor.

Although Mary Lou Foy personally believes that all funerals should be off limits to photographers, such news events sometimes need to be covered. She recommended the Aristotleian point of view when photographs of grieving victims at a funeral need to be taken. She wrote:

> Photographers must dress as if attending the funeral. When you get the assignment the day before, contact the family or close friend to let them know you are coming. Be early. If for some reason the family allows you to be up close and you are photographing tears, etc., for heaven's sake, pick your shots and don't unload with a motordrive. Whether or not you get up-close permission, don't forget that the pictures showing sorrow and grief can be made at many places, and often far away. (cited in Sherer, 1986, p. 26)

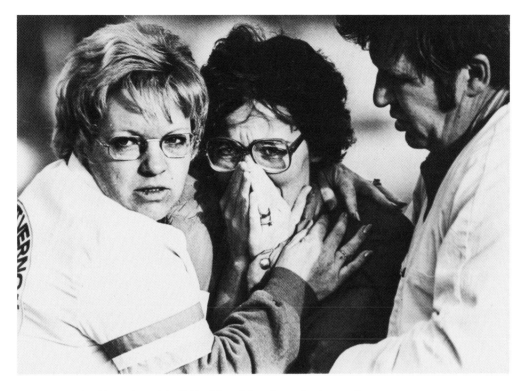

Golden mean. Don Hornstein used the Golden Mean philosophy to take pictures of
grieving family members. He stood at a distance with a telephoto lens (photo by
Don Hornstein/*Cedar Rapids Gazette*).

The Golden Mean most often demands that the photographer find a less obtrusive
way of covering the sensitive news event.

For an editor who is faced with the decision of how to print a funeral picture, one
extreme would be to print the photograph large and on the front page. The opposite
extreme would be to not print the picture. An editor who used the Golden Mean
philosophy would most likely decide to print the picture small and on an inside page.

The following two philosophies, Veil of Ignorance and Golden Rule, are usually
used to argue against the taking and printing a controversial image by photogra-
phers, editors, subjects, and readers.

Veil of Ignorance. In his book, *A Theory of Justice,* John Rawls (1971) outlined the
Veil of Ignorance philosophy where all members are equal. There are no advantages
for any one class of people when all are reduced to their basic position in life.
Seeing everyone through a veil, without noticing age, race, sex, and so on maintains
"basic respect for all humans . . ." (Christians et al., 1983, p. 16). In practical
terms, a photographer tries to imagine what it would be like to be the subject of the
photographs. Steele (1987) noted that "by transferring roles, an individual is forced
to consider values and loyalties from perspectives other than his own as a photojour-
nalist" (p. 10).

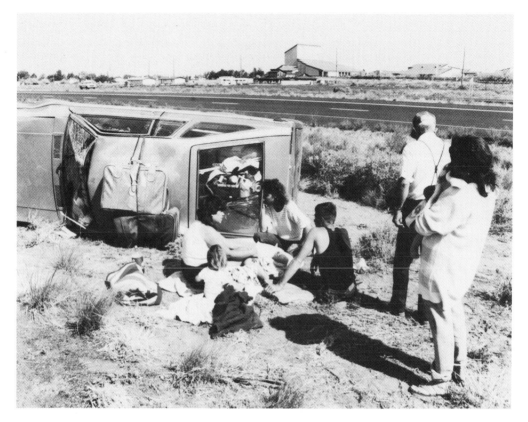

Veil of ignorance. A picture of accident victims outside Winslow, Arizona await-
ing rescue assistance might not be published if an editor feels that too many
readers would identify with the group of family members (photo by Paul Lester).

Rawls' "shoe on the other foot" approach can be found from Jim Gehrz of the
Worthington Daily Globe, of Worthington, Minnesota. In his letter to *News Photog-
rapher* magazine titled "How Would I Feel?" Gehrz wrote, "we are placed in an
awkward position where we must make photographs of people who are under great
stress. . . . My approach is to ask myself how I would feel if I were the person
being photographed? If the answer is unacceptable, I look for a different way to tell
the story in my photo" (cited in Sherer, 1986, p. 28).

Golden Rule. The Golden Rule philosophy teaches persons to "love your neighbors
as yourself." From the Judeo-Christian tradition, a photographer should be as humane
as possible to try to protect subjects from harm inflicted by photographic coverage.
"Love," according to Christians et al. (1983), "is personal, dutiful, but never purely
legalistic" (p. 16). Jay Mather, who won a 1979 Pulitzer Prize wrote simply, "Human
kindness has always been an effective and impartial editor" (cited in Sherer, 1986, p.
25).

Being aware that the different ethical philosophies are the basis for the values,
principles, and loyalties upheld by a professional code of ethics will help photogra-
phers come to a decision. The reason thoughtful photographers, editors, subjects,

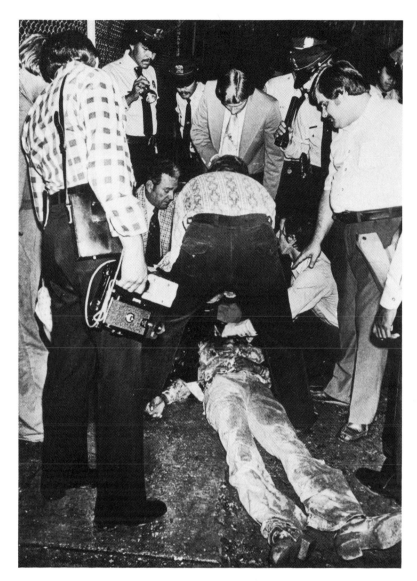

Golden rule. Police officials examine the body of a young shooting victim. The photograph was not printed in the newspaper because it was feared that many readers would object to its gruesome content (photo by Paul Lester).

and readers disagree over the same picture is that each person bases their decision on a different philosophy. Those who side with the Categorical Imperative, Utilitarianism, or Hedonism philosophies will never agree with those who base their decisions on the Veil of Ignorance or the Golden Rule philosophies.

Whether you take a picture during a controversial situation or whether you print a controversial image by one of your photographers is often a matter of which major philosophy is your prime concern. A picture of a father grieving over the death of his son killed in a traffic accident touches many philosophical bases. It is a strong,

news situation—Categorical Imperative. It might make people drive more safely—Utilitarianism. It might win an award—Hedonism. It should be published in an inside page—Golden Mean. It might remind you of your own son—Veil of Ignorance. It might add to the father's grief if it is published—Golden Rule.

Occasionally, there is blurring between the various philosophies. You may not want the picture to run large on the front page because it might add to the father's grief—Golden Mean and Golden Rule. You may not want to publish the picture at all. You may think people crying should never be the subject of news photography because such images upset readers—Categorical Imperative and Golden Rule. You may feel the picture is a good news photo and might make people drive more carefully, but should be used small, and on an inside page so as not to upset readers—Categorical Imperative, Utilitarianism, Golden Mean, and Golden Rule. Throughout this textbook, one of the six philosophies is often attributed to a journalist's motivation. It is important to understand that there may be other philosophies at work that guide a decision that are unknown to the author.

A photojournalist's job is to capture the news—not make it and not run from it. Sometimes, but fortunately not often, that mission runs afoul of the readers' level of sensitivity. As Jay Mather wrote, "When a reader's visual diet is composed of benign features, routine sports pictures and carefully controlled graphic illustrations, it's easy to see why the sudden confrontation with a hard news photograph promotes such virulent responses" (cited in Sherer, 1986, p. 25).

According to a survey conducted by Beverly Bethune (1983), an associate professor at the University of Georgia, when photographers in a national survey were asked, "What kinds of assignments do news photographers shoot most often?" hard news was at the bottom of the list. Only 12% of the photographers reported that more than about a third of their assignments could be called hard news. Nevertheless, news assignments are the ones that cause the most ethical problems.

The price of being responsible for the documentation of life in all its gloriously happy and tragically sad moments is that if some people do not like what they see, they will question a photojournalist's moral character. That reaction, however, is a necessary barometer of a photojournalist's ethics. It is a photographer's moral responsibility that the decision to take pictures is based on sound personal ethics that can be justified to all who disagree. Study hypothetical situations, know the values, principles, and loyalties that are a part of journalistic principles, and be familiar with the six major philosophies. With such a strong foundation, you will be better able to act decisively during a controversial situation.

Chapter 4
Victims of Violence

Violence and tragedy are staples of American journalism because readers are attracted to gruesome stories and photographs. "If it bleeds, it leads" is an undesirable rule of thumb. Judges of contests also have a fatal attraction. Pulitzer Prizes are most often awarded to photographers who make pictures of gruesome, dramatic moments (Goodwin, 1983). Milwaukee *Journal* editor Sig Gissler summed up the newspaper profession's sometimes Hedonistic philosophy when he admitted, "We have a commercial interest in catastrophe" ("Knocking on death's door," 1989, p. 49).

Ethical problems arise for photographers and editors because readers are also repulsed by such events. It is as if readers want to know that tragic circumstances take place, but do not want to face the uncomfortable details.

After the publication of a controversial picture that shows, for example, either dead or grieving victims of violence, readers in telephone calls and in letters to the editor, often attack the photographer as being tasteless and adding to the anguish of those involved. As one writer noted, "The American public has a morbid fascination with violence and tragedy, yet this same public accuses journalists of being insensitive and cynical and of exploiting victims of tragedy" (Brown, 1987, p. 80).

The Immediate Impact of Images

Photographs have long been known to spark more emotional responses than stories. Eugene Goodwin (1983) in his book, *Groping for Ethics* agreed. Goodwin wrote, "Pictures usually have more impact on people than written words. Their capacity to shock exceeds that of language" (p. 190). Other researchers have noted the eye-

catching ability of newspaper photographs. Miller (1975) wrote, "Photos are among the first news items to catch the reader's eye. . . . A photo may catch the eye of a reader who doesn't read an accompanying story" (p. 72). Blackwood (1983) argued that "People who either can't read, or who don't take the time to read many of the stories in newspapers do scan the photographs . . ." (p. 711). Nora Ephron (1978) asserted that disturbing accident images should be printed. "That they disturb readers," Ephron wrote, "is exactly as it should be: that's why photojournalism is often more powerful than written journalism" (p. 62).

When U.S. servicemen were killed in Iran during the 1980 attempt to rescue American hostages, gruesome images of the charred bodies were transmitted to American newspapers. Ombudsman George Beveridge of the defunct *Washington Star* defended his paper's publication of the photographs by writing, "newspapers were obliged to print them because they gave readers a dimension of understanding of the situation and the people involved that written words could not possibly convey" (cited in Gordon, 1980, p. 25). For Beveridge, if photographs accurately and dramatically document a news event, even though their content may be

An Iranian Revoluntionary guard views the wreckage of an aircraft and the charred remains of a body after the aborted rescue of the 50 American hostages. Editors were split on the appropriateness of using the gruesome picture (photo by Associated Press/Wide World Photos).

gruesome, those pictures should be printed. Beveridge is probably using the Categorical Imperative philosophy. Nevertheless, newspapers received hundreds of calls and letters protesting the use of the images. A Mississippi newspaper editor tore the pictures up when he saw them because he explained it would have been "the poorest kind of taste to display those ghastly pictures" (p. 28). The editor was most likely guided by the Golden Rule philosophy.

HISTORICAL FRAMEWORK

Because a photograph can immediately shock, educate, or enlighten a reader, visual impact has long been used by journalists. The emotional impact of the first war covered by photographs, the Crimean War, was low by today's standards. Roger Fenton, forced to use the slow film and lenses of that day, captured only static portraits and battlefield images. If Fenton's motivation for taking pictures was to

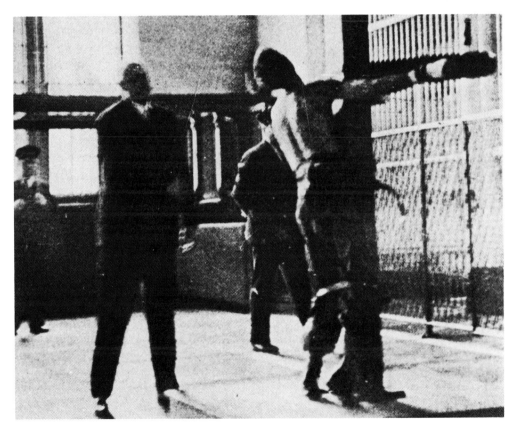

From a camera that was hidden by the photographer, a wife beater is shown getting flogged while in jail (photo by Joseph Costa/Associated Press/Wide World Photos).

educate the public, he was employing a Utilitarian perspective. Mathew Brady, recognized for his portraits of famous politicians that included President Lincoln, spent his entire family's income to employ photographers to document the Civil War. Brady hoped the pictures would be purchased in galleries for peoples' home photo albums or by the government. If Brady's guiding philosophy, as a businessman, was to make money from the pictures, he used the Hedonistic philosophy. Americans, however, had grown weary of the wrenching Civil War that divided the nation. Few were interested in static pictures taken with slow film and lenses of battlefield configurations, portraits of soldiers, and bodies mutilated by the arms of destruction.

Jacob Riis Illustrates His Words

Danish immigrant, Jacob Riis, a reporter for the *New York World,* saw what he considered to be inhumane treatment of the nation's poor and homeless by an insensitive government bureaucracy in the later part of the 19th century. He wrote of the dire conditions unfortunate individuals face on the streets of New York for his newspaper. He became frustrated when, despite favorable reception to his articles, relief for the poor never came. Riis decided that photographs were necessary to show public officials and the general public the horror of the back alleys and the flop houses. Riis, along with photographers he hired, most notably, Richard Hoe Lawrence, made photographs that brought light (literally magnesium powder that was ignited) to the dank, dark, dingy police stations and saloons. Riis gave public lectures, this time with images mounted on glass slides. The impact of his visual message shaped public opinion and helped make changes. Shortly thereafter, Riis published one of the first books to combine words and pictures in a documentary format, *How the Other Half Lives* (cited in Pollack, 1977, p. 91).

The Era of Sensationalism

The turn of the century brought the highlight of yellow or "Front Page" style journalism. Visual images played a crucial part in this era known for its sensationalism. Frank Mott (1962), in his history of journalism, noted that the reporting of crime news and disasters with the "lavish use of pictures" was a factor that helped define the yellow journalism period (p. 539).

Publishers such as William Hearst and Joseph Pulitzer were locked into a bitter circulation struggle. Their use of shocking and gruesome photographs, regularly featured large on their front pages, was imitated by other publishers throughout the country. The popular belief of the day was that potential newspaper buyers looking for visual amusement, would be attracted to pages filled with photographs. Such a money-oriented, Hedonistic philosophy, contributed to an era where any type of visually stimulating event was fair game for an enterprising photographer. Much of the poor reputation bestowed upon the photojournalism profession was a result of excesses during this time.

Collier magazine photojournalist, Jimmy Hare produced striking images of the Spanish–American War. Fellow reporter, Cecil Carnes wrote that Hare "pho-

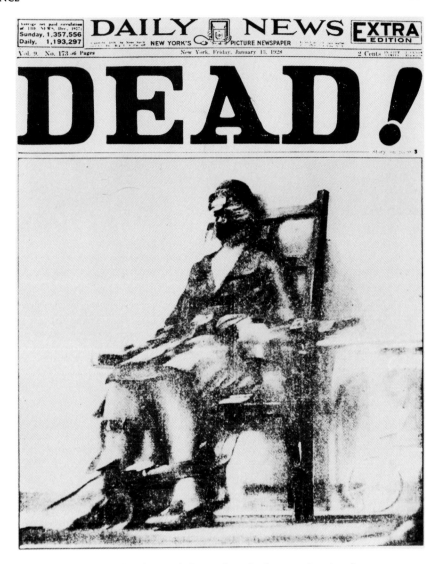

The Ruth Snyder execution photograph that ran the entire front page is an icon for
the Yellow Journalism era. The photographer hid a camera to make the picture and
made three exposures, one for each electric shock (photo by Thomas Howard/*New
York Daily News*).

tographed swollen bodies with bones breaking through the skin; he took pictures of
the emancipated living, and of the babies ravaged by disease (cited in Edom, 1976,
p. 31). Such images were not used by publishers to educate or explain the war to
readers, but to drum up support for a controversial conflict.

Joseph Costa of the New York *Daily News*, shocked readers with his sneaked
picture of a man whipped in a Baltimore jail for beating his wife (cited in Edom,
1976). He later made up for his young recklessness by becoming the first president
of the NPPA and teaching photojournalism at universities.

"Murder in Hell's Kitchen, c. 1940." Arthur Fellig (Weegee) was known for his direct flash approach to murders and other tragedies (photo courtesy of Wilma Wilcox Curator/The Weegee Collection).

Tom Howard, another New York *Daily News* photographer, used a camera hidden and taped to his leg to produce a picture for a front page that is an icon of sensationalism, the electric chair execution of Ruth Snyder (cited in Edom, 1976).

Probably the most famous newspaper photographer of this time was Arthur Fellig, better known by his nickname, "Weegee." Fellig was the quintessential ambulance chaser. He stalked the streets of New York City at night producing horrific images of murder, accident, and fire victims. His use of powerfully bright flash bulbs mounted on a 4×5 press camera produced shockingly clear pictures of dead and helpless victims of violence surrounded by the cloak of night's curtain.

The Pictures from World War II

Although many of their images were censored by government officials, photographers during World War II produced many dramatic visual documents. A picture cooperative was formed by Acme, Associated Press, International News, and *Life* magazine to cover land and sea battles for use in publications. Photographers such as Gene Smith and Robert Capa were famous for capturing emotionally charged moments.

One photograph that was delayed for several weeks by censors concerned for the public's reaction was published in *Life*. Captioned, "Here lie three Americans . . . ," George Strock's shocking picture of the maggot covered bodies of U.S.

Many Americans were shocked to see the bodies of soldiers lying on a foreign beach during World War II. "Three dead Americans on the beach at Buna" (photo by George Strock/*Life Magazine* © 1944/Time Inc.)

servicemen face down in the sand of a distant island's beach was the first picture of killed American soldiers published in a U.S. magazine. Many readers were stunned by the visually graphic image. But Susan Moeller (1989) in her chronicle of war photography, *Shooting War,* noted that many soldiers praised the photograph and the accompanying editorial. A lieutenant wrote, "Your Picture of the Week is a terrible thing, but I'm glad that there is one American magazine which had the courage to print it." A private wrote, "This editorial is the first thing I have read that gives real meaning to our struggle" (p. 207).

World War II was the last major conflict in which photographers were on the same side as the government. The Korean and Vietnam Wars produced films and photographs that brought home the terror like never before on a daily basis. David Douglas Duncan produced sensitive, almost romantic portraits of American servicemen in Korea. Duncan was criticized for his many sanitized views of war by those who thought Americans at home should know the realities of war—that men were dying. Gradually, Duncan came to reject the government's handling of the war and took an anti-war position. Many critics, however, mistook his pro-soldier pictures for a pro-war attitude.

The Disturbing Images from Vietnam

Perhaps due to political uncertainty about America's role or a younger crop of photojournalists who were willing to show the worst moments, films and still pictures from the Vietnam War were the most graphically brutal in war-time photographic history. Many photographs taken during the Vietnam War not only startled, but were responsible for helping to change the American public's opinion against that conflict.

In the Spring of 1963, Malcolm Browne of the Associated Press, received a telephone call to come to a public memorial service for Buddhist monks. Eight people had been killed during a recent demonstration against the South Vietnamese government's crackdown on their religion. The series of pictures he made at that service is unforgettable. In deliberate silence, two monks poured gasoline on a sitting third monk and set the man on fire. Browne made pictures of violent flames that engulfed the protestor who never uttered a sound. Horrified readers in the world's newspapers viewed this series the next day (cited in Faber, 1983, p. 10).

Eddie Adams' frozen moment of death is another unforgettable instant. In the Winter of 1968, General Nguyen Loan, the chief of police for the city of Saigon, fired his revolver through the temple of a Viet Cong soldier. The soldier was suspected in the killing of Loan's best friend, a police major, and knifing to death the major's wife and six children. At ⅟₅₀₀th of a second, Adams captured the swift judgment and brutal execution of a policeman's prisoner and sparked additional protest against America's involvement in the war. According to *Time* magazine photographer, Bill Pierce (1983), Adams never accepted the Pulitzer Prize money or seldom talks publicly about the image.

Huynh Cong "Nick" Ut's terrifying image of young children running toward the camera with open mouths and fire scorched arms held awkwardly away from their sides is all the more horrible when it is known that their injuries were a result of an

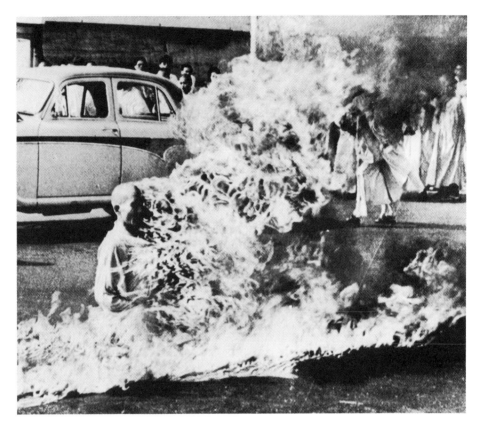

The suicide of a Buddhist monk in a protest of the Diem regime in Vietnam made
headlines throughout the world and sparked reader protests (photo by Malcolm
Browne/Associated Press/Wide World Photos).

accidental napalm attack by American forces. The girl in the picture, Kim Phuc, and
Ut were happily reunited 17 years after the picture was taken in Havana, Cuba
(Wilson, 1989).

Violent Photographs of the 1960s

During this same turbulent decade, visual images continued to isolate some of the
most strikingly terrifying moments in American history. Bob Jackson of the Dallas
Times-Herald captured the political assassination of Lee Harvey Oswald by the man
with the gray hat and the easily concealed revolver, Jack Ruby. Jackson's awful
moment is an American icon. In one picture, it shows the hunched determination of
the assassin, the painful gasp of the handcuffed victim, and the shock of help-
lessness on the face of a policeman.

Bill Eppridge and Boris Yaro were both covering Robert Kennedy's campaign
speech after the California presidential primary. For many persons, Kennedy sym-
bolized the hope that America would overcome the shock of a presidential as-

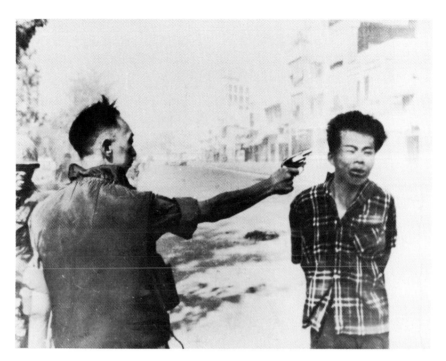

The street execution of a suspected Viet Cong soldier provoked a storm of protest back in America (photo by Eddie Adams/Associated Press/Wide World Photos).

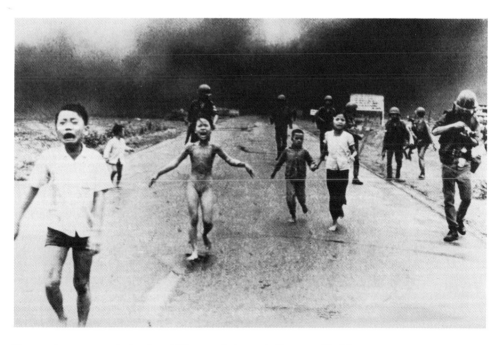

Many readers were upset at seeing children run in torment after an accidental napalm attack (photo by Huynh Cong "Nick" Ut/Associated Press/Wide World Photos).

sassination, a seemingly endless and costly foreign war, riots in cities across the country, and finally, the assassination of the leading African-American spokesman, Martin Luther King, 2 months previously. Who can forget, amid the technical problems of harsh lighting and the grainy appearance of push-processed film, the image of a caring busboy cradling the head of a man he never met. The loss seen on his face symbolizes all the world's loss.

In the Bible belt of America, John Filo, a college student with a borrowed camera, summed up many Americans' anguish over the Vietnam War in one angry photograph. The National Guard was called to the campus of Kent State University in Ohio to quiet a series of demonstrations against military involvement in Vietnam and Cambodia in 1970. Filo captured the image of Mary Vecchio kneeling over the bloodied body of Jeffery Miller. Vecchio seems to be screaming the hauntingly simple question, "Why?"

Vecchio, a 14-year-old runaway from Florida, was accused by Florida's Governor Claude Kirk of being planted by the Communists. The notoriety brought media attention to her subsequent troubles with the law. It was reported, for example,

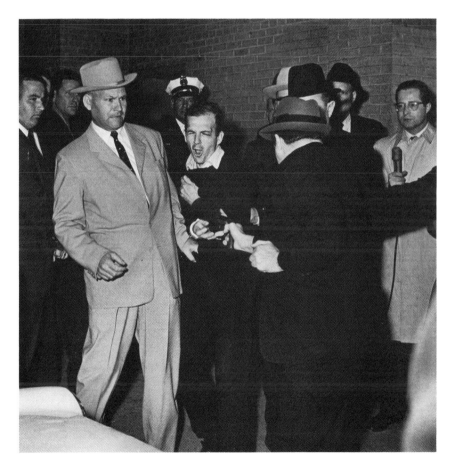

Jack Ruby takes his place in history after he silences Lee Harvey Oswald forever (copyright © 1963 by Bob Jackson).

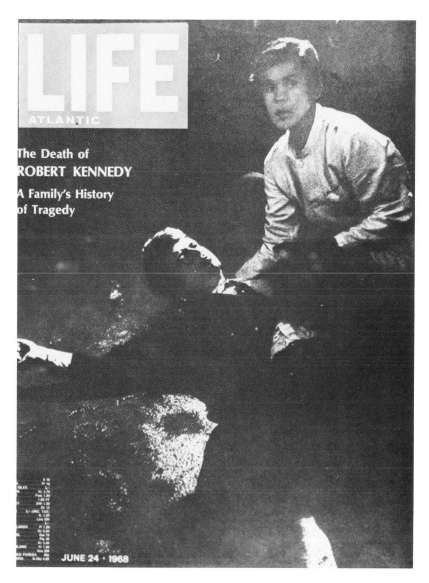

Bill Eppridge for *Life* magazine took the cover photograph of Robert Kennedy being comforted by a hotel employee (photo by Bill Eppridge/*Life* Magazine © 1968/Time Warner Inc.).

when she ran away from home again, when she was sent to a juvenile home, and when she was arrested for loitering and marijana possession. She later admitted that the picture "destroyed my life" (Bell, 1990).

Interestingly, moving films shown to television audiences were made at the same time during the Adams, Ut, Jackson, and other dramatic news events, but it is the powerful stillness of the frozen, decisive moment that lives in the consciousness of all who have seen the photographs. The pictures are testaments to the power and the

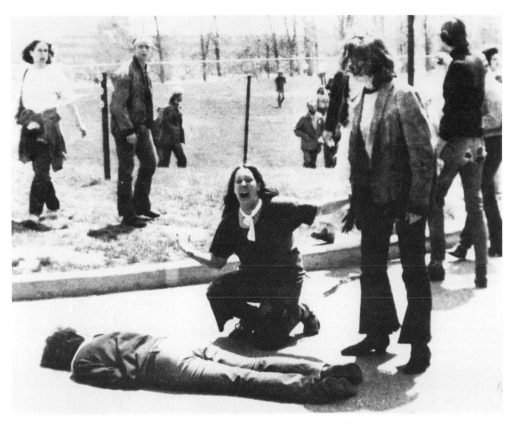

A runaway woman from Florida becomes a symbol for the Vietnam War protest
movement after the attack on students in which four were killed by the National
Guard at Kent State University in Ohio (photo by John Paul Filo).

sanctity of the still, visual image. Malcolm Mallette (1976) wrote that "the elec-
tronic image flickers and is gone. The frozen moment . . . remains. It can haunt. It
can hurt and hurt again. It can also leave an indelible message about the betterment
of society, the end of war, the elimination of hunger, the alleviation of human
misery" (p. 120).

The Public Suicide of Budd Dwyer

Editors have noticed that when emotionally charged and gruesome pictures come
from a local event, readers react the strongest. A mother grieving over a drowned
child in Bangladesh will not produce the same level of reactions as an identical
subject in a reader's home town.

(a)

National Press Photographers Association
For still and television news

May 1987

photographer

Minutes from tragedy: Reporting the suicide

(b)

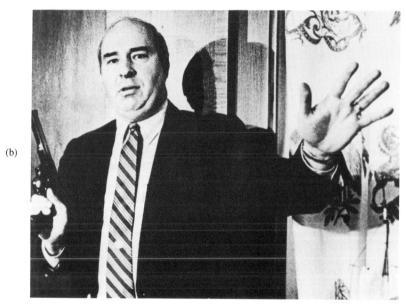

A general news press conference suddenly turns to a spot new tragedy with editors confronted with a wide variety of pictures that tell the story.(a) The cover of *News Photographer* magazine shows an unsuspecting group of journalists listening to Pennsylvania State Treasure, Budd Dwyer conduct his last press conference (photo by Fred Prouser/Associated Press/Wide World Photos).(b) In a photograph most often used by newspaper editors across the country, Dwyer waves off reporters while he holds a .357 pistol (photo by Terry Way/UPI/Bettmann Newsphotos).(c) The last seconds of Budd Dwyer's life (photo by Terry Way/UPI/Bettmann Newsphotos).(d) Dwyer reacts violently to a bullet through his head in a photograph that was used by many newspaper editors (photo by Paul Vathis/Associated Press/Wide World Photos).

(c)

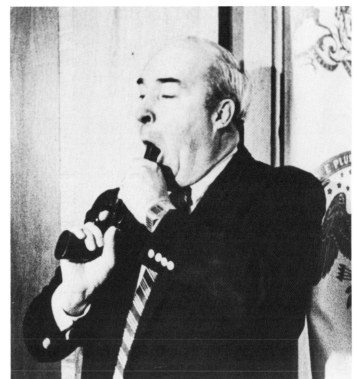

(d)

Pennsylvania State Treasurer, Budd Dwyer had just been convicted of bribery. Journalists from several newspapers, news services, and television stations gathered around a small podium that sat on a table expecting to hear Dwyer announce his resignation from state government. What they heard were the long, rambling last words of a seriously troubled man. Dwyer pulled out a .357 magnum, long barrel pistol, waved back reporters, stuck the revolver in his mouth, pulled the trigger and ended his torment. His desperate act also created torment with editors around the country who were left with some hard questions: Should any pictures be used? Should more graphic or less graphic pictures be used? Should only one or a complete series of pictures be printed? On what page should the pictures be displayed? How large should the pictures be? Should color or black-and-white pictures be used?

Journalism researcher Robert Baker (1988) found that among the 93 daily newspapers he studied, "Newspapers more than 200 miles away from the victim's hometown were two-and-a-half times as likely to use the 'very graphic' photographs than those within 100 miles" (p. 21). Editors were more likely to use the most gruesome images the further they were from the event.

Robert Kochersberger (1988), another journalism researcher, also looked at the Dwyer suicide photo use. He found a trend toward sensitivity to the publishing of the graphic suicide pictures. For him, this result may suggest the "abandoning [of] the time-worn patterns of 'Front Page'-style journalism that would have called for using the graphic photos with little second thought" (p. 9).

As evidence of this new sensitivity, Kochersberger cited two editors. "Jess Garber, managing editor of the *Record Herald,* Waynesboro, PA., wrote, 'I believe in the public's right to know but am not sure that carries to seeing a distraught person blowing his brains out' " (p. 8). "John Wellington, managing editor of the *Meadville Tribune,* published in Dwyer's home town, wrote . . . 'Would anyone with half a whit of common sense want graphic suicide pictures imposed on his or her children? I would not' " (p. 9).

Apparently, many editors disagreed with Garber and Wellington. Baker's (1988) data shows that "very graphic" suicide photographs were used by up to 58% of newspapers in his survey in one of his demographic categories. Editors that used the "very graphic" images justified their publication with statements such as, " 'Photos had tremendous impact as a news story' " and " 'We used the photo to show a bizarre news event. It's not normal for a person to shoot himself at the end of a news conference' " (Kochersberger, 1988, p. 7–8). Once again, opposing philosophies are at work. One group of editors would most likely side with the Veil of Ignorance or Golden Rule philosophies. Another group would probably side with the Categorical Imperative philosophy.

Reasons for Reader Reactions

Some writers fear that readers become calloused by the many images of the dead and dying shown in the media. Bill Hodge (1989), past president of the NPPA, recently wrote, "There's a change occurring among our audiences. I see a desensitized viewer and reader that is harder to offend or shock. They seem to be more

immune to—or more interested in—shocking things" (p. 14). Hodge cited such "Trash TV" shows led by Geraldo Rivera and Oprah Winfrey that regularly feature programs that test the public's sensitivity.

There is some concern among professionals that the real culprit in the controversy over gruesome images is not the content, but whether the picture is printed in color. Readers of the Minneapolis *Star Tribune* complained about several graphically descriptive pictures that were printed in color. One caller said, "Color should be something beautiful." Another reader complained that an image of a bleeding Arab mayor "needed black and white." Lou Gelfand (1989), ombudsman for the *Star Tribune* reported that former chief photographer, Earl Seubert "says color is the cause of most of the response. Some of the . . . pictures ran in black-and-white in an early edition and looked comparatively dull." Color may be a contributing factor to a reader's reaction, but readers are still moved by dramatic black-and-white content.

Many readers, editors note, complain when a graphically violent picture is published in the morning, rather than the evening paper. For some readers, there is a sacredness about the first meal of the day. A typical response can be found from a Minneapolis reader who admitted, "I can't handle that kind of picture with breakfast" (Gelfand, 1989, p. 12).

Another contributing factor to a reader's negative reaction to a controversial photograph is the reader's perception of the respect given to the victim and the family. An image of a photographer at a funeral wearing blue jeans and an open-collared shirt and hovering over a casket with a wide-angle lens for a close-up, gives readers the impression that the photographer has little respect for the subject. Of course, an editor will seldom print that uncomplimentary portrait.

An editor can show disrespect in the eyes of some readers, however, by running a picture extremely large on the front page or with only a brief caption explanation. Readers associate the importance given to a photograph with a story that accompanies it. When readers objected to a picture of a man killing a calf with a pistol during a mass slaughter of cattle during a protest over the cost of raising beef, Bill Cento of the St. Paul *Dispatch* and *Pioneer Press* said, "The story ran across the top of page one, but we ran the picture inside. A mistake, I believe. The words are needed to tell why it was done. The picture most forcefully tells that it was done" (Mallette, 1976, p. 118). Whenever possible, stories and photographs should be located on the same page.

One heartening note: Readers will voice their negative comments about a picture regardless of the victim's race or gender characteristics. Readers seem to be equal opportunity commentators. Many of the most controversial images printed in newspapers in the past 15 years have received reader wrath with subjects who were men, women, African-American, Asian, Caucasian, or Hispanic.

A FAMILY'S TRAGEDY BECOMES PUBLIC

One of the best ways for an editor to learn if readers have grown calloused and insensitive is to take note of the calls and letters produced after the printing of a controversial image. When an image offends, an editor knows of it quickly. It is almost reassuring, then, to learn that photographs still have the power to offend readers—particularly an image of a drowned child with distraught family members standing over the body.

The editors of the Bakersfield *Californian,* an 80,000-circulation newspaper, heard loud and clear the anger of readers over a remarkable photograph. The paper received 500 letters, 400 phone calls, 80 subscription cancellations, and one bomb

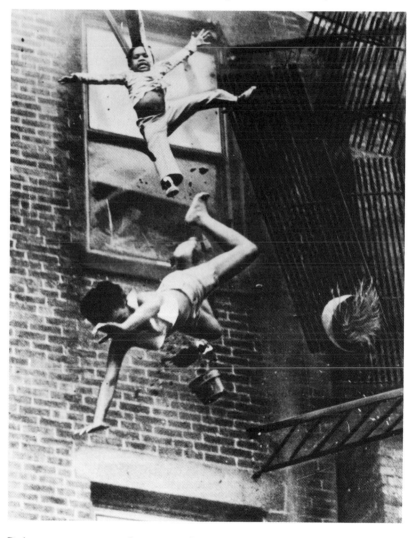

During a rescue attempt, a fire escape collapses and sends two victims to the ground below. Many readers were shocked by the gruesome nature of this Pulitzer Prize photograph (photo by Stanley J. Forman).

threat. Such a reader reaction is extraordinary given the paper's size. National columnist Bob Greene (cited in Gordon, 1986) wrote, "The picture should never have been published; in a way I hope you can understand, it was pornography." For Greene the picture, "epitomized . . . everything that is wrong about what we in this business do" (p. 19).

The controversy at the *Californian* was reminiscent of other disturbing photographs that are printed from time to time and objected to by the nation's newspaper readers. Stan Forman, then with the Boston *Herald-American,* captured a tragic moment with his 135mm lens. A woman and her young niece are frozen by the fast shutter speed in a fall from a faulty fire escape's metal platform. The woman was killed, while the child was saved because she landed on her aunt's body. One critic said the picture was a "tasteless breach of privacy" ("Tasteless breach," 1986, p. 27).

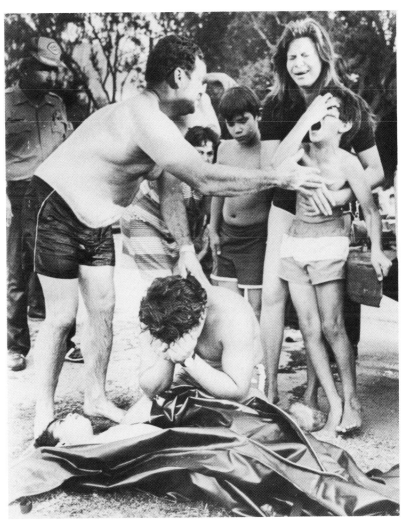

More readers complained about this picture of grieving family members than any other picture in the history of the newspaper (photo by John Harte/*The Bakersfield Californian*).

Many readers complained to editors that *The Miami Herald*'s front page was too gruesome for their tastes (photo courtesy of *The Miami Herald*).

Maria Rosas of the *Miami Herald* made a self-admitted shocking photograph of a lifeless, nude Haitian man from a group of 33 who were drowned while trying to reach the safety of Florida. Callers characterized the picture as "vulgar, racist and sensationalistic" ("Readers object," 1982, p. 2). Nudity, the fact that the picture was in color, and that it was used large on the front page were contributing factors in the protest. From a helicopter's overhead perspective, George Wedding made a striking photograph of the nude body of 11-year-old Andy Carr lying face-up in the back of an ash-filled pickup truck, a victim of Mt. St. Helen's powerful force (see Student Workbook for this photograph). Readers called the image "callous, insensitive,

gross, cruel, tacky, in very poor taste, barbaric, unimaginable, and repulsive" (Gordon, 1980, p. 25). With all three pictures, editors most likely justified them with the Categorical Imperative philosophy—the image described the tragic event like no combination of words ever could. With all three pictures, readers more often objected to them with the Golden Rule philosophy—the images contributed to the victim's family grief or upset readers who would rather not see such tragic events.

With a caption head titled, "A family's anguish," there is no doubt that John Harte's photograph of young, lifeless, 5-year-old, Edward Romero, halfway zippered in a dark, plastic body bag with family members crying and a bystander awkwardly reaching for one of the survivors, is a powerful and disturbing image. Under the outstretched arms and objections from a deputy sheriff, Harte made the picture with a 24mm lens from about 5 feet away. Harte admitted that the family scene was a "get-at-any-cost picture" and the most dramatic moment he had ever photographed. For Harte, his motivation was probably the Categorical Imperative philosophy—a dramatic, human tragedy should always be the subject of pictures.

After a discussion with Harte's weekend duty editor and the managing editor, Robert Bentley, who was called in to make a decision on the photograph, the editors ran the picture on an inside page agreeing with Harte's Categorical Imperative philosophy. Bentley also employed the Utilitarian approach. One other young boy had drowned on the same day. Clearly the swimming area was a dangerous spot that the editors felt the public needed to know about with Harte's dramatic image (Gordon, 1986).

A storm of protest from readers immediately followed and Bentley changed his position. In a column titled, "What should give way when news values collide with reader sensibilities?" Bentley admitted, "We make mistakes—and this clearly was a big one." Wrote Bentley, "The damage done to the memory of the late Edward Romero . . . and to the offended sensitivities of *Californian* readers cannot be undone. It can only be followed by sincere apologies and deep company-wide introspection" (Gordon, 1986, p. 19). Bentley now advocated the Golden Rule philosophy, shared by a majority of his readers, to justify his changed position.

Not all the letters were negative, however. Connie Hoppe wrote:

> I was horrified [by Harte's photograph], but I felt the item was newsworthy. . . . that picture was real—maybe a little more real to me because my own 2½-year-old son drowned. . . . If maybe just one parent saw that picture of the grieving family and drowning victim and has taken more precautions around pool and beach areas because of it, then that picture may have saved another child's life. (Gordon, 1986, p. 23)

Bill Hodge (1989) reported that in the 2 months prior to the boy's death, 14 people had drowned. In the month following the controversy, only 2 drowned. The newspaper and the photographer had to take the wrath of an angry readership who either did not want to be faced with a real tragedy of life or they sincerely were concerned about the rights to privacy for the Romero family. Whatever the rationale, lives were probably saved by the newspaper's coverage.

Ethics Codes Arguments

Ethical conduct may be guided by codes established by newspapers and professional organizations, but ethical codes cannot anticipate every situation. Consequently, the language of codes is hopeful, yet vague. For example, the "Code of Ethics" that all members of the NPPA must sign does not specifically mention gruesome situations (see Appendix A). The ethics code does contain phrases such as photographers "should at all times maintain the highest standards of ethical conduct," photojournalism "is worthy of the very best thought and effort," and members should "maintain high standards of ethical conduct."

Some would argue that codes should be ambiguous. Elliott-Boyle (1985–1986) wrote that "codes can provide working journalists with statements of minimums and perceived ideals" (p. 25). When a journalist uses highly questionable practices that are outside standard behavior, the offending reporter can be held accountable.

Others argue, however, that ethics codes should be less idealistic and more specific particularly with regards to the "exploitation of grief." In his 1986 article, George Padgett (1985–1986) asserted that vague ethical codes and brief textbook treatment of photojournalism ethical issues do not adequately provide guidelines for dealing with pictures of grieving victims. Without such guidelines, he wrote, regulation by the courts may classify grief pictures as invasions of privacy. "The problem should be addressed," wrote Padgett, "while it is still an ethical rather than a legal issue" (p. 56).

Conditions That Cause a Reader Firestorm

When confronting situations and photographs of accident and tragedy victims, journalists are torn between the right to tell the story and the right NOT to tell the story. Arguments by well meaning professional journalists can be made for and against the taking and publishing or the not taking and not publishing of almost any photograph. Curtis MacDougall (1971) in his visually graphic book, *News Pictures Fit to Print . . . Or Are They?* argued that news pictures sometimes need to be offensive in order to better educate the public. He wrote, "If it were in the public interest to offend good taste, I would offend good taste" (p. vii). The problem comes, of course, when journalists disagree on what is in the public's interest.

From the examples just given, it can be generalized that readers are more likely to object to a controversial picture if:

- it was taken by a staff photographer,
- it comes from a local story,
- the image is printed in color,
- the image is printed in a morning paper,
- the image is printed on the front page,
- it has no story accompaniment,
- it shows people overcome with grief,
- it shows the victim's body,
- the body is physically traumatized,
- the victim is a child, and
- nudity is involved.

If five or more of these conditions apply, editors should prepare themselves for reader reactions before the firestorm hits. Staff photographers and writers should be selected to help answer phone calls and letters. Editors should prepare notes for a column that justifies the decision. As many letters to the editor and telephone transcripts as possible should be printed. Readers may not agree, but most will respect the decision if the response to the controversy is prompt and the justification is consistent.

Michael Josephson, president of the Josephson Institute for the Advancement of Ethics, has suggested that editors and ombudsmen write "early warning notes" to readers that a controversial story is about to be printed. The note could describe the reasoning that led editors to print a controversial picture. Such a practice might head-off public misunderstanding about the intent of printing an image that may be graphically violent or intense. Public Editor Kerry Sipe of the *Virginia-Pilot* and *Ledger-Star* wrote a column on the same day a child-abuse story ran. The paper only received one call from a reader who said the story should not have run. "If he had not written his column, Sipe said, he was sure that he would have received many more" (Cunningham, 1989, p. 10).

To better understand what is the right course of action, a journalist should be familiar with the trends prevalent in newspapers and magazines, know what the readers think is acceptable for publication, and have a strong, personal ethical background.

Professional organizations and the literature that is produced by them give journalists a good idea of where photojournalism has been and where it is likely to head.

Discussions with a newspaper's ombudsman or editor, who receive many of the complaints, will help to determine the aspects of photographic coverage and publication most objectionable to readers. Guest lectures or formalized town meetings by journalists with concerned citizens will create a dialogue with readers that will help determine the acceptance level of controversial images.

Finally, personal reflection will help balance the sometimes conflicting goals of publishing the news while being sensitive to the feelings of subjects and readers. A photographer's personal ethics are influenced by many factors: family and religious upbringing, educational opportunities, professional associations, career goals, day-to-day experiences, and co-workers.

Nora Ephron (1978) in her book, *Scribble Scribble Notes on the Media,* devoted a chapter to a description and reaction to Stan Forman's fire escape tragedy. Ephron concluded that "I recognize that printing pictures of corpses raises all sorts of problems about taste and titillation and sensationalism; the fact is, however, that people die. Death happens to be one of life's main events. And it is irresponsible—and more than that, inaccurate—for newspapers to fail to show it . . ." (p. 61).

A photojournalist's mission is to report all the news objectively, fairly, and accurately. The profession can only improve in quality and stature if photographers are mindful of those they see in their viewfinders and those they seldom see, their readers. Decisions, however, should be guided, never ruled, by readers.

Chapter 5
Rights to Privacy

When victims of violence and their families, through no fault of their own, are suddenly thrust into the harsh light of public scrutiny, they often bitterly complain. Their private life is suddenly the subject of front-page pictures and articles. Readers are quick to react when they feel a journalist has crossed the line and intruded into a subject's personal moment of grief. Anne Seymour, public affairs director for the National Victim Center in Fort Worth said, "Any time there is a yellow line, some journalists in the interest of news will cross over" (Zuckerman, 1989, p. 49).

Public officials and celebrities also feel that journalists sometimes cross that yellow journalism line in covering their everyday activities. Television actress, Roseanne Barr, who frequently advocates her and her family's right to privacy, told a story on the "Oprah Winfrey Show" (1989, November 20) that illustrates this point. Her mother saw a television camera, Barr said, coming through the window of her home. Barr's mother was forced to lie on the floor to avoid being videotaped.

The judicial system in America has recognize that private and public persons have different legal rights when it comes to privacy. Privacy laws, as can be imagined, are much stricter for private citizens not involved in a news story than for public celebrities who sometimes invite media attention. Journalists need to be aware of the laws that are concerned with privacy and trespass. But ethical behavior should not be guided by what is strictly legal.

PRIVACY IS AN EARLY ISSUE

Historically, invasion of privacy issues are linked with candid photography. Limitations with the type of camera, lenses, and film in the early days of photography prevented many of the candid moments that are commonplace today. Once cameras became hand-held and lenses and film became faster, amateur and professional photographers were able to make pictures that previously were impossible.

Early news photographers were forced to use bulky cameras that limited the type of picture possible. Candid pictures were simply not possible when subjects quickly spotted a photographer. The photographs of Paul Martin and Jacques-Henri Lartique stand out as wonderful exceptions. They captured many candid moments among 19th-century citizens.

Typical subjects of Martin's candid style were Victoria-era children playing in public parks, women enjoying the surf during holidays, and men working along the busy streets of London (Flukinger, Schaaf, & Meacham, 1977).

It was rare when a photographer could capture a spontaneous news event. More likely, subjects in news and feature assignments were carefully composed by the photographer to create a static or stereotyped look. As Wilson Hicks (1973), author of *Words and Pictures* wrote, "Instead of picture consciousness, it was a time of

Paul Martin was one of the first photographers to show a more candid view of Victorian England. "Yarmouth. 1892. Another couple on the sands" (photo courtesy of the Photography Collection/Harry Ransom Humanities Research Center/The University of Texas at Austin).

camera consciousness. Practically everybody looked at the camera. . . . When the photographer entered a situation of movement involving people, life stopped dead in its tracks and orientated itself to the camera" (pp. 26–27).

The successful documentary photographers during the early years of newspaper photojournalism were the ones who could make pictures that did not have a highly manipulated look. Jacob Riis and Lewis Hine were photographers who used the equipment of their day—large, bulky cameras with slow film and lenses. Although their photographs, for the most part, showed individuals and groups looking into the camera's lens, their pictures are classic documentary statements because of the lack of manipulation by the photographers. It is a rare occurrence to find images by Riis or Hine that show subjects unaware of the camera's presence.

Lewis Hine, of Oshkosh, Wisconsin, worked in a factory for long hours during the day when he was a boy. Consequently, his photographs of children suffering for many hours at low pay and with dangerously, fast-moving machines were vivid and disturbing. Child labor laws were passed to protect children, a direct result of his photographs (Pollack, 1977, pp. 91–93).

George Eastman launched the amateur photography market when he invented the "Kodak" camera that used the gelatin photographic process in combination with roll-film technology. Photographed by Fred Church on board ship in 1890, Eastman holds one of his first cameras (photo courtesy of the International Museum of Photography at George Eastman House).

George Eastman's Amateur Craze

The invention of a faster dry plate film meant that medium-sized and smaller, hand-held cameras could be used. Such cameras allowed amateur and professional photographers to make pictures of unsuspecting subjects. George Eastman came up with a camera he dubbed, the Kodak. The Kodak slogan was, "You push the button—and we do the rest." The camera was small, easy to use, and contained 100 pictures on a dry gelatin roll. When the snapshot shooter had exhausted the roll, the camera was mailed to Rochester, New York where the film was processed, printed, and returned to the owner with the camera and a fresh roll of exposures.

Amateur photographers immediately took snapshots of practically anything that moved with the little Kodaks and other cameras. No one was considered safe as unsuspecting strangers clicked off exposures. The camera craze that began in the 1880s was an international epidemic that prompted retaliation by those upset with photographers taking candid pictures of people without permission. The *New York Times* "likened the snapshot craze with an outbreak of cholera that had become a 'national scourge' " (Jay, 1984, p. 10). A popular poem, a parody of the Kodak slogan was,

Picturesque landscape,
Babbling brook,
Maid in a hammock
Reading a book;
Man with a Kodak
In secret prepared
To picture the maid,
As she sits unawares.
Her two strapping brothers
Were chancing to pass;
Saw the man with the Kodak
And also the lass.
They rolled up their sleeves
Threw off hat, coat and vest—
The man pressed the button
And they did the rest! (Jay, 1984, pp. 11–12)

Vigilante associations were formed to protect the honor of unsuspecting women. A brick thrown through a camera's lens was advocated as a possible remedy. The *Chicago Tribune* wrote in an editorial that "something must be done, and will be done, soon. . . . A jury would not convict a man who violently destroyed the camera of an impudent photographer guilty of a constructive assault upon modest women" (Jay, 1984).

A photographer intent on capturing people in embarrassing or compromising situations was despised by a great many people. Although anti-photography bills were never introduced in America, Victorian London photographers required free official permits to take pictures in parks. Restrictions often included "Persons and groups of persons . . . on Sundays . . . [with] hand cameras" and without tripods (Flukinger et al., 1977). Germany passed a statute prohibiting photography without permission in 1907.

Of newspaper and magazine photographers who put small cameras to use, Bill

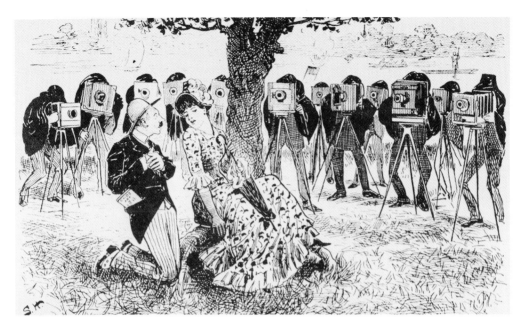

"The advent of the dry plate led to hordes of amateurs and frequent infestations by groups from various camera clubs. The public was painfully aware of the growth in popularity of this particular hobby. From The Amateur Photographer, September 23, 1887, p. 136" (photo courtesy of the Photography Collection/Harry Ransom Humanities Research Center/The University of Texas at Austin).

Jay (1984) in his article, "The Photographer as Aggressor," wrote, "As any impartial observer will admit, no aspect of a life was too private, no tragedy too harrowing, no sorrow too personal, no event too intimate to be witnessed and recorded by the ubiquitous photographer" (p. 12).

Small, hand-held professional cameras, particularly those made by the Leica company, made it possible for photographers to take high quality pictures of people in low-light situations without a subject's knowledge or consent. Two early prolific and respected users of the small cameras were Paul Wolff and Erich Salomon. Wolff became known for his feature pictures where he, according to Hicks (1973), showed that a picture could be made out of any subject. Salomon, a lawyer who took up photography to earn a living after the loss of his family's fortune, made unposed pictures of presidents and statesmen during meetings and public functions. Salomon's images are beautifully composed candid moments of hard-talking politicians caressed by the gentle glow of available light. His photographs were published in several illustrated German publications and became a model for candid pictures for future generations of news photographers. Salomon's photographic career was tragically cut short when he was captured and executed by the Nazis.

Little is Private in the Era of Sensationalism

Privacy violations would not became an issue if it were not for editors who were willing to publish the revealing, hidden moments. Magazine and newspaper editors, once the halftone process became relatively inexpensive and aesthetically accept-

able, were eager to fill their pages with photographs that were used, admittedly, to sell more copies. Hicks (1973) summed up the philosophy of the editors of the day with, "Get the picture—nothing else mattered" (p. 25).

This was the era of the scoop. Competition was so fierce that photographers would go to great lengths to beat a rival photographer. One of the best known freelance newspaper photographers, Arthur Fellig, gained his reputation for taking pictures of accident and murder victims no one else had. Fellig's motto was, "F/8 and be there." Professionally known as "Weegee," a variation of the popular table entertainment, "Ouija," Fellig, aided by police informants, arrived at news events often before the police (Stettner, 1977).

The Courts Ban Cameras

The era culminated with the trial of Bruno Hauptmann for the kidnapping and murder of aviator, Charles Lindbergh's baby. Over 700 reporters and 125 photographers covered the sensational events of the trial. Although photographs were al-

The judge during Richard Hauptmann's trial for the kidnapping and killing of Charles Lindbergh's baby did not allow photographs taken during the court proceedings. Nevertheless, a photographer made the picture of Lindbergh on the stand. Consequently, cameras were barred from courtrooms for several decades (photo courtesy of Associated Press/Wide World Photos).

lowed in the courtroom before the trial, during recesses, and after the trial, there were many abuses by competitive-crazed photographers. After the trial, the American Bar Association issued the 35th canon of Professional and Judicial Ethics. Most states adopted Canon 35 to ban photographers from their courtrooms. Before the ruling, a judge could independently decide whether to ban news photographers.

In the 1950s, Joseph Costa and the NPPA lobbied to appeal the states' ruling. Slowly, acceptance for photographers' presence in the courtroom grew. Florida's cameras-in-the-courtroom model, approved by the Florida Supreme Court, was tested successfully during the Ronnie Zamora trial in 1978 (Kobre, 1980).

In another Florida case, the Supreme Court in 1981 upheld the conviction of two Miami Beach police officers for burglarizing a restaurant. Officers Noel Chandler and Robert Granger felt that they were denied a fair trial by the presence of television and still photojournalists in the courtroom. The Supreme Court allowed individual states to decide how to regulate the coverage of trials. Florida, as with many other states, does not require permission from all participants for photo news coverage, but restrictions were imposed. "Only one television camera and only one still photographer are allowed in the courtroom at one time. Equipment must be put in one place; photographers/camera persons cannot come and go in the middle of the proceeding, and no artificial light is allowed." Other states have opened up their courtrooms to photographers. Federal trials are still off limits for cameras (Nelson & Teeter, 1982).

As opposed to the small, 35mm camera, the bulky 4×5 press cameras were seldom used for candid images. The press camera was simply a hand-held version of the view camera that had to be set on a tripod. The camera only held one 4×5-inch negative holder with two sheets of film at a time. The negative holders were awkward to manage. There was no through-the-lens or rangefinder mechanism to aid focusing. After each exposure a new flash bulb had to be inserted into the flash unit while an unexposed film holder had to be inserted in the back of the camera. Despite the availability of small, hand-held cameras, a 1951 survey of 61 newspapers with circulations of over 100,000 showed that 97% of the staff photographers used the 4×5 press cameras (Horrell, 1955).

Arthur Geiselman of the York, Pennsylvania *Gazette* and *Daily* was attacked by a crowd at the scene of a child's drowning. "The 4×5 is not the camera for this kind of spot news coverage," wrote Geiselman (1959). "I believe if I had had a 35 millimeter camera I could have avoided trouble. The clumsy, black box is too much in evidence at a time when a camera should be inconspicuous" (p. 13).

The subjects of the press cameras, were for the most part, aware of the photographer's presence, unless the subject was greatly preoccupied. Privacy problems arose when editors chose to use sensational pictures on their front pages. In an era of yellow journalism, photographs contributed greatly to the public's repulsion of news photography as a profession. Photojournalists were labeled as mindless ambulance chasers without a thought for the subjects of the images. As one writer (Edom, 1976) noted, photographers were considered "reporters with their brains knocked out" (p. 26). Such a characterization was misleading because reporters also wrote stories that contributed to the sensational era.

Members of the photo staff of the *Milwaukee Journal* in 1949 exhibit their bulky, 4×5 Speed Graphics press cameras and not so portable 125-watt/second Strobo Research strobe units developed by Ed Farber. The awkward equipment of the day often necessitated subject awareness and manipulation (photo by George "Sam" Koshollek/John Ahlhauser Collection).

Should a News Subject be Compensated?

Photographers did produce moving photographic documents with large, press cameras, however. The Farm Security Administration (FSA) was a governmental agency set up by the Roosevelt administration to document the weather and economic affects upon people during "The Great Depression." Led by Harvard economics professor Roy Stryker, the photographic unit of the FSA included such household names as Walker Evans, Dorothea Lange, Russel Lee, Carl Mydans, and Arthur Rothstein.

One of the most memorable images of all time came from the FSA collection. Dorothea Lange made "The Migrant Mother," a sad, roadside close-up of a destitute mother with a faraway look and her shy children. Unfortunately, the mother in the portrait, Florence Thompson, complained that Lange received fame for the picture while she lived in relative poverty. Nevertheless, when Mrs. Thompson suffered a stroke and her family could not pay her medical expenses, people around the country donated over $15,000. Many wrote that they were touched by Lange's photograph (see *Los Angeles Times,* November 18, 1978, p. 1 and "Symbol of depression," 1983).

Newspaper photographers eventually replaced their 4×5 cameras with more easily manipulated 35mm cameras. Consequently, photojournalism reporting gained respect as many more photojournalists were more inclined to photograph people as

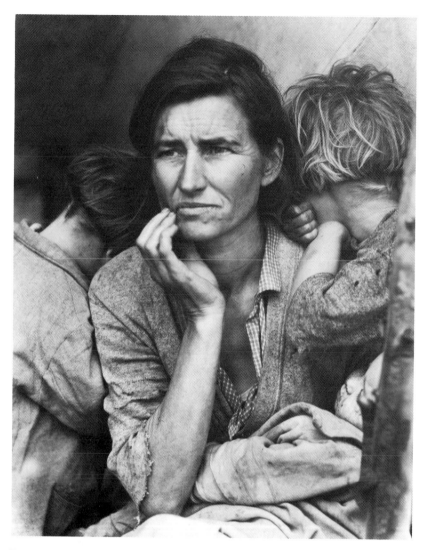

Throughout her life, the "Migrant Mother," Florence Thompson, complained that she received no compensation for the image (photo by Dorothea Lange/The Library of Congress).

they really were rather than stage direct a subject's actions. Private moments that involved social problems were now the subject of photographers. Picture magazines such as the London *Post* and America's *Life* and *Look* ushered in what many considered to be the "Golden Age of Photojournalism." Gene Smith, Margaret Bourke-White, Alfred Eisenstaedt, Leonard McCombe, and Bill Eppridge are some of the photographers that worked for the picture magazines.

Eisenstaedt's Time's Square celebration kiss between two strangers, a soldier and a nurse, beautifully shows the joy the world felt that World War II was at an end. The picture, however, has been embroiled in controversy as up to 10 sailors have claimed to be the man in the famous picture. The ultimate goal of the claims made

by the soldiers is a percentage of the profits Time, Inc. has made throughout the years for the sale of the image.

Smith made classic picture stories of individuals: a country doctor and a nurse mid-wife are two of his favorite stories. McCombe produced one of the first "A Day in the Life" stories with his coverage of a young woman from a small town working in New York City. Bill Eppridge produced one of the most dramatic picture stories in the history of *Life* magazine. Headlined, "We are animals in a world no one knows," Eppridge and a reporter, James Mills, produced a sensitive and shocking portrait of a young, educated couple forced into prostitution and robbery to feed their $100 a day heroin addiction. Eppridge and Mills received permission to intrude into their daily lives without paying their subjects (Edom, 1980).

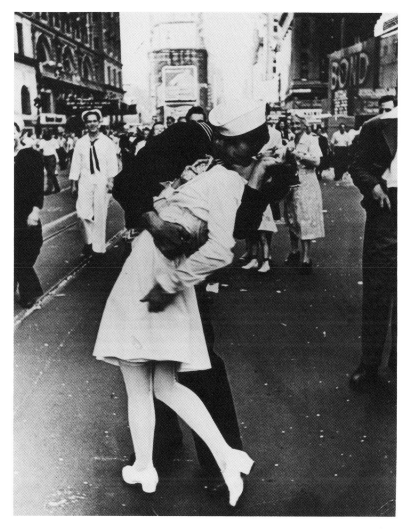

At least 10 sailors have claimed to be the "smooching swabbie" and have demanded payment from *Life* magazine for the use of the valuable photograph (photo by Alfred Eisenstaedt/*Life* Magazine/© Time Warner Inc.).

Bill Eppridge obtained permission from the married couple addicted to heroin to photograph them for *Life* magazine. No payment was made to the couple (photo by Bill Eppridge/*Life* Magazine/© Time Warner Inc.).

Robert Frank and Magazine Photography

Many photographers established a style of photography that was unique to the 35mm film medium. Their images were usually of people in bars or on the street who were unaware of the camera's presence. Inspired by the writings of "beat" novelist, Jack Kerouac, Robert Frank is best known for his gritty portrait of America contained in his book, *The Americans*. Frank spent more than a year "on the road" through a Guggenheim grant. He made pictures that showed a side of America that contrasted greatly with the pretty picture postcard scenes that typically "documented" America at that time. Although his photographs were severely criticized by photography experts, Frank inspired future generations of photographers who realized that the subjects for photography were not limited to traditional, postcard views.

Photographers such as Diane Arbus, Bruce Davidson, Lee Friedlander, Danny Lyon, Mary Ellen Mark, and Garry Winogrand use a shooting style that opened the streets to subjects previously not photographed.

Magazine photographs developed a more casual visual style as many of the "street photographers" freelanced for the magazines. Magazine images are usually more graphically complicated than straight-forward news photographs because readers spend more time viewing an image in a weekly or monthly magazine.

Curiously, magazine images of hard news subjects can be much more graphically violent and threatening to an ordinary person's privacy without the typical reader uproar found with similar images published in a newspaper. Readers have a more protective, almost personal commitment to their hometown newspaper. Nevertheless, newspaper photographers started to imitate the candid shooting style seen in the magazines. When that style is used for spot news situations in newspapers, subjects and readers sometimes object that their privacy has been violated.

News Photographer magazine has printed several articles that detail the right to privacy of a photographer's subject. In an article titled, "'Inside Story' Inside Photos," a television program hosted by the former state department spokesman for President Carter, Hodding Carter, featured a discussion of controversial images. Editors and photographers in the program generally agreed that a newspaper's mission is to sometimes make people uncomfortable. Although it is unfortunate that people complain when their anonymity is taken away when their picture is published, Hal Buell of the Associated Press remarked that if newspapers do not print pictures that upset people once in awhile, "Don't we stand a chance of the reader losing his credibility in the newspaper?" ("Inside story," 1982, p. 30).

Some critics complain that deadline pressures and competitiveness are responsible for journalists sometimes trampling on the privacy of others. Zuckerman (1989) noted that "News organizations, driven by intense competition, rarely let concern for a victim's privacy get in the way of a scoop" (p. 49).

Hilda Bridges Sues for Her Privacy

A woman in Florida did more than complain about the loss of her privacy. She sued the newspaper for millions of dollars. Hilda Bridges was kidnapped by her estranged husband, Clyde Bridges and forced to remove all of her clothes. He thought that his wife would be unwilling to escape if she were nude. When police surrounded the apartment building, Bridges killed himself. Behind police lines, Scott Maclay of the *Cocoa Today* newspaper was waiting with a 300mm lens. The photograph Maclay made shows a frightened woman, disrobed, but partially covered by a dishtowel, running with a police official who's face shows deep concern with his hand firmly grasping the woman's shoulder. After several hours of consultation with various editors, Maclay's picture of Hilda Bridges' rescue ran large on the front page. The newspaper's editor said that the picture "best capsulized the dramatic and tragic events" (Hvidston, 1983, p. 5). Some readers later complained that the picture of the scantily clad woman was published to sell additional copies of the newspaper and for no other reason.

Bridges claimed that her privacy had been invaded because she was naked. She testified that the photograph made her want to "crawl away, hoping nobody would see me." A lower court awarded the woman $10,000. On appeal, the decision was overturned. The key in court cases seems to hinge on the conduct of the news photographer or the news medium. "If the conduct is so extreme, so 'beyond all possible bounds of decency' . . . then one may be found guilty of intentional infliction of emotional distress" (Hvidston, 1983, p. 5).

The court in the appeal said that the picture "revealed little more . . . than some

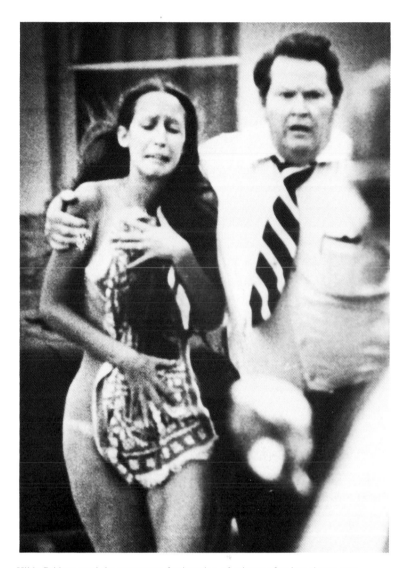

Hilda Bridges sued the newspaper for invasion of privacy after her picture was printed on the front page (photo by Scott Maclay/*Florida Today*).

bathing suits seen on the beaches. The published photograph is more a depiction of grief, fright, and emotional tension than it is an appeal to other sensual appetites." Furthermore, the court said, "Because the story and photograph may be embarrassing or distressful to the plaintiff does not mean the newspaper cannot publish what is otherwise newsworthy" (Johns, 1984, p. 8).

Ron Galella and Jackie Onassis: Celebrity Photographs

A classic example of a photographer overstepping the bounds of decency was Ron Galella. Galella had one passion in his life—to photograph Jackie Onassis and her family. It was a lucrative passion. He once earned over $20,000 a year just for his pictures of Onassis. But Galella was no "one shot wonder." He followed Onassis

and her family wherever he could. Galella was seen taking pictures of her while hiding "behind a coat rack in a restaurant, jumping out from behind bushes into the path of her children, and flicking a camera strap at Onassis while grunting, 'Glad to see me back, aren't you Jackie?' " Galella even disguised himself as a Greek sailor and made pictures of Onassis sunbathing in the nude on the island of Scorpios. The pictures were later published in *Hustler* magazine.

Galella claimed he was simply exercising his right as a journalist under the First Amendment. In two courtroom decisions, (he simply ignored the first decision that ordered he stay at least 25 feet from Onassis) the court said he was guilty of "acts of extremely outrageous conduct." To avoid a possible 6-year prison term and a fine of $120,000, Galella signed an agreement to "never again aim a camera at Mrs. Onassis or her children" ("Photographers pledge," 1982, p. A-27).

Thousands of dollars and careers can be made by photographing famous people either doing extraordinary or quite ordinary actions. Readers seem to enjoy seeing famous people in ordinary situations given the popularity of the publications that use the images and the high prices editors pay to photographers for their pictures. Pictures that show the windblown skirts of a queen, the bikini look of a pregnant princess, and a president slipping down a plane's steps have earned large paychecks for the photographers. The foreign and national press have a tremendous interest in star-studded photographs as the popularity of personality publications and "info-tainment" television programs attest.

Ron Galella made a career of pestering Jackie Onassis and her family until a court order prevented his actions (photo by Joy Smith/Associated Press/Wide World Photos).

Photojournalist Ross Baughman suggests that pictures of famous people undergoing ordinary activities need to be taken. Such pictures "can play an important role in democratizing royalty or in letting the public know these people are only human like the rest of us" (Johns, 1984, p. 7).

The intense competition among photographers to come up with unique angles of famous people have led to some obvious excesses. Six helicopters filled with photographers flew over the wedding of movie stars Michael Fox and Tracy Pollan. Recently, photographers have drawn criticism from the public and their colleagues by confronting a famous person until a reaction is visually demonstrated. Comedian Eddie Murphy was recently badgered by a photographer until he angrily reacted. The photographer then took the unflattering portrait of Murphy. Other celebrities such as Cher, Sean Penn, Meryl Streep, and the bodyguards for Prince have all had recent confrontations with overzealous photographers with some resulting in criminal action (Stein, 1988).

While waiting at the New Orleans airport for a reunion of two brothers who had not seen each other in several decades, the photographer took a picture of the actress, Faye Dunaway, who happened to be on the airplane. It was a picture that should not have been taken as it invaded her privacy (photo by Paul Lester).

Louisiana State University journalism instructor Whitney Mundt said, "The furtive manner in which paparazzi operate in order to track down famous individuals is inherently unethical." Mundt suggested that photojournalists should not photograph famous people simply because they have familiar faces, but wait until they are involved in a situation that has "intrinsic news value" (cited in Johns, 1984, p. 8). A photographer who saw Zsa Zsa Gabor walking her dog would avoid taking her picture, according to Mundt's standard. A photographer, however, who saw Gabor slapping a Beverly Hills policeman would take the photograph. Such a standard, according to Mundt, "would have photojournalism which is no longer exploitive, and would no longer endanger the credibility of the press." The trend in that direction may have started with the publisher of *The People* newspaper in London who fired his editor for printing pictures of 7-year-old Prince William urinating in a public park ("London editor," 1989).

Although photographers have been criticized for their over-zealous candid coverage of the rich and famous, studio portraits of stars, for the most part, are carefully controlled public relations pictures. Jim Marshall, a photographer represented in the book, *Rolling Stone The Photographs,* criticized the magazine for accepting the strict photographic demands of stars and their representatives. "The stakes are much higher now," Marshall explained, "and with that kind of money at stake, everybody is very edgy about everything. Now we're seeing only what the artists and their managers want us to see. I think we are the lesser for it" (Sipchen, 1989, p. E-1).

FOUR AREAS OF PRIVACY LAW

A quarterly publication of the Reporters Committee for Freedom of the Press titled, "Photographers' Guide to Privacy," is helpful in sorting out the areas of privacy law that affect news photographers. Privacy law is divided into four areas:

- unreasonable intrusion into the seclusion of another,
- public disclosure of private facts,
- placing a person in a false light in the public eye, and
- misappropriation of a name or likeness for commercial gain (Strongman, 1987).

Unreasonable Intrusion

Consent is the most important factor when dealing with unreasonable intrusion or public disclosure of private facts. Generally, anything that can be seen in plain, public view can be photographed. Pictures in private places require permission. A photographer must be sure that the person who gives permission has the authority to grant the request. Some states will not accept the authority of a police or fire official or a landlord for a photographer to enter a private home. Written consent is preferred over oral consent. The Galella case was certainly an example of unreasonable intrusion on public property. The Lindbergh case was another.

A picture of the burned remains of Cindy Fletcher became a court case in Florida. The photographer gained access to the house through permission of a police official. The family felt that their privacy had been invaded (photo by Bill Cranford/*Florida Times-Union*).

Disclosure of Private Facts

Trespass laws require that photojournalists have the permission of an owner of a property before access can be gained. However, court rulings have sent mixed messages. A tenant at an alleged substandard apartment complex in Philadelphia gave permission to a television crew to enter the property. The landlord sued, but loss the case. Permission from a tenant is acceptable. A Kansas film crew lost its case when it was shown they used deceitful methods to obtain permission to film a nonpublic area of a restaurant. Misrepresentation is not acceptable. A Florida news-

paper photographer was found not guilty of trespassing after obtaining permission from police and fire officials to photograph the body remains of a young girl killed in a fire. Permission from police officials is acceptable. However, that same Florida Supreme Court upheld a lower court decision in the case of a television crew who obtained permission from police officials to enter a private home that was part of a drug raid. States have different laws for journalists and trespassing. Editors should put together a package with the newspaper's legal representatives for all journalists on their staff telling them the trespassing laws that apply in their state (Sherer, 1986a).

The two people pictured agreed to pose without payment for a feature story on second-hand clothing stores. If the story had been about people who are too poor to shop at traditional department stores, the photographer, writer, and the newspaper could have been sued for misrepresentation (photo by Paul Lester/*Times-Picayune*).

False Light

Dr. Michael Sherer (1987) of the University of Nebraska explained the concept of *false light*. "Generally speaking," Sherer wrote, "a photojournalist can be found guilty of false light invasion of privacy if a person's image is placed before the public . . . in an untrue setting or situation" (p. 18). For there to be a false light decision against a photographer, the image must be highly offensive to a reasonable person, the photographer must have known that the image was false, or the photographer acted "with 'reckless disregard' (in other words, did not care) about whether the information was true or not" (p. 18).

The publication of a "stoutish" woman was ruled acceptable as the court noted, "There is no occasion for law to intervene in every case where someone's feelings are hurt." Filming by a camera crew of a man holding hands with a woman who was not his wife was ruled "not an act of extremely outrageous conduct." A person accidentally identified falsely in a caption does not constitute outrageous conduct. However, the publisher of *Cinema-X* magazine was cited for a "misidentified . . . photograph of a nude woman in a section of the magazine featuring 'aspiring erotic actors and actresses' " (Sherer, 1986b, p. 26).

Misappropriation

The fourth area of trouble for a photojournalist in a privacy case is using a person's image for monetary gain without that person's permission. Clarence Arrington sued the *New York Times* for a picture it printed on the cover of its Sunday magazine illustrating an article, "Making It in the Black Middle Class." Arrington's "suit for invasion of constitutional and common law right to privacy was dismissed, but his complaint based on the sale of the photograph (by Contact Press Images—CPI—to the *New York Times*) was upheld in the New York Court of Appeals." The newspaper could not be sued because of the First Amendment protection, but CPI and the freelance photographer, Gianfranco Gorgoni, could have a claim against them. Unfortunately, the case was settled out of court without a ruling that might have protected picture agencies and freelance photographers (Henderson, 1989). A photographer may have the right to photograph anyone in public, but problems will occur when that image is published and is used to represent a class of individuals without that person's consent (Coleman, 1988). Freelance photographers need to be especially careful. One of the main reasons magazine editors and picture agency managers require releases from freelance photographers is to protect them from lawsuits by subjects.

When covering a news event, courts have ruled that photographers do not have to conform to rigid rules required for a subject's consent. Nevertheless, news media organizations are sometimes sued by individuals who argue that because the newspaper makes money, their violation of privacy case is valid. Most of these cases go in favor of the news organization on appeal because of the newsworthiness of the images. Freelance photographers, as Sherer (1987) noted, "need to pay special attention to the appropriation concept. There have been cases in which the selling of a photograph without the permission of those in the image had been held to be an appropriation of the person's likeness" (p. 18).

If this photograph had been used in an advertisement for a hair-care product without the subject's written permission, the photographer could be sued by the person for misappropriation. "Woman at the Jazz and Heritage Festival, New Orleans" (photo by Paul Lester.)

The Where and When of Picture Taking

Because many readers react strongly to pictures that seem to violate the privacy of others, it is important to be clear on the legal and ethical issues surrounding the right to privacy. An editorial writer in a 1907 edition of *The Independent* commented, "As regards photography in public it may be laid as a fundamental principle that one has a right to photograph anything that he has the right to look at" ("The ethics and

etiquette," 1907, pp. 107–109). Such a declaration is not true for today's more complicated society, however. Ken Kobre (1980) in his textbook, *Photojournalism: The Professionals' Approach* listed where and when a photojournalist can take pictures (see Table 5.1).

TABLE 5.1
Where and When Pictures Can be Taken

	Anytime	If No Objections	Restricted	Permission
Public Area				
Street	X			
Sidewalk	X			
Airport	X			
Beach	X			
Park	X			
Zoo	X			
Train station	X			
Bus station	X			
In Public School				
Preschool	X			
Grade school	X			
High school	X			
Univ. campus	X			
Class in session				X
In Public Area—With Restrictions				
Police headquarters			X	
Govt. buildings			X	
Courtroom				X
Prison			X	
Legislative chambers				X
In Medical Facilities				
Hospital				X
Rehab. center				X
Emergency van				X
Mental health center				X
Doctor's office			X	
Clinic				X
Private but Open-to-the-Public				
Movie theater lobby		X		
Business office		X		
Hotel lobby		X		
Restaurant		X		
Casino			X	
Museum			X	

TABLE 5.1
(Continued

	Anytime	If No Objections	Restricted	Permission
Shooting from Public Street into Private Area				
Window of home	X			
Porch	X			
Lawn	X			
In Private				
Home		X		
Porch		X		
Lawn		X		
Apartment		X		
Hotel room		X		
Car		X		

Although the funeral for the slain police officer became an orchestrated media event, some readers complained that the family's privacy had been invaded with the publishing of this cemetery picture (photo by Garrett Cope/*Jackson Citizen-Patriot*).

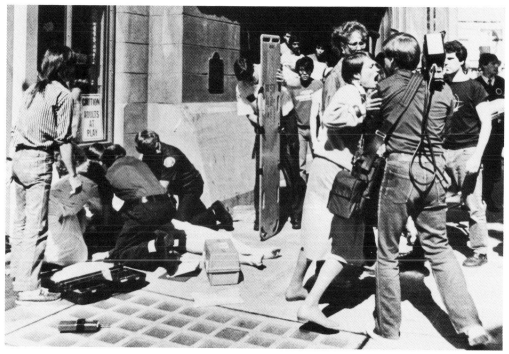

In these two photographs, a television videographer learns the limits to personal space while covering the death of a Japanese performer (photos by Sherry Bock-winkel/*The Morning News Tribune*).

If photographers persist in harassing their subjects, courts can further limit their actions in public and with famous persons. If courts can limit the actions of photographers making images of famous individuals, there may come a time when injured and grieving subjects are ruled off limits by sympathetic courtroom decisions as was done in some countries during the early years of photography.

Legal rights should not be the guiding principles for ethical consideration. What is legally acceptable is not always the right action to take. Staff photographer Sherry Bockwinkel of the Bellevue, Washington *Journal-Gazette* photographed a photojournalist who learned a lesson about the ethics of privacy. During a rope-descending performance, a Japanese acrobat fell to his death. A television videographer moved close to the scene as attempts were made to help the dancer. Suddenly a spectator angrily pushed him back. Although the news event occurred on a public sidewalk in downtown Seattle, managing editor, Jan Brandt wrote that the videographer "had moved into a sensitive area. Bockwinkel defines it as personal space, others call it invading privacy. His presence had become an intrusion seen and felt by those close to the scene and the feeling spilled over onto other photographers" ("Boundaries," 1986, p. 24).

A photographer must be aware of the privacy laws that apply to his or her jurisdiction, but that photographer must also realize that credibility, a highly valued principle, might be lost if a publicly grieving or famous person is unduly harassed.

Chapter 6
Picture Manipulations

Photojournalism has a long and cherished tradition of truthfulness. The impact of the visual image on a viewer comes directly from the belief that the "camera never lies." As a machine, the camera faithfully and unemotionally records a moment in time. But a machine is only as truthful as the hands that guide it. John Szarkowski (1980), director of photography for the Museum of Modern Art in New York, explained that when truthfulness and visual impact are combined in a powerful picture, such an image can shock the public. But that public trust, however, can also be manipulated.

The faking of photographs, either through stage direction by the photographer or through picture manipulations, also has a long tradition. Photographers and editors learned early in photography's history that economic and political gains can be made by photographic manipulations because of a naive and trusting public. Even Pulitzer Prize winning images, photographs that have been hailed as beautiful, humanistic documents filled with sorrow, hope, or joy, have been questioned because of rumors of manipulation.

The media have been criticized for showing so many gruesome images that the public has hardened toward violent injustices. There is growing concern that new technological advances that allow easy and undetectable picture manipulation cause the public to be unconcerned about the truthful content of photographs as well. With the acceptance of television "docu-dramas" that show fiction within a factual framework, it is not surprising that news organizations have used Hollywood techniques to create facts. When pyramids are moved and moons are enlarged for cover pictures of well-respected photojournalism publications, the public grows cynical and mistrustful of journalism. The Hedonism philosophy is taken to its most exaggerated point when business, not telling the truth, is the prime concern.

Howard Chapnick (1982) eloquently summed up the dangers to journalism with such manipulations. "Credibility. Responsibility. These words give us the right to

call photography a profession rather than a business. Not maintaining that credibility will diminish our journalistic impact and self-respect, and the importance of photography as communication" (pp. 40–41). With all the other ethical issues photojournalists should be concerned about, picture manipulation, especially through the use of computers, is a topic journalists are most concerned about. The threat to credibility is irreversible if the public starts to mistrust the integrity of the news photograph.

Hippolyte Bayard and the First Faked Photograph

Early photographic history is filled with artists-turned-photographers who set up situations with models and backdrops and made elaborate compositions from several negatives. Although he is seldom given credit, Frenchman Hippolyte Bayard

The first faked picture and caption. "Portrait of the Photographer as a Drowned Man, 1840." Hippolyte Bayard made this self-portrait of his own suicide to protest the French government's treatment of his photographic process (photo courtesy of the Collection Societe Francaise de Photographie).

"Street urchins tossing chestnuts, 1857." Stopped action was not possible with the camera and film of the day, but it could be achieved with a thread (photo by Oscar Rejlander/Photography Collection/Harry Ransom Humanities Research Center/The University of Texas at Austin).

discovered a useful photographic process independent of Daguerre and Fox Talbot in 1839. Frustrated by the lack of recognition, Bayard made the first faked picture and caption combination in 1840. He made a photograph of himself posed as a corpse and wrote on the back of the print, "The Government, which has supported M. Daguerre more than is necessary, declared itself unable to do anything for M. Bayard, and the unhappy man threw himself into the water in despair." Two years later, the Societe d'Encouragement pour l'Industrie Nationale gave Bayard a prize of 3,000 francs (Gernsheim, 1969, p. 87).

In 1857, Oscar Rejlander produced a picture with a documentary quality. Captioned, "Street urchins tossing chestnuts," the photograph shows a young boy in

ragged clothes, delightfully looking up at a chestnut he has presumably just tossed into the air. But stopping a moving object in mid-air was a technical feat impossible with the slow film and lenses in use at that time. Rejlander produced the effect through the use of a fine thread. In that same year, he also made the controversial, "The Two Ways of Life," an elaborate story of a young man's decision to follow the good or evil way of life. Thirty separate negatives were combined to produce the single image (Pollack, 1977, p. 175).

Another artist-photographer who produced composite pictures was Henry Robinson. From five separate negatives, Robinson created the enormously popular, "Fading Away." In a stage-like setup, the image shows a young woman on her deathbed accompanied by grieving family members in various poses.

Cliff Edom (1980) noted that "Both composite pictures were criticized by a minority group for 'misrepresenting the truth'" (p. 184). The criticism apparently moved Rejlander to denounce the process. In a letter to Robinson he wrote, "I am tired of photograph-for-the-public, particularly composite photos, for there can be no gain and there is no honor, only cavil and misrepresentation" (Gernsheim, 1969, p. 247).

Portrait photography was enormously popular among the middle class, but picture patrons complained that the images showed all their facial peculiarities. Consequently, photographers of the day regularly softened wrinkles and removed facial blemishes with elaborate techniques. One of the earliest portrait photographers was Frenchman, Gaspard Felix Tournachon, or Nadar as he was professionally named. Although Nadar employed "six retouchers of negatives; and three artists for retouching the positive prints," he personally found the custom of retouching photographs to be "detestable and costly" (Newhall, 1982, pp. 69–70).

"The Two Ways of Life, 1857." The image was a composite made from 30 separate images (photo by Oscar Rejlander/International Museum of Photography at George Eastman House).

The photographic materials of the 1840s and 1850s were not overly sensitive to green and extremely sensitive to blue. Consequently, prints of nature scenes were often disappointing as a landscape was either a silhouette with clouds appearing in the sky, or the landscape was exposed correctly and the sky was printed white. To satisfy the public's thirst for photographs that contained a well-exposed landscape and sky, photographers usually reduced the sky with cyanide of potassium or painted on the sky with India ink. As Gernsheim (1969) noted, "By the first method dark rain clouds were obtained, by the second, white cumulus clouds." Double exposure techniques were sometimes used to bring land and sky into exposure harmony. Some photographers by the 1880s even traded or sold favorite cloud negatives to other photographers "with incongruous results: a dramatic cumulus cloud might serve for an Alpine scene, an English cathedral, and the Pyramids" (p. 264).

Civil War Manipulations

By the time of the Civil War, photography was well established as one of the most influential mediums in the world. Mathew Brady, a respected portrait photographer with galleries in Washington, DC and New York, established the first picture agency

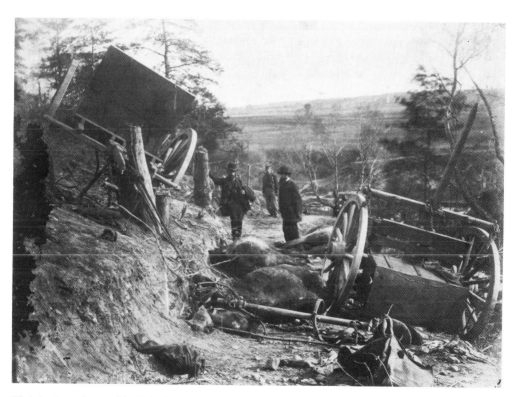

"Rebel caisson destroyed by Federal shells at Fredericksburgh, May 3, 1863." The photograph was attributed to Mathew Brady, but probably was taken by a photographer under Brady's employ (photo courtesy of the International Museum of Photography at George Eastman House).

to cover the war. He hired brave photographers and equipped them with all the necessary tools of the trade to ride in horse-drawn portable darkrooms and make pictures of the war. Most of the pictures Brady's photographers took were in the form of tintypes, cheaply made images printed on metal or inexpensive images called, "cartes de visite." The soldiers sent the images to their loved ones back home.

Many of the battle scenes and portraits, credited to Brady, are valued documentary images in the Library of Congress. But Brady made few photographs during the Civil War. When pictures were sent to him from the cannonball covered battlefields by his staff photographers, he quickly attached the credit line, "Photograph by Brady." Brady hoped to increase the likelihood of picture sales if people thought he made the images. Brady thought he would make a fortune with the documentary pictures from the war. But the public, grown weary of a costly war, were not interested in paying for the images. Brady died practically penniless (Pollack, 1977, pp. 56–59).

Other unethical picture manipulations during the Civil War have been discovered by researchers. William Frassanito (1978) located two stereocard views attributed to Brady taken after the first battle of Bull Run in July 1861. One view shows a group of standing, kneeling, and firing soldiers. The second picture titled, "Confederate Dead on Matthews Hill," shows the same group of soldiers lying on the ground, presumably killed. Frassanito disputed the authenticity of these scenes because Brady fled with the Union Army shortly after the battle and one man in the picture is dressed in a heavy overcoat, a strange wardrobe choice for July. "Someone apparently told the soldiers to pretend they were fighting in the one view," wrote Frassanito, "and then instructed them to pretend they were dead in the other" (pp. 31–32).

In an article titled, "The Case of the Rearranged Corpse," Frederic Ray (1961), art director for *Civil War Times* magazine, detailed a more famous manipulation. A photographer under Brady's employ, Alexander Gardner, is credited with a series of pictures he made of 18-year-old Pvt. Andrew Hoge of the 4th Virginia Infantry in Gettysburg. Hoge was stationed in a sniper's nest behind a barricade of rocks. The photograph captioned, "Home of a Rebel Sharpshooter," in Gardner's book, *Gardner's Photographic Sketch Book of the War,* shows the dead sniper lying on his back, his face turned toward the camera, and his rifle propped up against one of the rocks. The image would have remained a striking photographic document if it were not for another picture by Gardner that shows the same soldier in a different location. This photograph is a closer view of the young man still lying on his back, but his face is turned away from the camera and his rifle lies on the ground by his side. Apparently, the frustration with using slow films and lenses that made it impossible to photograph action during the heat of a battle, caused Gardner to create his own dramatic pictures. Ray wrote that Gardner "was guilty of at least a misdemeanor as a photographic historian" and concluded that his ethical transgressions were "nothing serious" (p. 19). But when a photographer is shown to fake a picture, all of his work is put into question. Again, the issue is credibility.

Stefan Lorant found an early photographic fake when he was investigating pictures for a book about Abraham Lincoln. Lorant was the art director for the London *Picture Post* magazine, the inspiration for *Life* and *Look* magazines. He discovered that the popular close-up portrait of Lincoln seen on the $5 bill was sandwiched atop

Pvt. Andrew Hoge, an 18-year-old from the fourth Virginia Infantry, is a Confederate and Union soldier in two separate photographs. (a) Alexander Gardner's, "Home of a Rebel Sharpshooter, Gettysburg, July 1863," shows Hoge's body behind a barricade of rocks. (b) Gardner's, "A Sharpshooter's Last Sleep, Gettysburg, July 1863" is an example of subject and picture manipulation. Gardner moved Hoge's body, rifle, hat, and leather case for a better composition. The

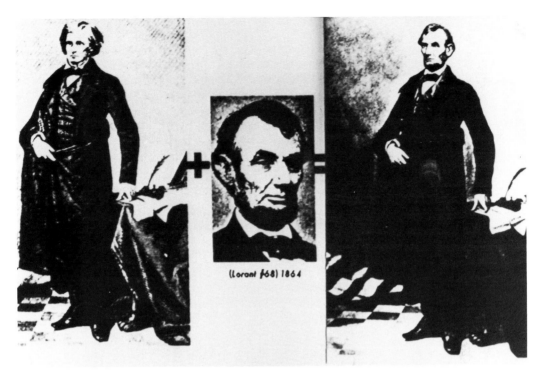

(Lorant f68) 1864

Southern statesman, John Calhoun's body is used for a famous portrait of President Lincoln in this 1864 composite (photo courtesy of Toby Massey).

the body of Southern statesman, John Calhoun by a darkroom technician. The result was a classic full-length portrait of the former president. The North and the South were once again united. Entrepreneurs at the time were eager to make money from Lincoln's assassination. But in their haste, the President's famous mole appeared on the wrong side of his face. Nevertheless, the full-length view of Lincoln is a popular portrait (MacDougall, 1971, p. 120).

Mathew Brady and his staff were responsible for one last photographic fake that involved the Civil War. General Sherman and his staff came to the Brady studio to have their group portrait made after the War. However, General Blair, an important member of Sherman's staff, could not attend the photo shoot. Nevertheless, the group picture was taken. At a later date, a head and shoulders picture of Blair was made. The image of his head was then attached to the group picture with his name already imprinted. Lucky for Brady that Blair did not suddenly die between the two portrait sittings (Pollack, 1977, pp. 193–194).

Although never accused of faking a picture, documentary photographer and writer, Jacob Riis, did use a manipulation technique that was successfully accomplished by Mathew Brady. Because Riis was not a trained photographer, he often hired them to accompany him on his nightly journeys through New York's seedy underworld. The popular story is that Riis could not rely on his photographers because they either would not show up for scheduled appointments or became frightened by the rough characters they were asked to photograph. Riis was forced to learn photography and took the pictures that were used in his lectures and for his

picture was later used in the *Harper's Weekly* battlefield composite engraving shown in the "Harvest of Death" photograph on page 98 (photos courtesy of The Library of Congress).

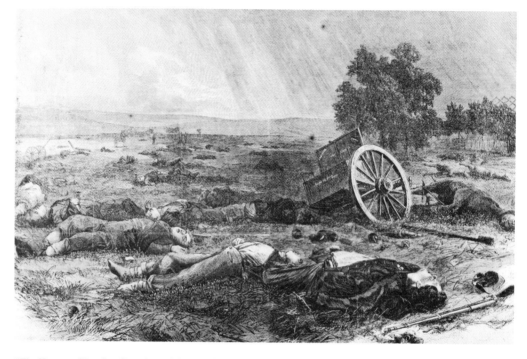

"The Harvest of Death—Gettysburg, July 4, 1863" appeared in *Harper's Weekly,*
July 22, 1865, p. 452. A composite engraving from three separate photographs
(photo courtesy of The University of Central Florida).

book, *How the Other Half Lives.* But one of his most famous photographs, "Bandit's Roost," was actually taken by Richard Hoe Lawrence. How many other photographs Riis took credit for, but were actually the work of Lawrence or another amateur photographer, Henry Pifford, is not known (Jussim, 1989, p. 40).

Engraving and Halftone Manipulations

Stephen Horgan in 1873 is credited with inventing the halftone printing process that replaced the artistic renderings of the engraved images with real pictures that were captured "from nature." The first photograph printed with the new technique, captioned, "A Scene in Shantytown, New York" showed crumbling buildings and piles of dirt from an obvious poor section of town. The image printed in 1880 by the New York *Daily Graphic,* was not meant to be an illustration of the newspaper's commitment to correcting dire social problems within the city of New York, but was simply part of a set of various printing techniques that were demonstrated by the newspaper. The Horgan invention was considered too expensive and difficult to use. F. E. Ives improved the process in 1890 to a technique that is still in use today (Jussim, 1989, pp. 44–45).

It took several years before the halftone process caught on because publishers had a large investment with engravers, many disliked the quality of printed pho-

"Bandit's Roost, 1888." The photograph was attributed to Jacob Riis, but was taken by Richard Hoe Lawrence (photo courtesy of the Museum of the City of New York).

tographs, and editors and artists had more control over engraved images. Once publishers started using photographs, however, engraving technology was abandoned (Jussim, 1989, pp. 42–45).

As Estelle Jussim (1989) wrote in *The Eyes of Time: Photojournalism in America,* the turn of the century began an era when readers were "impressed more by the fact that a photograph could finally be made to appear in a newspaper or magazine than by the content of that picture. . . . It was an era deluged by the products of the press and manipulated by warring publishers who displayed few ethical concerns. Photojournalistic images would be perceived as visual fact, but were actually more often propaganda and pure sensationalism" (p. 38). Faked pictures, as Jussim wrote, "became a frequent accompaniment to hyped stories" (p. 53). Robert Taft (1938) noted in his book, *Photography and the American Scene,* that "by the time the faked photograph is reproduced in halftone, it is impossible to detect the forgers

"A Scene in Shantytown, New York, March 4, 1880" is considered the first
reproduction of a photograph through Stephen Horgan's halftone invention (photo
courtesy of the New York Daily Graphic/International Museum of Photography at
George Eastman House).

from the print alone" (p. 448). Art directors who regularly ordered the manipulation
of engravings saw nothing ethically wrong with manipulating photographs.

Stage-managed and composite photographic techniques were common contrivances by the turn of the century. The highly theatrical photographs were usually
made by painters new to the photographic medium. Typical of the genre was the
early work of painter-turned-photographer, Edward Steichen. In 1902 he made a
striking portrait of the artist, Rodin with his famous piece, "Le Penseur." The
"portrait of the artist and the sculpture were exposed on separate negatives and
combined into a single print" ("Caption," 1989). Later in his career, Steichen is
most known for creating one of the most successful photojournalism exhibitions in
the world, "The Family of Man."

Worried over real estate prices and population declines, Gladys Hansen (1989),
in her recent book, *Denial of Disaster,* showed evidence that many of the photographs made during the 1906 earthquake in San Francisco were re-touched. City
officials authorized artists to alter photographs to minimize the appearance of
damage from the earthquake. It was assumed at the time that prospective settlers to
San Francisco would understand damage from a great fire, but would not move to
the area if the full fury of the earthquake was publicized.

Susan Moeller (1989) wrote that many pictures taken by war photographers

The "Shantytown" picture was not published to change the conditions within the city, but was part of a demonstration of various printing techniques. "Fourteen Variations of the Graphic Process, March 4, 1880" (photo courtesy of the New York Daily Graphic/International Museum of Photography at George Eastman House.)

covering the Spanish–American War in Cuba were posed. Fighting scenes were re-enacted and bodies were moved for better compositions. Some creative photographers even re-enacted famous battle scenes in New Jersey backyards and bathtubs. During World War I, many photographs were manipulated for propaganda purposes. For example, newspapers showed faked photographs of Kaiser Wilhelm of Germany cutting off the hands of babies (Edom, 1976, p. 31).

In *Making People Disappear,* Alain Jaubert (1986), chronicled numerous photographic abuses by mostly totalitarian regimes. Through retouching, blocking, cutouts, recentering, and effacement techniques, historical pictures have been altered to reflect a political leader's version of the truth. For example, the photograph that showed the 1917 attack by revolutionary soldiers on the Winter Palace in Russia was actually a re-enactment during a daylight street celebration 3 years later. The actual attack occurred in almost total darkness. The famous photograph was darkened and the windows of the Palace "were painted white to give the illusion of a building seen at night and lighted from within" (p. 44).

"Reverend Tweedle and Spirits, no date." Spirit photographers used double exposure and double printing techniques to produce images of the deceased, including Sir Arthur Conan Doyle at the top left (photo courtesy of the Photography Collection/Harry Ransom Humanities Research Center/The University of Texas at Austin).

Spirit Photography

A curious and little-mentioned photographic genre, spirit photography, supposedly captured the likeness of the spirit of a deceased person. Spirit photography, an outgrowth of the Spiritualism religious movement, was proven by photographic experts, including the famous magician and escape artist, Harry Houdini, to be double exposure fakes. Unsophisticated to the technical considerations of photography and wanting to believe in the truth of the photograph, people paid money to spiritual mediums and believed the results. Usually a psychic medium would make an appointment with a customer and ask for a picture of the deceased. This portrait,

it was told, was necessary in order to communicate more easily with the dead loved one. The spirit photographer would expose part of a negative plate with the image. Using that same negative during a portrait sitting, the photographer simply developed the image and showed the print to the amazed and grateful customer (see Black, 1922; Bird, 1923; Edmunds, 1966; Houdini, 1924).

Houdini traveled the world exposing the tricks mediums used to dupe their customers. There were hundreds of ways the spirit photographers used to manipulate negatives to produce spirits on film and Houdini usually caught them all. He often traveled with Arthur Conan Doyle, of the Sherlock Holmes stories, to debate the truthfulness of the spirit photographs. Curiously, Doyle, an amateur photographer, was one of the most strident advocates of spirit photography in the world. With large prints and stories from mediums, Doyle would spread the gospel of ghosts. He usually opened his lectures with, "Tonight I propose to put before you some pictures and photographs which will illustrate . . . the physical results which come from psychic knowledge" (from the "Opening of the Photographic Lecture," Humanities Research Center, Austin, TX, Doyle collection). As more people became technically sophisticated about photography, spirit photographs soon faded into thin air.

The "Yellow Journalism" era, fueled by the intense competition between Joseph Pulitzer, publisher of the *New York Tribune* and William Hearst, publisher of the *New York Journal*, created a readership that demanded dramatic and sensational stories in their newspapers. In a time when ethical considerations gave way to

A composograph purporting to show an actual divorce trial is actually a stage managed re-enactment by employees of the newspaper using 20 pictures (photo by Harry Grogin/*New York Evening Graphic*).

economic interests, editors and photographers were willing to obliged their publishers.

Ken Kobre (1980) in his textbook, *Photojournalism: The Professionals' Approach,* credited editor Emile Gavreau and assistant art director Harry Grogin of the *New York Evening Graphic* with creating a faked news picture. The technique called a composograph, used 20 separate negatives to fake a sensational divorce trial after photographers were ejected from the courtroom by the judge. Newspaper staff personnel posed as trial participants for the picture. Although the *Graphic* admitted in tiny print that the composographs were faked, the sensational images were enormously popular among readers.

Photographers were recruited to satisfy the visual needs of the newspapers. "Competition for the low-paying, exhausting [photographer] jobs was fierce," wrote Claude Cookman (1985), a photography historian. Joseph Costa, NPPA's first president, admitted that the heightened sense of competition fostered many unethical acts besides faked images. Some photographers put ear wax on lenses, exposed negatives, and stole negative holders from other photographers. "Sabotage was standard practice," said Costa, "and no photographer with any street savvy at all would ever let his camera bag or equipment out of his sight" (p. 116).

As William Strothers (1989), readers' representative for *The San Diego Union* wrote, sometimes those camera bags contained more than camera equipment. "There are stories of some long-ago reporter-photographers covering the police beat who used to carry teddy bears in their cars. When they sped to the scene of an accident involving a child, the toy would be employed to add poignancy to the photograph. It also was common practice for photographers to pose participants in news events to get good pictures" (p. 25).

In 1943, *New York Journal* photographer Harry Coleman admitted in his book, *Give Us a Little Smile, Baby,* that he would dress up a body at the morgue with a shirt and tie and prop it up for a seemingly life-like portrait of the deceased subject. At the scene of a homicide, Coleman would also describe the victim to a fellow photographer over the telephone who would "dig up a real photograph of, say, John L. Sullivan, remove his ferocious mustache, paint a General Grant beard across his massive chin, and send it to the engravers as a legitimate picture of an unidentified body in a foul murder" (cited in Ahlhauser, 1990, p. 2).

In a reaction to the many manipulated pictures by news photographers, Kent Cooper (1947), an executive for the Associated Press wrote the following:

> This is a personal appeal for a new approach to pictures of people taken individually or in groups. I earnestly ask that you put a premium on the natural, unposed pictures of people. Obviously you cannot pose spontaneous shots without being deceitful. It is just as deceitful for a photographer to make a man or woman to look some way or act some way that is unnatural. (p. 48)

C. William Horrell (1955) noted in a survey of newspaper photographers that "a need was expressed for more natural and truthful photographic reports, a kind of report which could be achieved through greater use of unposed subjects being photographed with existing light" (p. 187). By the 1950s, the manipulation of subjects was widely condemned by professionals. However, abuses still occurred.

April Fool's and Political Fakes

April Fool photographic fakes were popular in newspapers during the first half of this century. Curtis MacDougall (1940) in his book, *Hoaxes,* detailed several instances where newspapers published such images as giant sea creatures, Viking ships, and a man supposedly flying by his own lung power. The Madison, Wisconsin *Capital-Times* went so far as to publish a photographic composite of the capitol dome collapsing in 1933 that needlessly alarmed hundreds of people. Photography editor Cliff Yeich ("One person's gallery," 1985) recently revised the April Fool joke for his newspaper, the Reading, Pennsylvania *Eagle-Times.* Yeich used double printing techniques to show the Concorde SST aircraft landing at the Reading airport, an oil tanker cruising down the Schuykill River, and two children playing with a giant wishbone from a 750-pound turkey. Although popular with many readers, such examples of fun with photography do not belong in a newspaper. A photographer who employs such trickery might be tempted to use the technique for news events. Yeich, for example, after a recent rain storm, created the look of flooded conditions on Reading's main street with a mirror. Another wet day at a horse racing track resulted in a picture of a faked motorboat ride on the oval course.

An April Fool's Day hoax upset many readers when it was believed that the Wisconsin state house dome had actually collapsed (photo courtesy of *The Capital Times*/Madison, Wisconsin).

Children appear to play with the wishbone from a 750-pound turkey in this April
Fool's Day double print (photo by Cliff Yeich).

The pictures were not printed on April Fool's day. Curiously, April Fool's day
hoaxes can still be found on college campuses. Many university newspapers have
April Fool's editions that lampoon campus issues and personalities in faked stories
and pictures.

More serious fakes involved political subjects. A 1928 campaign picture of
Herbert Hoover and his runningmate was faked because Hoover refused to pose
with the vice-presidential candidate, Charles Curtis. *Life* magazine revealed a com-
posite photograph, produced by a rival politician, of a Maryland Democrat running
for office that looked like he was conferring with a Communist leader. The image
was actually the result of two separate photographs. The image was widely dis-
tributed among the electorate. The Democrat lost the election (MacDougall, 1971).

Floyd Collins' Faked Caption

Truth was again a victim during journalism's most sensational era. Floyd Collins
was a man who wanted to build his own amusement park. In 1925, he became

A rainy-day racetrack feature picture for a September issue, not an April Fool's edition, is made more visually interesting through double printing (photo by Cliff Yeich).

trapped while exploring Sand Cave a few miles from the famous, Mammoth Cave in rural Kentucky. For 17 days, rescue workers attempted to free Collins, but without success. He died from starvation. Fifty reporters on the scene turned Collins into a national martyr. Over 20,000 people from 16 states jammed into the area after reading the newspaper articles. In the movie, *Ace in the Hole,* Billy Wilder critically presented the side-show atmosphere surrounding the hole in the ground (Lesy, 1976, p. 220).

Competition was intense among journalists on the scene to get interviews and pictures no other newspaper had. William Eckenberg, a photographer for the *New York Times,* learned that a farmer had a picture of Collins taken 10 days earlier while inside another cave. Eckenberg found the picture, made a copy and sent it to New York. The picture was used by many papers across the country. Some papers, including the *Chicago Daily Tribune,* accurately described the circumstances surrounding the picture's history. Many other newspapers, however, perhaps to heighten interest in the image, used the picture without an explanation. A team of journalism historians were also fooled by the picture. In *America's Front Page News 1690–1970,* a caption under a reproduction of the front page of the New York, *The*

College newspapers regularly lampoon topics and university officials in an April Fool's edition. The April Fool's issue for *The Central Florida Future* includes three photographs that were manipulated to varying degrees (photo courtesy of *The Central Florida Future*).

World reads, "The haunting picture of explorer Floyd Collins, peering from the Kentucky cave in which he was wedged for 17 days, appeared on the day he was found dead of exhaustion and starvation" (see Emery, Schuneman, & Emery, 1970; Faber, 1978).

Manipulations by Cropping

Cropping out significant elements of a picture in order to produce a misleading image has been used for various motivations by photographers. President Franklin

Roosevelt, stricken with polio and confined to a wheelchair, was photographed with close-ups by sympathetic photographers who did not want to show the public the full extent of his feeble condition. Likewise, photographs of Governor George Wallace, after he was paralyzed from an assassination attempt, were cropped for the same reason. An infamous example of creative cropping occurred during Senator Joseph McCarthy's hearing on Communists in the government. To imply that Secretary of the Army Robert T. Stevens had a close relationship with an enlisted man, Private G. David Schine, a picture of the two was closely cropped omitting a third man in the photograph, Air Force Colonel Jack T. Bradley (Cook, 1971).

The picture of Floyd Collins was actually taken earlier while he was exploring another cave. Many newspaper editors around the country ignored the circumstances surrounding the image to enhance its dramatic effect (photo courtesy of Vis-Com Inc.).

Cropping can be misleading. To imply that Secretary of the Army Stevens had a close relationship with enlisted man, David Schine, a picture of the two was closely cropped (photo courtesy of Associated Press/Wide World Photos).

CHARGES OF MANIPULATION CLOUD FAMOUS PICTURES

Perhaps most troubling to the reputation of photojournalists and their photographs are reports that well-known and deeply moving pictures have been stage directed by the photographers.

Three famous photographs, Robert Capa's moment of death of a Republican soldier during the Spanish Civil War, Arthur Rothstein's skull on parched South Dakota land, and Joe Rosenthal's raising of the American flag over Iwo Jima, have all been reported to be photographic manipulations. These three images have a cloud of uncertainty that surrounds each photographer's reputation.

Robert Capa's 'Moment of Death'

Published in *Life* magazine in 1937, Capa's photograph shows in one instant the sudden and lonely death of an anonymous soldier. The picture shocked readers with its sudden impact. Never before had the public witnessed in such graphic horror a soldier's moment of death. After an offhandedly made remark by the teasing Capa and weak evidence that the killed soldier appeared alive in subsequent images in Capa's contact sheet, rumors spread that the picture was either a result of Capa simply shooting blindly and capturing the shot by chance or stage managed for the camera (Knightley, 1976). Luck often helps experienced photographers. Bob Jackson who took the Oswald murder picture and Eddie Adams who captured the Viet Cong soldier's assassination were startled by the sound of a gunshot and pressed their shutter buttons. Photographic reflexes, a result of years of experience, plus a little luck can produce extraordinary photographs.

Robert Capa was never the kind of photographer who needed to set up his subjects. Capa, who's motto was, "If your pictures aren't good, you aren't close enough," would have been dismissed had the moment-of-death photograph been the only picture in his portfolio. However, Capa produced many war-time photographs throughout his career. Another famous picture of Capa's is the grainy and blurred image, caused by a lab assistant's high drying temperature, of a soldier crawling in the shallow waters of Normandy during the D-Day invasion. He photographed in

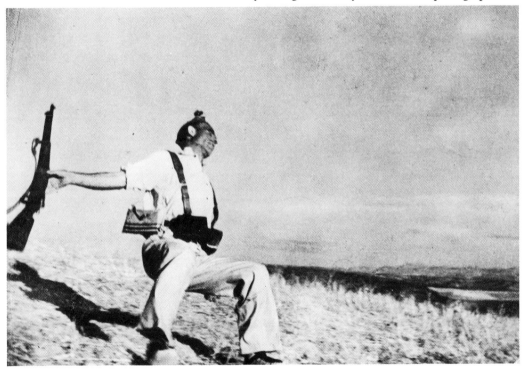

"Death of a Loyalist soldier, 1936." It has been asserted that this moment of death was stage managed with a willing volunteer (copyright © Robert Capa/Magnum Photos, Inc.).

Spain, China, Israel, and finally in Vietnam, where he was killed when he stepped on a land mine (Rothstein, 1986). Capa consistently produced images with strong emotional impact and high technical expertise. He was not a photographer who needed to fake a photograph in order to enhance his career.

Arthur Rothstein's Skulls

Arthur Rothstein (1961), a documentary photographer for the Farm Security Administration (FSA) during the American Dust Bowl era, made photographs of a steer's skull on grassy and parched land. When the different backgrounds were discovered, the skull was labeled a prop by Republican politicians who used the Rothstein pictures to attack the credibility of all the FSA photographs and particularly the Democratic administration. The Democrats, it was argued, were using the photographs to make environmental conditions look worse than they actually were in order to pass controversial legislation through Congress. Rothstein was accused of traveling around the country with his suitcase, his camera, and his skull. Although he only moved the skull 10 feet, Rothstein would be the first to admit that it was wrong of him. He regretted the controversy for the rest of his career.

Rothstein produced several memorable photographic documents including the classic Dust Bowl photograph of a father hurrying toward shelter through a dust storm with his two young sons trailing behind. He received more than 50 photog-

(a)

(a) (b) Arthur Rothstein was severely criticized for moving the skull to different locations. (c) Because of Rothstein's ethical indiscretion with the skull, this classic dust bowl picture was viewed by some to be stage managed (photos courtesy of The Library of Congress).

(b)

(c)

raphy awards and wrote several books on the subject of photojournalism and documentary photography. Given such a reputation, it is difficult to imagine him packing a skull with his clothes and camera.

Joe Rosenthal's Flag

An Associated Press photographer, 33-year-old Joe Rosenthal, made three photographs atop Suribachi, a Japanese observation post on the island of Iwo Jima in 1945. His first picture became the most reproduced photograph in history and won for him a Pulitzer Prize. His second picture, although similar to the first, did not capture a dramatic moment and was forgotten by history. His third photograph became the source of accusations that the first photograph had been set up (Evans, 1978).

The first picture is the image most remembered. It shows six soldiers erecting a large, American flag on a long diagonally slanted flagpole. The soldiers seem to be straining, as they had strained to capture the mountain from the Japanese, to fly the banner of the United States. This large flag, however, was not the first American flag to fly over Suribachi. Staff Sgt. Louis Lowery, a Marine photographer, who beat Rosenthal to the top by several hours, recorded the first flag-raising ceremony that used a small flag (Colton, 1989).

On his way up to the top, Rosenthal saw a Marine carrying a much larger flag. The raising of that larger flag was recorded on film by a motion picture cameraman and by Rosenthal with his Speed Graphic press camera. After the raising of the flag, Rosenthal made a group picture of 18 soldiers smiling and waving for the camera. Although the flag-raising ceremony was re-enacted, it was the Marines who were responsible for the decision—not Rosenthal.

The confusion over the authenticity of the famous photograph resulted from Rosenthal's casual response to a correspondent 9 days later in Guam. Congratulations poured in from newspapers across America about the picture. A writer happened to ask if the picture was posed. Thinking that he meant the third photograph, Rosenthal admitted that it had been set up.

Speaking later of the famous picture, he rightly argued that "had I posed the shot, I would, of course, have ruined it. I would . . . have made them turn their heads so that they could be identified for AP members throughout the country" ("Flag raising," 1980, p. 13). Nevertheless, when the picture was first offered to the editors of *Life* magazine, it was rejected because it looked too perfect. As one writer noted, "*Life* was all for making movie stars look glamorous and frequently staged photos, but this was hard news, and they wanted to be careful." After the photograph was used throughout the world as a symbol of America's victories, the picture was printed in *Life*. Incidentally, Mt. Suribachi was soon recaptured by the Japanese. Many of the Marines who were photographed by Rosenthal were numbered as casualties (Elson, 1968, p. 56).

Writing of the Rosenthal icon, picture editor Harold Evans (1978), in his book *Pictures on a Page,* noted that "no genius could have posed the picture if he had spent a year in a studio with lights and a wind machine" (p. 145). Lucky for photojournalism, Rosenthal did not carry a wind machine to the top of Iwo Jima.

RECENT MANIPULATIONS BY TRADITIONAL TECHNIQUES

In the present era of ethical awareness, some photographers have learned the hard way that giving stage-managed, manipulated prints or misrepresented subjects to editors without explanations is ethically wrong. Professor Jim Gordon (1981) of Bowling Green State University, Ohio and editor of *News Photographer* magazine detailed the firing of Norman Zeisloft.

Norman Zeisloft's Feet

A 17-year veteran of the St. Petersburg *Times* and *Evening Independent,* Zeisloft was assigned to cover a baseball tournament. As baseball games often go, sports action was hard to find. He spotted three fans in the stands and said that it would be "cute if you had 'Yea, Eckerd' written on the bottom of your feet." One young man agreed and Zeisloft started to write. A photographer for a competing newspaper took a picture of him writing on the bottom of the fan's foot and later put it up on his photography lab's bulletin board as a joke.

Zeisloft's pen would not write on the man's dirty sole so he returned to shooting the game. In the meantime, the man in the stands washed his feet, wrote the message on his foot and called Zeisloft over. He took the picture. Zeisloft gave the image to his editor without a word about the stage-managed situation. Two days later it was printed in the *Evening Independent.*

Someone sent the picture of Zeisloft writing on the bottom of the fan's foot to Norman Isaacs, who served as chairman of the Pulitzer jury for commentary and was chairman of the National News Council in New York. Isaacs sent the picture to Gene Patterson who was Isaacs' close friend and president and editor of the St. Petersburg newspapers. Patterson was also chairman of the Pulitzer Prize Board who had recently voted against awarding the Pulitzer to *Washington Post* reporter, Janet Cooke. (Cooke had admitted that a story she wrote of a little boy surrounded by drug dealers was actually fiction. Her scandal was an embarrassment for the *Washington Post* and the Pulitzer Prize Board.) Zeisloft was fired.

At his administrative appeal, he explained, "we set up pictures for society and club news, recipe contest winners, ribbon-cutting and ground-breaking ceremonies, award shots and enterprise features." Zeisloft, at 61 years old, may have been influenced by the stage managing techniques that photographers had used several years earlier because of their bulky cameras. Even Gene Smith, *Life* magazine's premier picture story producer, has admitted, "If I really felt that it was absolutely essential to the truth of the story, I would not hesitate to pose the subjects" (Kobre, 1980, p. 302). Another famous *Life* magazine photographer, Margaret Bourke-White, regularly posed her documentary subjects in order to get better compositions and emotional impact in her photographs. Posing is close to the ethical line. Writing on a foot to create a more interesting picture is over the edge.

Executive editor, Robert Haiman made the decision to fire Zeisloft. His explana-

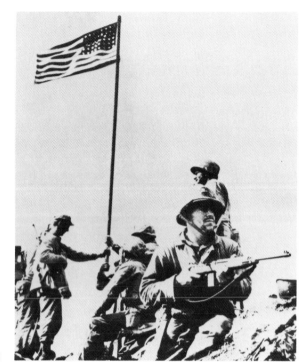

(a)

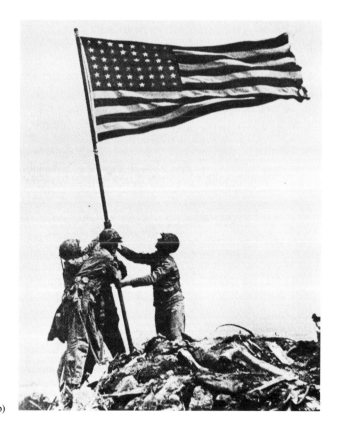

(b)

116

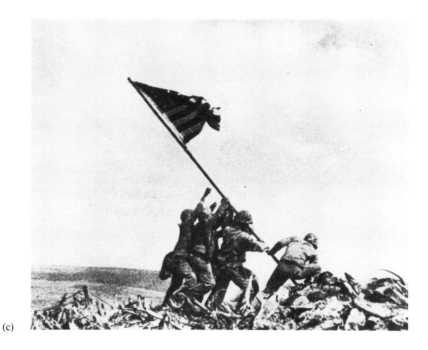

(c)

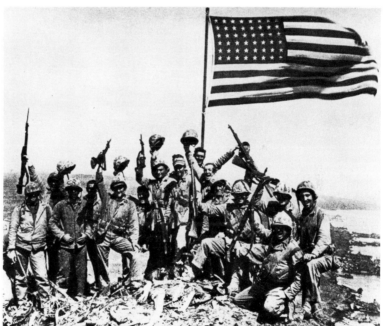

(d)

A U.S. victory in the Pacific during World War II produced a classic photographic icon and an unrelenting ethical controversy. (a) The first and smaller flag to be erected over Iwo Jima by U.S. soldiers (photo by Louis Lowery/U.S. Air Force). (b) Joe Rosenthal's second picture of the flag-raising ceremony over Iwo Jima with the second and larger flag. (c) Rosenthal's first picture—a Pulitzer Prize classic. (d) Rosenthal's third picture—a snapshot for the folks back home (photos b,c,d courtesy of Associated Press/Wide World Photos).

117

tion should be tacked to the bulletin board of every newsroom in the country. "It seems to me," Haiman said,

> the worst thing from the standpoint of the photographic community is for editors to have that condescending attitude, well, you know, he's only a photographer. I'm told that there are still some editors in this country who regard photographers as second-class citizens in the newsroom. . . . I don't happen to buy that. I believe that a photographer is every bit as much a first-class citizen in this journalistic community as any reporter. And there is one thing about the journalistic community which is more important in it than in any other community. And that is the obligation to tell the truth, the whole truth and nothing but the truth. There is simply no room for people who don't tell the truth. (p. 34)

Zeisloft's defense of his picture are the words of a past generation of press photographers. "It was just a whimsical thing, just for a little joke," he said. "It was just a little picture to make people smile rather than an old accident scene" (p. 32).

Norman Zeisloft's sin was not realizing that the ethics of stage-managed pictures had changed.

Norman Zeisloft was fired after 17 years of service for stage managing this sports feature picture (photo by Norman Zeisloft/*St. Petersburg Times* and *Evening Independent*).

One of the great images of all time shows Tokomo Uemura, a victim of mercury poisoning, being bathed by her mother. As observer and participant, W. Eugene Smith would sometimes encourage an action if he thought it contributed to the meaning of the story (photo courtesy of the Estate/W. Eugene Smith).

Other Subject and Picture Manipulations

Other photographers have lost or been suspended from their jobs when editors were not told of a print or subject manipulation. Eric Demme, a freelance photographer for United Press International (UPI), was fired for a double printing manipulation. A picture of a jet airplane in one photograph was combined with a chicken wing restaurant's sign. The sign read, "Air traffic controllers dont [*sic*] affect our wings" and referred to the national air traffic controller strike of 1981. When the composite was discovered, UPI ordered a "mandatory kill" on the picture. All editors were instructed to destroy the picture. Demme explained that because staffers helped him produce the image, he expected "a slap on the hand." "It [the photograph] doesn't involve people," said Demme. "Why not?"

A panda bear "in his last remaining natural habitat" was found to have been photographed in a 2-acre pen at a research center in China's Wuyipeng province. Contract photographer for *Geo* magazine, Timm Rautert, was fired. *Geo* managing editor, David Maxey said that the experience "will make us more vigilant in the future. Embarrassing though this message is, there's no substitute in journalism for candor" (Gordon, 1981, pp. 35–36).

Eric Demme was fired from UPI for creating this picture in the darkroom (photo by Eric Demme/UPI/Bettmann Newsphotos).

The Sunday newspaper magazine, *Parade,* illustrated a cover story on teenage prostitution with three pictures purported to be actual scenes of women soliciting themselves for money. Under the headline, "Kids For Sale," one of the pictures from New York City was taken by Pulitzer Prize winning photographer, Eddie Adams. Professionals became concerned when it was discovered later that Adams' "prostitute" was actually a paid model. A disclaimer, identifying the woman in the picture as a model, had been "dropped." Adams admitted that stories concerning children require the use of models because of problems with obtaining parental permission. Magazines set up cover pictures, Adams explained, "to draw attention to the story, to illustrate a point. Newspapers have even more instances with it with set-up feature pictures" (Brill, 1986, pp. 4–8). Nevertheless, if models are used to illustrate a news editorial picture, the readers should be told.

Eddie Motes of the Anniston, Alabama *Star* was looking for a weather feature picture after a rainstorm produced flooded conditions. He asked Angie Shockley, a community center employee, to walk with an umbrella through ankle-deep water so that he could make pictures of her. Shockley suddenly disappeared as she stepped into a ditch hidden by the flood waters. Paul Kennedy had been watching the photography session and immediately jumped into the culvert to save Shockley. A group of basketball players and the Anniston Rescue Squad were needed to rescue Kennedy who had become trapped against the culvert. Meanwhile, Shockley had been sucked through the 50-foot drain and was unhurt on the other side. Kennedy was treated and released at a local hospital. In one assignment, Motes had created human interest feature and spot news pictures.

Motes reported that his editor did not hold him responsible for the accident. But in letters to *News Photographer* magazine, photojournalists around the country let Motes know what they thought of him setting up a situation that almost turned into tragedy. Typical of the responses was Jason Grow's letter. "Motes' situation clearly illustrates the danger of explicitly, or implicitly, encouraging someone to perform for the sake of the camera. Eddie Motes was damn lucky that neither Shockley nor Paul Kennedy were killed. Maybe through this near-tragedy we all may re-evaluate what it is we are doing when we put our cameras to our eyes" (Grow, 1989, p. 55).

Pulitzer Prize photographer for the Detroit *Free Press,* Manny Crisostomo was suspended for 3 days after it was learned he "bought a Sony Walkman and a sausage from a crack addict referred to as Tim in a story. . . ." Crisostomo "feared the addict might become violent if he wasn't given any money" (AP News Wire, 1989). For *Life* magazine in 1965, Bill Eppridge photographed a young couple addicted to heroin. Eppridge admitted that the couple asked for money, but he explained "that if we paid them, the story could no longer be valid . . ." (Edom, 1980, p. 98). Crisostomo and a reporter gave money and then drove the addicts to where they could buy more crack. The large, lead picture in the layout of the addicts smoking crack was taken inside the reporter's car. In an article in *News Photographer* magazine, Crisostomo (1989) admitted that "Integrity is everything. Reputations are hard to come by, but easy to lose. When confronted with a serious ethical question, I can't go it alone. My editors have to know what's going on. And if it comes down to a choice between compromising my ethics or dropping the story, I'll drop the story" (pp. 22–24). Credibility is severely damaged when reporters set up a situation or provide money and transportation for subjects to purchase illegal drugs.

When the Tokyo newspaper, *Asahi Shimbun,* sent a photographer to document the environmental problems with a coral reef, he carved his initials in the reef for the picture when he could not find enough damage. The newspaper received 6,000 phone calls and 2,000 letters in 1 month when the alteration was learned by the public. The photographer was fired. But the Japanese did not stop with the photographer's punishment. As William Strothers (1989) wrote, "Another photographer involved was suspended, the salaries of the executive editor and three other editors were cut, and the managing editor and photo editor were demoted. Finally, the president of the newspaper resigned" (p. 25). The Japanese really know how to get the message across.

Color as a Culprit?

The spread of color photography for magazines and newspapers has been blamed for the trend toward the increased use of set ups and illustration assignments. John Coffeen of the *Tampa Tribune,* noted that because of the lighting techniques necessary to take good color pictures, many photographers have returned to the posed shooting style, popular in the 1950s while on location and in the studio (Fitzgerald, 1988, p. 16).

When newspapers bought new color presses, studio shots increased "because it was a chance to show off what we could do with the new presses," according to Coffeen. When color photography is well printed it attracts more readers and advertisers to the newspaper. Editors felt that color slide materials would be best for color reproduction on the presses. Slide exposures have to be right on the mark and that sometimes requires the use of fill-in flash and set up techniques. Many newspapers have purchased computer-controlled picture scanners that make color separations. Consequently, photography staffs have been able to change to more forgiving negative color films that can be used under adverse technical conditions. Editors have also steered away from meaningless sunset and sailboat pictures and use photojournalism photographs that happen to be in color. Nevertheless, *USA Today,* with its pages filled with colorful, tiny head and shoulder portraits, has been a model for many newspapers around the country (Lester, 1988). Photographers continue to get assignments for food, fashion, and editorial illustrations where they use highly manipulative techniques common to advertising photographers and then are expected to be straight documentary photojournalists when they cover any other assignment.

Concern runs high among professionals about the increased use of the illustration assignment. The judges for the Pictures of the Year (POY)/47 competition, sponsored by NPPA and the University of Missouri, have eliminated the editorial illustration category from the competition. The contest instructions state, "Given the growing popularity of set-up and contrived pictures and the threat to photographic credibility posed by computer manipulation POY will, in the future, focus entirely on documentary work" ("Contest instructions," 1989). The POY judges will also prefer photo reportage over photo illustration in every category.

COMPUTER MANIPULATIONS

In national surveys sent to photographers, editors, and educators, as if guided by a single voice, all exclaim the same concern: The most serious threat to the integrity and credibility of photojournalism images is computer manipulation (Brink, 1988). Why is there such a concern for a technique that is simply a technological step up from photo retouching by hand? To simulate color in early daguerreotypes and tintypes, photo retouchers with brushes and inks added rouge to cheeks and cyan to dresses. Before the halftone invention, engravers regularly "improved" a photograph's content and composition. Wedding portrait photographers regularly remove unwanted warts and wrinkles. Advertising art directors customarily combine

parts of pictures, change colors, and create fantasy images to attract customers. But people are well aware, and knowingly suspend their belief, when it comes to portrait and advertising photographic images.

The concern comes when computer retouching is used for untouchable images—photojournalism photographs ("Whose picture," 1987). Imagine a newspaper thats masthead motto is, "April Fool's Day—Every Day." Like the little boy who cried wolf in the fairytale, magazine and newspaper readers would eventually turn their backs on the media out of mistrust.

Hal Buell of the Associated Press said, "I don't think your ethics can be any better or any worse using electronic methods than they are using the classical methods. Ethics is in the mind. It is not in the tools you use" (Bossen, 1985, p. 30). There are two approaches that one can take about the use of computer technology: absolute or relaxed. Either computer manipulation should never be performed for news/editorial images, or changes are allowed. Robert Gilka, former director of photography for *National Geographic* magazine, articulated the absolute viewpoint. Gilka said that manipulating images is "like limited nuclear war. There ain't none" (Ritchin, 1984, p. 49). Jack Corn, director of photography for the *Chicago Tribune* said manipulations are "ethically, morally and journalistically horrible" (Reaves, 1987, p. 31).

Michael Evans (1989), editor of graphics and photography at the Atlanta *Journal* and *Constitution* and former White House "photo opportunity" photographer for the Reagan administration, has a more relaxed opinion. Evans cited W. Eugene Smith's work as an example of "emphatically accurate photos" that are nevertheless manipulated. Evans wrote that "Through burning, dodging, bleaching, negative-sandwiching, double-printing and a veritable arsenal of other brilliant special effects, Gene Smith produced prints that dazzled a photographically unsophisticated world that literally thirsted for images" (pp. 26–28). A famous portrait of Dr. Albert Schweitzer by Smith was a composite print from two images because the main negative was technically flawed due to fogging. Even the famous photograph, "The Migrant Mother" by Dorothea Lange was retouched to eliminate a "ghostly thumb" in a corner of her composition (Ohrn, 1980).

The first time many learned that a new age in photo retouching had dawned were the reports of cable mogul Ted Turner using computerized colorization techniques on classic, black-and-white movies. The motive was profit—it was hoped viewers would be more attracted to the color versions. The list of computer and set up abuses grows daily at an alarming rate. Most of the computer enhancements have occurred on the covers of various magazines. *National Geographic* (1982a, 1982b) magazine, long known for its reputation of photojournalism excellence, used a computer digitizer on two occasions. On a cover story of Egypt, the Great Pyramids of Giza in a horizontal picture by Gordon Gahen were squeezed together to fit the magazine's vertical format. Editors for a picture story on Poland used a photograph by Bruno Barby for the cover and the special supplement that combined an expression on a man's face in one frame with a complete view of his hat in another picture.

Tom Kennedy, who became the director of photography at *National Geographic* after the covers were manipulated, recently stated that "We no longer use that technology to manipulate elements in a photo simply to achieve a more compelling

Computer technology was employed to make a cover image that would attract
potential book buyers. Originally a horizontal, computer technology transformed
the image to a vertical format for the cover (copyright © 1986 Frans Lanting/*A
Day in the Life of America*).

graphic effect. We regarded that afterwards as a mistake, and we wouldn't repeat
that mistake today" (personal interview with Carla Hotvedt, March 22, 1990).

The photojournalism compilations in the *A Day in the Life* books of America,
Australia, Canada, and California all had cover pictures manipulated by computer
technology. The horseman, hill, and tree on the cover of *A Day in the Life of
America* were moved closer together enlarging the moon. The photograph was
originally a horizontal. The objects in the picture were moved to fit the cover's
vertical format. Dandelions behind a boy and a girl on the cover of *A Day in the Life
of Canada* were turned into green grass. An inch of water was added to the top of
the cover picture to include the title, *A Day in the Life of Australia*. The top of a

surfboard was created for the cover picture of *A Day in the Life of California*.

The short-lived and experimental magazine, *Picture Week* fused two different photographs in tabloid magazine style of Nancy Reagan and Raisa Gorbachev to portray a misleading attitude of friendliness (Reaves, 1987). A cover picture for *Rolling Stone* magazine was altered with the computer (O'Connor, 1986). The gun and shoulder holster were removed from "Miami Vice" actor Don Johnson because editor Jan Wenner is an ardent foe of handguns (Lasica, 1989). *Popular Science* magazine used the computer to combine an airplane in one picture with the background of another (Lasica, 1989). Television interviewer Oprah Winfrey's head was spliced on top of Ann-Margret's body for a *TV Guide* cover ("Why tamper," 1989). To illustrate Rob Lowe's troubles with videotape, *Atlanta* magazine used a model holding a video camera and Lowe's smiling face in a computerized cover composite (Lee, 1989). Shiela Reaves (1989) reported that a cover picture of planes flying over the Chrysler building in New York City for the *Conde Nash Traveler* was a composite from three separate negatives. A former art director for *Better Homes and Gardens* admitted that "45 of the 48 covers from 1984 to 1988 were digitally manipulated, primarily because the magazine often uses inside photos for its cover" (p. 1). For the examples just given, readers were not told that the covers had been altered with a computer.

Editors argue that the cover photograph can be altered in order to achieve maximum impact because the image is designed to attract a potential buyer just like an advertisement. Sean Callahan, former editor of *American Photographer* magazine feels that covers are sales tools that are used to attract browsing newsstand buyers. "There is tremendous competition in that kind of environment and so you have to do something to get [buyers'] attention," Callahan said. Co-director David Cohen of *A Day in the Life of America* said, "I don't know if it's right or wrong. All I know is it sells the book better" (Lasica, 1989, p. 22). Creator and photographer for the *A Day in the Life* series, Rick Smolan said, "We are very proud of the fact that we were able to use this technology to make the covers more dramatic and more impressive" (Reaves, 1989, pp. 26–32). In a later interview, Smolan altered his position. "At some point the audience deserves to know," Smolan said, "whether or not [the cover picture] is something you caught on the fly or something either you created in the darkroom or created by setting it up" (Rosenberg, 1989, p. 47).

What if a newspaper editor decides that the front page or a section front is a sales tool that should be used to attract more readers? Such a philosophy would send computer retouchers scrambling to make front-page news photographs as visually dramatic as possible. *Arizona Republic*'s art director, Howard Finberg sees the danger of eager editors who might "clean up photographs as they might clean up grammar in a quote." "I know who runs the newspaper and it's not the photographers," Finberg asserted. "It's the editor who has no visual literacy at all" who makes the retouching decisions (Rosenberg, 1989, p. 54).

Such editorial decisions have crept into the news photography divisions of newspapers. The *St. Louis Post-Dispatch* used a computer to remove a can of Diet Coke from a picture taken of a Pulitzer Prize winning photographer. *The Hartford Courant* (CT) used a computer to show readers what the downtown skyline would look like with a new skyscraper. The *Asbury Park Press* (NJ) ran an illustration that confused readers. For a health and fitness story, computer artists combined a picture of a cow eating hay with a studio set up of a salad. The *Orange County Register* (CA) changed a smog-filled sky into cloudless blue for an outdoor Olympics pho-

tograph and still won a Pulitzer Prize in 1984 for its coverage. Backshop personnel for the *Register* also mistakenly changed the color in a news picture. When vandals dyed a swimming pool red, the production staff, unaware of the news story, thought the water should be blue and used the computer accordingly (Lasica, 1989).

Publishers spend millions on computer retouching systems that may pressure art directors to show some results. However, most newspaper editorial departments have adopted policies for the use of the computer. Since the Coke can incident, the motto at the *St. Louis Post-Dispatch* is "If you don't do it in the darkroom, don't do it in the system." But despite the best of intentions, abuses still occur. *Chicago Tribune* associate design director, Judie Anderson, says, "We do not do anything to alter a photograph unless it's absolutely necessary." Nevertheless, she admits, "If there are blemishes on somebody's skin that do detract, then we may do something" (Chaney, 1989, p. 17). Hopefully, Anderson will not put Oprah Winfrey's head on that person's body.

Editors of *TV Guide* provoked intense professional criticism when editors borrowed Ann-Margret's body for a cover portrait of Oprah Winfrey. However, such a technique is not new. See the "President Lincoln" composite on page 97 (photo courtesy of Toby Massey).

In 1981, Sony was the first company to introduce a film-less camera, the Mavica. Because the image quality was low, most experts viewed the camera as an expensive toy (see Morse, 1987). Since 1981 however, improvements have been made. The ProMavica camera with a 2-inch, reusable floppy disk can record 25 frames of still video images and time-compressed FM audio sounds at a higher degree of quality. Nikon, Canon, and Kodak also have still video cameras with transmission and computer-recording devices that can send images via telephone lines to a photo editor's computer terminal. Scitex, Crosfield, and Hell are leading manufacturers of digital retouching and pre-press electronic scanning devices used by newspaper and magazine art directors.

Reproduction quality and price are barriers to widespread acceptance of the new technology. A computerized image is composed of tiny dots, called *pixels* or *picture elements*. A high quality video image typically contains approximately 380,000 pixels. Kodak has manufactured a floppy disk that can record 1.4 million pixels. With high definition television (HDTV) systems, the pixel count can be raised to 2.2 million. But computer technology is far behind traditional film resolution standards. Typically, a medium resolution film product contains over 18 million pixels. The computer storage capability necessary for saving pictures increases enormously in direct proportion to the resolution.

Optical disk technology has the capability to record high resolution video images at the fraction of the cost of traditional floppy disk recording devices. There is little doubt that by the new century, photographers and editors will commonly use still video cameras and computer terminals to record, manipulate, and save images.

Steve Stroud demonstrates the Scitex pre-press picture scanning device (photo courtesy of Presstime/*Chicago Tribune*).

There is an increasing trend in using television images for newspaper reproduction. When only television cameras have recorded an important news event, Polaroid and other print technologies can capture a video image with a "Frame Grabber" for use in a publication. Newspaper publishers may sign licensing agreements with cable operators to use still images captured with this technology. Although the quality of the reproduced picture is not as high as with traditional film products, the images are certainly good enough to print. Why send photographers to an important news or sporting event when an editor can "grab" pictures off a television screen?

On October 6, 1989, the NPPA published the first issue of *The Electronic Times,* an all-electronic newspaper. Digital and video cameras recorded images that were manipulated using computer scanner and pagination systems. The Associated Press recently announced its plan to supply member newspapers with picture receiving and editing computer stations. Students at the Rochester Institute of Technology produce a totally electronic publication, *E.s.p.r.i.t.* Electronic cameras, video, film and print scanners, and electronic darkroom software are available for students in the electronic still photography program run by Associate Professor, Douglas Ford Rea. Darkrooms will soon turn into lightrooms as photographers move out into the newsrooms ("AP darkroom," 1990).

TELEVISION MANIPULATIONS

Television news organizations, on the 50th year since the introduction of the medium at the New York's World Fair, are not immune to simulation criticism. NBC's "Unsolved Mysteries" and "Yesterday, Today and Tomorrow"; CBS' "Saturday Evening with Connie Chung"; and Fox Broadcasting's "America's Most Wanted" and "A Current Affair" are programs that have all mixed real news with re-enactments of events. The loudest opposition to news simulations came when ABC's "World News Tonight" aired a re-enacted segment depicting Felix Bloch, the U.S. diplomat under investigation for spying, handing a briefcase filled with secrets to an enemy agent. Sam Donaldson, a senior correspondent for ABC, told the Associated Press that viewers could be easily mislead by the film to believe "that they had actually seen the event. [But] they didn't. They didn't see that at all." Peter Jennings apologized for the failure of ABC to properly and promptly label the film as a simulation with, "We're sorry if anyone was mislead and we'll try to see that it doesn't happen again" (Strothers, 1989, p. 25).

Because of the criticism, some changes have been announced by news executives. Roone Arledge, president of ABC News said that since the Bloch simulation, anything done out of the ordinary must receive the approval of the president or his assistant. However, ABC's "20/20" later used a re-enacted scene that was screened by executives, of a private detective rummaging through a garbage can looking for evidence. Arledge defended the film with, "It didn't confuse anyone. Everyone knew we weren't actually there when he was first going through the garbage." Arledge then admitted, "I don't know if I would have it done that way, though" (Goldman, 1989, p. A-4). NBC announced that it would "stop its use of controversial news re-creations and shift the only one of its programs that uses the technique

from the news to the entertainment division" ("NBC puts," 1989, p. A-4).

Subject manipulations are an unfortunate necessity for television videographers. Photojournalists and reporters are faced with demanding deadlines often exasperated by the trend toward live newscasts by local stations. Professional video cameras need a tripod for static pictures. Additional lighting is often required for high quality illumination. Vans that contain a satellite link with the newsroom sometimes need a specially trained technician to operate the elaborate broadcasting system. Most on-the-air broadcasts show interviews between reporters and a subject. Consequently, technical and subject constraints combine to produce a televised report that is at best, not spontaneous and at worse, rehearsed. Videographers can compare themselves to the press photographers of the 1940s and 1950s who also produced set up images due to their technological constraints. With the advent of small, handheld, high quality video cameras, television reports may become more candid as happened with newspaper and magazine photography with the introduction of handheld still cameras.

FUTURE THREATS TO CREDIBILITY

In an article for *American Photographer,* Dr. Willi Heimsohm (1982) described a scenario in which editors played with history with their computer. Heimsohm detailed a faked assassination, made possible through computer technology, of Colonel Muammar Kaddafi of Libya for a fictitious publication. The hypothetical situation, although far-fetched, can be considered the ultimate fear of professionals. The re-creation is reminiscent of a quote from George Orwell's (1949), *1984:* "There were the huge printing shops with their sub-editors, their typography experts, and their elaborately equipped studios for the faking of photographs" (p. 43).

Photographs, particularly those used as accurate and trustworthy accounts of a significant event by respected publications, are our best hedge against the threat of devious editors and special interest groups who want to change truth and history. If the manipulation of photographs is accepted for any image, the public will naturally doubt all photographs and text within the publication.

At the very least, readers should be informed that an editorial image has been altered. For example, Jim Dooley, photo editor/chief for *Newsday,* was careful to let the readers know that a fashion feature picture was a "photo-illustration with a caption that said a model with clothes" (Fitzgerald, 1988, p. 34). Such a disclaimer does not always help a reader understand a complicated computer procedure. Nancy Tobin, the design director for the *Asbury Park Press,* explained that the cow and salad illustration was labeled, "composite photo illustration, but some people were left scratching their heads" (Lasica, 1989, p. 24). With the price of digitizing equipment getting so low that editors for corporation newsletters can afford to manipulate images, the temptation to combine pictures without readers being notified will be great.[1]

[1] "Digital Darkroom" and "Image Studio," for example, are digital retouching software programs for Macintosh computers that sell for under $500.

Because of the new technologies, photographers may have limited input over the use of their pictures. The digital transmission of images, recently demonstrated during the Olympic games and national political conventions, allows a photographer to instantly send a digitized color negative directly to the computer terminal of the photography editor across a city or across the world via telephone transmission. Although telephone transmission of photographic images has been a common practice for many years, the photographer has always been able to print the picture the way he or she thought it should look. The photo editor was only able to crop the picture to fit into the space on the newspaper's page. When the picture is sent to a computer, the photo editor can crop, but also dodge, burn, correct the color, elimi-

Brian Horton poses with the AP Leaf Picture Desk (photo courtesy of Associated Press/Susan Clark).

nate distracting elements, flop, and combine images from separate photographs. Editors are even capable of sharpening blurred or out-of-focus pictures (Hesterman, 1988).

When computer-digitized transmissions become common, staff photographers may have as much say over picture selection and use as freelance photographers or television videographers who frequently transmit live images via satellites without an opportunity to edit their work. Such a trend would conflict with *Houston Post* staff photographer Craig Hartley (1983), who wrote that the "photojournalist must be responsible for his or her actions in the field and at the publication" (p. 304). It would be difficult for a photographer to discuss a controversial image with an editor over the telephone.

Beverly Bethune (1983), in a national survey of photographers, reported that newspaper photojournalists listed "input into photo use, layout, etc." as a major factor that defined job satisfaction. "Photographers," wrote Bethune, "who said they have a strong voice in making photo decisions that affected their work as it appeared in their papers were generally more satisfied overall than photographers with voices less strong. They are happier, then, when they have a say in how their work is used" (pp. 27–28). Computer transmission technology could take away that job satisfaction requirement.

Freelance photographers have been the first group affected by computer technology. A picture agency, The Image Bank, offers their best-selling transparencies on videodisc to their clients throughout the world. Jim Mostyn, president of The Image Bank/Chicago, predicted that "within the next 10 years, all photography will be viewed and transmitted electronically." As detailed in *Photomethods,* "special software offers image masking capabilities which enable clients to combine elements from many different photographs to form one image" (Thall, 1988). A photographer's style, established over a lifetime of experience, will be lost once pictures are fabricated on a computer. Furthermore, if for example, 30% of one picture and 70% of a picture from another photographer are used to make a third image, how is payment divided between the two shooters? Does the art director/computer operator get a percentage? How are copyrights for the created image assigned?

As much as it is possible, photographers should be consulted if a news picture is controversial. When discussion is not possible, written guidelines for such use, strictly adhered to by the editor, would be appropriate.

After all is said and done, the photojournalist is still left with the question, should all forms of subject and picture manipulations be banned, or are exceptions acceptable? For many writers, the choice is simple. J. D. Lasica (1989) features editor and columnist for the *Sacramento Bee* wrote in an article titled, "Photographs that Lie," that "the 1980s may be the last decade in which photos could be considered evidence of anything." Director of photography for the *Sacramento Bee,* George Wedding, also warned, "The photograph as we know it, as a record of fact, may no longer in fact be that in three or five years" (Lasica, 1989, p. 22). Brian Steffans, a graphics photography editor at the *Los Angeles Times* pointed out, "You've got to rely on people's ethics. That's not much different from relying on the reporter's words. You don't cheat just because the technology is available" (p. 25). In a column titled, "Troubles with re-creating news," William Strothers (1989) wrote that "There is no substitute for truth. Viewers and readers expect that when we give them the news we are telling the truth as best as we can determine it. We may not

always get it right, but we try. We can't make up for lack of truth by re-enacting the event the way we think it ought to be" (p. 25). Finally, John Long (1989), of the *Hartford Courant* and former president of the NPPA, wrote:

> Each day when you step out onto the street, remember that you have been granted a sacred trust to be truthful. You have the responsibility to produce only honest images. You have no right to set up pictures; you have no right to stage the news; you have no right to distort the facts. Your fellow citizens trust you. If you destroy the credibility of your work, even in small ways, it destroys the credibility of your newspaper or TV station in the eyes of the people you are covering. (pp. 13–14)

As demonstrated by the many examples in this chapter, photographic truth is an elusive, often subjective, concept. Generally speaking, whenever the Hedonistic philosophy is put into play, the truthfulness of an image suffers. Personal presumptions about how a subject's story should be told, concerns for clean, photographic compositions, deadline pressure panic, unreasonable demands from an editor, layout efficiency, a cover picture's eye-catching ability, and political, religious or personal beliefs can all demean the credibility of the photograph, the photographer, and the publication. Let a truth based on sound, journalism principles be your guiding philosophy. When an objective truth is put first, photographs and the stories behind them can be easily defended and are a source for humanistic concern and inspiration.

Chapter 7
Other Issues of Concern

Ethical concerns are more common conversational topics among news personnel than in past years. A discussion of ethics among journalists moves photographers from a mob of "animals" who are only concerned for their next contest-winning picture to a fraternity of professionals who deeply care about their rights as journalists and the public they serve.

There are several miscellaneous issues that photojournalists regularly face that do not fit into the neat and ordered categories of victims of violence, rights to privacy, and picture manipulations. Nevertheless, when a photographer is confronted with one of them, the ethical problems the issues pose can be equally troubling for photographers and editors.

In responses to surveys, telephone interviews, and within the pages of *News Photographer,* photojournalists bring up at least 20 issues that occasionally cause them trouble. The topics in no particular order are as follows:

- Police/press relations,
- job-related stress,
- proper dress,
- helping or taking a picture,
- objectivity,
- the use of hidden cameras,
- office politics,
- accepting gifts,
- nude subjects,
- deadline pressures,
- photo packs and pools,

- obeying minor traffic laws,
- encouraging violence with presence,
- misrepresentation,
- contest pressure,
- comical, obscene, or offensive subjects,
- inaccurate caption information,
- children shown playing unsafely,
- covering hazardous assignments, and
- context-excluded images.

At first glance, the 20 miscellaneous issues do not seem to be related. But they can be divided into three areas: organizational, photographer, and reader concerns.

ORGANIZATIONAL CONCERNS

The pressure to produce attention-grabbing, award-winning, and technically pleasing pictures on a daily basis causes a whole host of problems between editors and photographers. When a newspaper organization emphasizes photography contests as a way to give raises and promotions, but does not give photographers time to adequately work on assignments, the mix can lead to ethical troubles.

The combination of contests and deadline pressures can lead photographers to take unethical actions they might not attempt at a more relaxed organization. The use of hidden cameras and other misrepresentation techniques might be justified. A photographer might remain a cool, detached, objective journalist who is happy to let a situation become visually dramatic and not help a subject in physical trouble. Other, less objective photographers may encourage subjects to become more violent during a demonstration so that dramatic pictures can be taken. The photojournalists might rush to the scene of a news event and break minor traffic laws. Such an action might cause trouble between the photographer and the police resulting in film confiscation and arrest. Trying to get a competitive edge over another photographer may actually result, when many photographers cover the same event in a photo pack, in all shooters using the same lens and camera angle. Creativity suffers when every photographer is afraid of missing what some other photographer may have. Trying to get a picture in a hurry, a photographer might inaccurately report names and other facts for the caption. Finally, shooting for contest wins while being pressured by editors to produce those images quickly, results in strained relationships in the office and even stress-related illnesses.

In order to take pictures of young, tired children working with dangerous machinery in factories, Lewis Hine at the turn of the century, regularly misrepresented himself. He would tell the foreman of a factory that he was working for the company and needed to take pictures within the plant. Other times, he would simply hide his bulky view camera under a large overcoat and sneak into the factory. He justified his actions with the Utilitarianism philosophy. Although it may be wrong to falsely represent himself, the greater injustice was the exploitation of children. More recently, journalists have used the same philosophy to justify their questionable actions.

Lewis Hine often misrepresented himself or hid his camera in order to take pictures of children working in factories (photo courtesy of International Museum of Photography at George Eastman House).

A famous misrepresentation/hidden camera case is the Mirage Tavern story by the *Chicago Sun-Times*. Photographers hid in a secret compartment above a bathroom and photographed reporters giving bribes to corrupt city inspection officials. Pamela Zekman, the principal reporter for the project, does not support such techniques in a private home, but thinks "it to be an acceptable technique in a public place, like the Mirage" (Goodwin, 1987, p. 188).

Freelance photographer, J. Ross Baughman's Pulitzer Prize winning photographs of Rhodesian soldiers torturing their victims were withdrawn from the Overseas Press Club (OPC) competition because of "so many unresolved questions about their authenticity." Baughman, who has infiltrated Nazi and Ku Klux Klan groups in the United States "had worn a Rhodesian soldier's uniform, carried a gun and

joined a Rhodesian cavalry patrol for two weeks in order to get the pictures." John Durniak, picture editor for *Time* magazine and a member of the OPC stated that "the jury felt the pictures had been posed" ("Pulitzer photos," 1978, p. 5). When a photographer misrepresents him or herself and becomes a participant to violent actions, credibility should be severely questioned.

Persons would change their actions, especially if they were involved in a criminal activity, if they knew a photographer were capturing their movements. Therefore, the use of long and hidden lenses are sometimes justified. Former president of NPPA, Bill Sanders admitted that if "a city official was using city trucks and work crews for personal jobs" it would be acceptable to use hidden cameras in public places (Goodwin, 1987, p. 189). Editors and photographers need to weigh the public's right to know against the paper's need for credible news practices that can be defended.

A Minneapolis *Star Tribune* reader criticized photographer Stormi Greener for taking a picture of a mother spanking her child that was part of a story on a family near "the edge of serious abuse" of their children. "Greener," the reader wrote, "could have helped her wash a dish, bathe a child, buy groceries for the week. The mother needed some help . . . not the documentation of her treatment of those poor kids on film."

Greener admitted that she could have easily helped the family by giving money to the mother. "But our story," Greener explained, "was not about a journalist coming to the aid of the family. My job was to take an honest look at a family in a struggle. I was guilt-ridden and frustrated with the ethics that I had to live with, [but] the first rule of journalism is to divorce yourself from your subject . . . and do nothing but document and record. . . ." Would Greener have dropped her objectivity principle if the mother was severely beating her child? Greener asserted that had the mother abused the child, she would have intervened (Cunningham, 1989, p. 8).

The principle of objectivity is valued among the journalism profession. But taken to its extreme can result in the loss of a subject's life when help could have easily been rendered. Bill Murphy of the *Oregon Journal* tried his best to be a compassionate journalist. While trying to convince a man not to leap from a bridge, Murphy also took pictures. Unfortunately, he was unsuccessful in his attempts to convince the man not to jump. The man leaped to his death. Murphy was severely criticized by readers who asked why he took pictures instead of helping. Despite admitting that "I did all I could," he was in agony over his decision.

Cecil Andrews Protests Unemployment

Greener and Murphy know there are limits to a journalist's strict interpretation of the objectivity principle. Two television news journalists did not set such limits. The two recorded on videotape an obviously distraught man who set himself on fire. They hid behind the principle of objectivity to justify capturing a dramatic piece of news film that their station did not even put on the air.

Cecil Andrews was an unemployed roofer in the small town of Jacksonville, Alabama (Gordon, 1983, pp. 11–17). He called the TV station late in the evening and said he would set himself on fire to protest unemployment in America. Ron

Simmons and his part-time assistant, Gary Harris, who thought Andrews sounded intoxicated, made several calls to the police warning them about Andrews and where to meet him. Andrews, Simmons, and Harris met in a dark, downtown park. Simmons was concerned that he could not see any police officials. If they were hiding in the bushes, he thought he could signal them by turning on his camera light. But when he did, Andrews squeezed charcoal lighter fluid on his pants leg, made several attempts with matches to light the spot, and eventually started a small flame. For over 30 seconds, the camera crew let the flame grow higher before an attempt was made to put out the fire. By that time, the fire was out of control. Andrews started running across the park, his body a terrifying ball of flame. Luckily, a volunteer fireman with an extinguisher was there to save Andrews' life. Andrews survived with severe injuries. He later filed a $4 million suit against the television news crew.

On national television news shows, special reports, and on front pages of newspapers across the country, the story was reported—not the story of Cecil Andrews

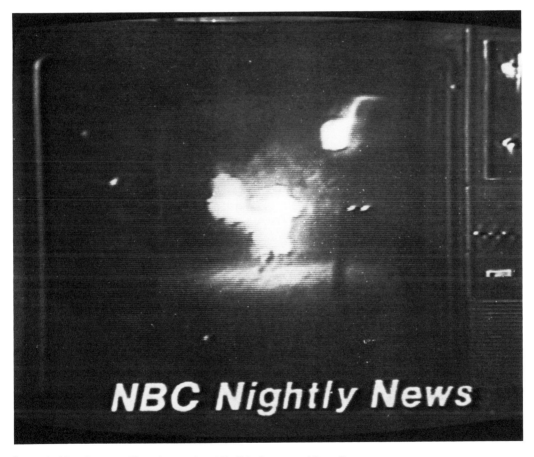

Some television viewers could watch unemployed Cecil Andrews run while on fire because of the inaction by two objective journalists (photo courtesy of *News Photographer*).

protesting unemployment, but the story of two journalists who watched a man trying to kill himself. Typical of the response from the media was a *Time* magazine story that called the camera crew's actions a "gruesome result of lapses in communication and judgment."

The situation brings to mind Malcolm Browne's coverage of a Buddhist monk who set himself on fire to protest the Diem regime's crackdown on his religion. Newspaper editorial writers at the time "maintained that the newsmen should have intervened." The media is often criticized for contributing to the violence they cover. Journalists noticed that Iranian students outside the American Embassy in Tehran during the hostage crisis in 1979 only yelled their insults against America when the red lights of the television cameras were lit. The police chief of Jacksonville, Alabama summed up the popular opinion when he told the Associated Press that "I'm not trying to condemn the news media but it's a fact when you have lights and cameras that people are going to perform for the cameras" (Gordon, 1983, pp. 12–13).

Cecil Andrews would not have set himself on fire if no news personnel had shown up at the park. He orchestrated the photo opportunity, like any public relations person, to promote his cause. Andrews knew that the television reporters would be interested in a dramatic, eye-catching visual demonstration. One reason protest marchers for any issue carry signs is because they know that media personnel like to see highly visual slogans written on signs.

Two questions remain: If a journalist knows he or she is being manipulated by a subject, should the event be covered? and, Once a decision to cover the event is made, should a journalist step in to help a subject in physical trouble?

It seems unlikely that journalism will ever come to a point when it can resist being manipulated by subjects. Press conferences and White House photo opportunities are scheduled all the time to allow reporters access to governmental officials. Local organizers of craft and art fairs make it easy for photographers to cover their charitable events by giving information and schedules to editorial staffs. But during a demonstration, photographers can make sure that their presence does not contribute to the violence. A thoughtful photojournalist should watch the demonstrators closely, perhaps from a far vantage point. As more journalists with their cameras arrive at the scene, does the intensity level of the protestors seem to grow? Does a demonstrator ask to have his or her picture taken? If the protest occurs at night, do the protestors react to a camera's flash or a video camera's light? These are some questions you can ask yourself to help determine if the media's presence and not the issue is creating news. Unfortunately, when protestors and police are battling, no matter the contributing factors, it is a major news story that should be covered. Knowing what is and what is not news (as detailed in chapter 2) becomes extremely important in these situations. The arrest of many protestors is clearly news. The self-immolation of a possibly drunk individual is not news. But the fact that two videographers taped a man trying to kill himself instead of preventing the act, is news.

News Photographer magazine often reports stories of journalists putting away their cameras and helping people in trouble (see "Helping hands," 1983; "Shoot or help?," 1980; "Walkie-talkie," 1983). Ed Bradley of CBS rushed to rescue refugees

from Vietnam off the coast of Malaysia. Reporter Christine Wolff of the *Bradenton Herald* (FL) physically prevented a man from jumping off a bridge until state troopers arrived. Arriving at the scene of a serious car crash before emergency personnel, Cramer Gallimore of the Fayetteville, North Carolina *Observer-Times,* stopped the bleeding from a head wound of one of the drivers before he made pictures. At another assignment, Gallimore rushed into a burning apartment building to save the life of a hysterical woman. Photographer John Doman and writer Chuck Laszewski of the St. Paul, Minnesota *Pioneer Press* saved a woman from possible drowning. Doman used his portable radio to call the police for help.

Jeff Greenfield on ABC's "Nightline" program feels that journalists should always help a subject "where you as an individual have a direct possibility of stopping a life-threatening piece of behavior. Put down your pad and pencil, put down the camera; save the life. You can get the story later, if indeed there is a story" (Gordon, 1983, p. 17).

Police–Press Relations

One of the largest index sections in the NPPA directory (1989) is a list of stories in *News Photographer* on relationships between the press and the police. From 1978, over 45 articles have been published about the issue. Problems with the police typically result from overly anxious police officers, during an emotionally charged situation, who do not understand the reporting rights of journalists. Sometimes, however, a photographer exasperates the situation with an impolite or cavalier attitude (Adaskaveg, 1985, pp. 8–12).

One of the primary principles for journalists is the monitoring function. Reporters observe government officials to make sure individual rights are not violated. But when those officials do not want to be monitored, problems can result. Alec Costerus, a freelance photographer for the *Boston Globe,* AP, and UPI, was driving to his parents home in Marion, Massachusetts late one night. He saw a police car with its blue lights flashing and decided to stop. Costerus observed two teenagers suspected of driving while intoxicated being beaten up by the police officers. Costerus identified himself and started taking pictures. He was immediately arrested and charged with interfering with a police officer. Costerus was acquitted and he was eventually awarded $24,000 in damages, but that is not the important issue. From his case, guidelines were established by the Marion police department that stated "the mere presence of a photographer or reporter at an accident, crime or disaster scene, and the mere taking of pictures . . . relative to the incident do not, in themselves, constitute unlawful interference with police activity and should not be restricted" (Holland, 1989, p. 4). NPPA and Mark Hertzberg, regional director and photographer for the Racine, Wisconsin *Journal-Times,* drafted guidelines for police/press relations in 1981. The guidelines are meant to be "incorporated into a [police] department's training manual" (Guidelines, 1989, p. 36).

- journalists may not restrict, obstruct, or oppose an officer in the lawful execution of a legal duty;
- journalists may be asked to show their press credentials;
- journalists have the right to photograph events on public property;
- when permission is granted to enter private property, journalists should be peaceful and not cause damage;
- no journalist should be denied access on the basis of public safety;
- if access is ever denied to a news event, the reasons must be clearly explained by police officials;
- a police officer should not restrict a journalist from taking pictures or asking questions;
- police officers will not attempt to restrict any actions by journalists unless their actions are clearly interfering with an investigation;
- journalists apprehended for violating the law will be dealt with in the same manner as any other violator; and
- police officers should not pose, encourage, or discourage the photographing of suspects.

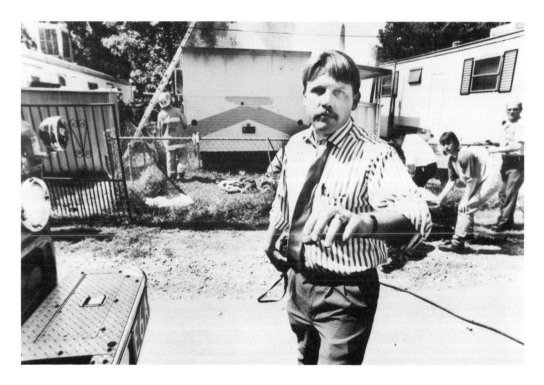

At the scene of a two-fatality trailer fire, Larry R. Erickson has his cameras taken by a sheriff's detective (photo by Larry R. Erickson/Photo News).

Despite NPPA's best wishes, photographers usually do not have good relationships with police personnel. Seminars and lectures explaining the roles of each group are helpful to create better understanding.

Photographers should respect the difficult jobs police officials have. That respect starts with obeying traffic and trespass laws. Photographers are divided on the issue. In a national survey, a photographer said that "Breaking any kind of law should be extremely unethical, although we all fudge a little bit on the accelerator. I will not park illegally as television vans do. But what do you do when you need close access and there is no parking?" A director of photography has a direct answer, "I feel very strongly that especially with regards to traffic laws all journalists should be accountable and not feel above the law" (Lester, 1989, p. 106).

At a news scene, photojournalists should be especially careful not to unduly upset victims or their families. Many problems with the police are a result of a photographer trying to get too close to a distressed subject. A police officer will often try to protect such an individual. Whenever possible, use long, telephoto lenses. Speak simply, directly, and politely to any police officer who asks you questions. If an officer gives you trouble, try to speak to his or her superior or save the issue for a later meeting with police officials after emotions have cooled. Remember that you may be right, but it is hard to take pictures while handcuffed.

Pack and Pool Photojournalism

Deadline and competitive pressures are blamed for contributing to pack journalism. Writers and photographers must produce meaningful stories and photographs within a narrowly defined time frame. As a result, journalists often ban together into a media mob so that no event, no matter how trivial, will be missed. The media was criticized for its coverage of the 1988 presidential campaign because journalists concentrated on photo opportunities orchestrated by campaign handlers instead of under-the-surface issues. Journalists need to break from the pack and find stories and pictures that are not a part of a handler's plan. The main story is not always what the candidate looks like when speaking to a crowd. Photographers need to observe quickly developing human interest moments that only occur outside the special press section next to the candidate's podium. Remember the maxim: Only hacks travel in packs.

When access to an assignment is unusually limited, photographers often find themselves members of a pool with reporters and videographers. In a photo pool, a photographer is allowed access to an important news event with the understanding that the pictures produced will be shared openly with other news organizations. The U.S. government was severely criticized by members of the journalism community when it barred reporters and photojournalists access during the invasion of Grenada. Consequently, photo pools were established during the invasion of Panama. The day following hurricane Hugo's rampage across South Carolina in 1989, Tom Fowler (1990) of the South Carolina Educational Television network provided news footage taken by a videographer in a government helicopter at courtesy credit to any news organization who wanted it. Because access to the South Carolina beaches by journalists was severely limited, the photo pool gave the public vital visual information that would otherwise been unknown.

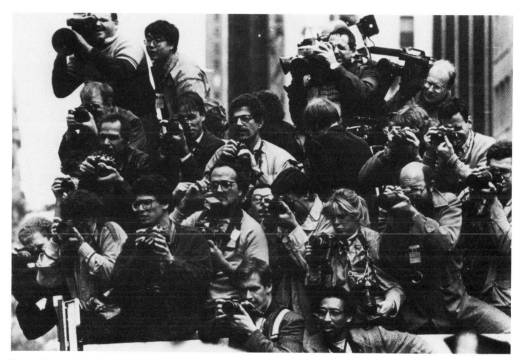

News photographers covering a presidential candidate in New York City form an intimidating photo pack (photo by Ley-Chyun Lin).

Photojournalists, especially freelance photographers, need to be sure that members of a pool are selected fairly. Although a pool of photographers were selected, a rescue picture of a man trapped in his car for 4 days after the 1989 earthquake in San Francisco was taken by one of the rescue workers. The picture was used in several newspapers, despite objections from members of the pool (personal communication, March 1990).

The Need for Accurate Captions

The verbal information that photographers gather during an assignment is as crucial to the reporting process as taking pictures. Facts, whether verbal or visual, need to be absolutely accurate. When a photographer misspells a person's name or juggles the order of participants in a group portrait by mistake, the result can be embarrassing, but not serious. But if a major fact is wrong, the result can be devastating. Photographs of the family of teacher-in-space, Christa McAuliffe were mislabeled in the captions. Three photographers thought they were taking pictures of the family reacting to the shuttle's explosion. The pictures all show what could easily be interpreted as a family reacting to an extremely stressful moment—the death of their loved one. There is open-mouth screaming, crying, and hugging among the family

The family of teacher and astronaut Christa McAuliffe react to the shuttle's lift-off
and not to its explosion as stated in the original caption (photo by Jim Cole/Asso-
ciated Press/Wide World Photos).

members. The subjects in the pictures, however, are simply animately reacting to
the shuttle's lift-off.

Jim Cole, an AP stringer, summed up the feelings of the photographers involved
in the caption controversy. "Obviously this mistake has caused me considerable and
personal anguish. While it will always be my loss, I hope photographers and editors
will be able to profit from my experience" ("Photographers' caption," 1986). Either
as a result of deadline pressure that prevented a thorough investigation of the facts or
heat-of-the-moment concentration that ignored important details, photographers
must be sure that they remain calm and accurate reporters.

Pressure from Contests

Contests are often blamed for contributing to an atmosphere of hectic competition among staff photographers. Competition can be healthy. It encourages all involved to produce their best work. But when competition is combined with an emphasis on contests, unethical actions can sometimes result.

In a national survey of 157 newspaper editors, "most newspapers . . . had policies, usually informal, that encourages prize seeking." It was also found that most editors encourage their reporters to enter contests (Coulson, 1988). As with competition, contests can be positive. Photographers in another national survey generally agreed that contests can improve a shooter's output. "We're probably the only profession with such an emphasis on awards. However, it does allow us to measure ourselves and our work against others in the rest of the country," wrote one photographer. Another photojournalist wrote that contests "improve the quality of photos by providing good examples to younger shooters." A third photographer made the point that "In many ways competition helps improve quality over the years, but photographing grief is usually done simply to get a clip winner" (Lester, 1989, p. 110). Another valuable function of contests is that the winners are published in

Students in a beginning photojournalism class view newspaper clippings photographers have entered in a monthly contest (photo by Michael Laughlin).

News Photographer and other magazines, along with the stories behind them. The problem with contests is that their results are often inconsistent. Judging is often subjective with few but the winners satisfied. Judges select contest winners for a variety of reasons. Most picture prizes, it is hoped, are given on the basis of good journalism. But judges sometimes let personal likes and dislikes, personality conflicts among judges, and simple fatigue sway results. Although the size of the picture and the reproduction quality of tearsheets are overlooked in competitions, judges do not always follow that mandate. Judges in the Pictures of the Year contest are typically asked to select winners out of over 36,000 photographs and tearsheets. It is an exhausting task. Good pictures sometimes fall through the cracks.

When a photography staff emphasizes contests as raise and promotion requirements, the politics within the department can become critical. Friction between photographers and editors often results when photographs are cropped, used small, and on an inside page despite a photographer's recommendations. Photographers know that a larger size will influence some contest judges. Photographers will complain when other staff members get better assignments. Instead of sharing information and helping one another, photographers become secretive and jealous. Editors should never require photographers to enter contests. Likewise, raises and promotions should be decided on the contribution the photographer has made to the community by a consistent body of solid photojournalism. Editors, those who are familiar with a photographer's work, should make crucial career decisions and not judges who view only a small sample.

An ideal competition would be a monthly clip contest in which first, second, and third places are chosen for the assignment categories by judges outside the photographers' region. A monthly publication would immediately publish the judges' results and comments. Technical and background information from the photographers would also be included. No points would be awarded as no end-of-the-year winner would be selected. Such a contest would award a photographer's effort, let others know what content is most respected by members of the profession, and relieve much of the stress associated with traditional contests.

Stressful Assignments Take Their Toll

Too many deadlines, contests, and gruesome assignments can be dangerous to a photographer's mental and physical health. Photojournalism is a highly stressful profession. Besides the everyday life stresses that all must face, photojournalists must also deal with picture demands from editors and writers, technical decisions that determine proper exposure and coverage, assignment schedules that are sometimes vague or conflict with other events, and subjects that are uncooperative, grieving, or dead. Within a few years on the job, a photojournalist learns all the ways people die—drownings, car and plane crashes, murders, and many mind-numbing accidents. And as with others who witness such dreadful events—police, fire and ambulance workers, nurses, and doctors—post-traumatic stress disorder (PTSD) or "battle fatigue" effects photojournalists as well. When a victim is a small child or a person the photographer knows or can relate to, the impact can be devastating.

A newspaper writer described the personality of emergency rescue workers. The description could easily fit most photographers:

Emergency-service workers tend to be perfectionists; they have an eye for detail and enjoy taking risks. Typically highly dedicated, they want to set things right and hate to take no for an answer. They often develop a false sense of security—they have always tolerated the pressure, and assume they always will.

Those suffering from PTSD "may become depressed, refuse help, hallucinate, quit jobs and families, even kill themselves" (Spitzer & Franklin, 1988, p. E-4). A stressed photographer may also turn to alcohol and drugs as short-term relief.

Dr. Jeffery Mitchell, a University of Maryland psychologist, travels around the country setting up programs in local communities to help "paramedics, firefighters, and police officers cope with tragedies they see" (Salamone, 1988, p. B-1). Newspaper organizations need to recognize that PTSD is a condition that can be treated if diagnosed early enough. Photography editors must know how to recognize a staff photographer who exhibits symptoms of stress-related illnesses. Journalists should

Photographers must often photograph gruesome victims of violence, as in an automobile accident, that can lead to stress-related illnesses (photo by Paul Lester).

be included in group discussions for rescue workers that would not only help those who participate, but would foster appreciation of the problems both journalists and rescue personnel face. Editors need to give their photographers adequate time to complete assignments. Picture story deadlines, for example, need to be realistic. An in-depth lifestyle story cannot be accomplished in a few hours. If a photographer has a problem brought on by stress or any other factor, editors need to seek compassionate help for that valued employee.

Photographers need to be included early in discussions with editors and writers about stories. Photographers are often told to produce meaningful pictures in a few hours while a writer has been working on a series of articles for several months. Photographers need to realize that their whole world does not revolve around equipment and subject concerns. Strong personal relationships and interests unrelated to news photography make photographers more interesting, caring, and relaxed people. If a photographer feels the stress that the many pressures can apply, he or she should never hesitate to talk it over with a friend, colleague, or editor and seek professional help.

PHOTOGRAPHER CONCERNS

Covering Dangerous Assignments

Photographers are sometimes asked to cover assignments that can be hazardous to their health. Without proper training and safety equipment, photographers can be injured covering accident scenes where "unstable and reactive materials, corrosives, liquid, gas and solid flammables, toxics, explosives and radioactive materials" are present. Photographers can also be injured covering a demonstration that turns into a violent riot. Michael Green of the *Detroit News* gave advice to photojournalists covering dangerous assignments. "It's important to stop and think before going in to [a hazardous area]," Green warns. "It's also one time you might want to listen to the cops or authorities when they tell you not to stand some place or enter certain areas" ("Warning," 1986, pp. 7–11).

At an NPPA convention, Greg Lewis, a professor of journalism gave tips for covering an assignment that involves hazardous materials:

- when you first arrive at the scene, check with a police or fire commander for information about the hazardous materials;
- use a long lens;
- stay uphill and up wind;
- do not walk through or touch any liquid;
- green, yellow, or orange smoke indicates a chemical source;
- do not inhale smoke;
- toxic vapors can be odorless and tasteless;
- because of the danger of explosion from internal sparking, motor drives, flashes, and radio gear should not be carried to a flammable liquids fire;
- assume hazardous materials are involved at any industrial site; and
- if contaminated, seek immediate decontamination. ("Warning," 1986, p. 11)

A firefighter collapses while fighting an oil storage tank blaze. Photographers run
the risk of injury or death if they are not cautious when covering such assignments
(photo by Art Smith/*The Marietta Times*).

Time magazine photographer, Bill Pierce (1983), has covered combat zones in
troubled areas throughout the world. Pierce has had many photojournalist friends
killed and wounded photographing wars. His advice can be applied to newspaper
photographers covering violent events in their own communities.

- wear a flak jacket all the time;
- minimize equipment for quick movement;
- travel in pairs;
- know the language of the people you photograph;
- take pictures that show the cost on lives after the firing has stopped; and
- have clear, journalistic reasons why the violence should be documented. (p.
 126)

Editors have a responsibility for the safety of their personnel. Safety concerns
start with proper ventilation and handling of photographic materials (Tell, 1988).
Jim Jennings of the Lexington, Kentucky *Herald-Leader* said that covering the news
should not "take precedence over the safety of their personnel." An editor must
never put photographers "into a situation that is even remotely life-threatening"
("Warning," 1986, p. 10).

Personal Appearance as an Issue

For most assignments, dress and personal grooming is a matter of taste and professionalism and not a matter of ethics. But a photographer's ethics may be questioned if his or her appearance is inappropriate for an assignment. In a national survey, photographers were asked to voice their opinions about attending an assignment while improperly dressed. One photographer wrote, "You may come to work dressed for a sporting event and then be called to go on a different assignment. As long as your clothes are clean and not tacky you should be able to cover almost any assignment." Another respondent wrote, "If I wanted to wear a tie I'd work in a bank!" A third photographer said, "Oftentimes the scheduling of assignments precludes changing clothes. However, dressing appropriately for the assignment at hand is as important as other ethical concerns" (Lester, 1989, pp. 103–104).

The appearance issue was hotly debated in the late 1970s when the television show, "Lou Grant" was aired. Daryl Anderson played the sloppily dressed and unshaven, "Animal." Many news photographers objected to his appearance, but producers said that his character was based on real, West Coast photojournalists. Rich Clarkson, the former director of photography at *National Geographic,* said that photojournalists "dress and behave so poorly that they increasingly face restrictions in covering major news events." Photographers, Clarkson asserted, are roped off in out-of-the-way locations during sporting events, out-of-sight of television cameras and fans, because of their appearance (Sanders, 1986).

A photographer's appearance is never so critical as when a funeral is covered. Those on the scene judge a photographer's concern for the family by what the photographer wears. Obviously, cut-off blue jeans and a t-shirt is inappropriate attire, but photographers have been known to cover such events wearing not much more. Photographers should have a coat and a tie or a nice blouse and a skirt in their car in case they are needed for an unexpected assignment. Mark Hertzberg wrote that "Dress is an important part of the way the public perceives us and in their acceptance of us in times of stress. I think many of us can dress better day-to-day without having to wear a three-piece suit" ("Photographers give," 1986, p. 24). During a sensitive assignment, if a photographer is dressed neatly with a tie or skirt, the awkward job of taking pictures is made a little easier.

Accepting free gifts from subjects can cause a reporter to lose his or her credibility. How can a photographer be an objective recorder of facts if money or gifts are changed hands? Richard Oppel, editor of the *Charlotte Observer,* (NC) recalled that when he was a young Associated Press reporter covering the Florida legislature, the press corps "accepted electric razors as gifts from Gov. Haydon Burns." Oppel said that "Even the sole woman correspondent got a lady Remington" (Vaughan, 1989, p. A-16).

Subjects sometimes hand out small gifts or amounts of money in the hope of buying loyalty or favoritism. Seldom is a gift given as a simple act of friendship. Journalists need to recognize the practice for what it is and not succumb to the temptation. A press junket, a trip organized by a corporation to show correspondents a new operation, can amount to a gift of thousands of dollars. The *Observer,* like many newspapers across the country, do not allow their reporters to accept anything for free from any source. Just as newspapers should pay for a movie critic's ticket and a food critic's meal, if a story is worth covering, the paper should pick up the entire tab for any writers or photographers.

Many photojournalists objected to the portrayal of the "Animal" character for the "Lou Grant" television show as being sloppy and unprofessional. Producers, however, stated that the character was based on real-life photographers (photo by Rick Meyer/*Los Angeles Times*).

One photographer said that "The gifts we are allowed to receive must not exceed $5 in value." A director of photography at a newspaper admitted that "if after the work has been published, a subject wants to offer something out of friendship, I will make a trade, offering prints." Photo sales is a common practice with newspaper photographers, but they should be handled by a business manager and not the individual photographers. Another director of photography said simply, "Company policy is we accept nothing" (Lester, 1989, p. 105).

Television journalist, Linda Ellerbee was severely criticized by journalism professionals for accepting a large amount of money to participate in a series of

television commercials for a coffee producer. Making paid, public endorsements for any product damages a journalist's credibility. As Loren Ghiglione, president of the American Society of Newspaper Editors said, "the public demands higher and higher standards from public officials, and journalists are feeling that too" (Vaughan, 1989, p. A-16).

READER CONCERNS

Nude or Embarrassing Images

Just as with gruesomely violent images that editors place on their front pages, embarrassing or obscene behavior by subjects caught with a camera, can produce a flood of mail from readers who object to the pictures. Editors need to be sensitive to the taste of readers, but not be guided exclusively by those changing standards.

Many editorial decisions are based on a publication's readership. London's Fleet street newspapers have a reputation for printing pictures of scantily clad, beach-strolling women. The New York *Daily News* often prints the same subject in its tabloid. Editors print these images because their readers expect to see them. Many

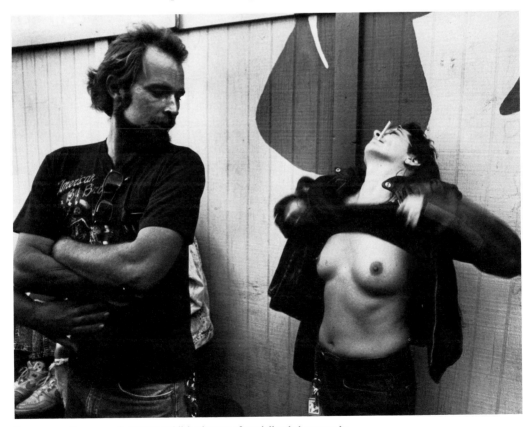

Newspaper editors are reluctant to publish pictures of partially clad women because most readers would object. A woman reveals her bare breasts during "Biker Week" at Daytona Beach, Florida (photo by Michael Laughlin).

readers would complain if the pictures were omitted. The same kind of pictures found within the vertical fold-out of *Playboy* magazine would never be considered by an editor of a "family-oriented" newspaper.

A college newspaper sometimes covers subjects that are not covered because of the acceptance level of readers. When running nude through college campuses, streaking, was popular in the late 1970s, college photographers regularly covered the over-exposed subjects. The *Daily Collegian,* the student newspaper for Pennsylvania State University, printed a bare-chested winner of a wet t-shirt contest. Kathleen Pavelko, columnist for the *Collegian,* wrote that the picture was printed not because of its nudity, "but as a student phenomenon and a possible trend on American college campuses. The contest was a slice of student life" (Goodwin, 1987, p. 218).

Hal Buell of the Associated Press admits that nudity is a delicate subject with readers. "We will not carry full frontal views of nude men or women except in a most extreme case," wrote Buell. "We will transmit pictures of bare bosoms when such pictures are pertinent to the story." A bare-chested protestor during the 1972 political convention in Miami, a topless woman on a beach in Denmark, and an opera soprano disrobing at the end of her aria are examples of AP wire transmissions. Yet most editors filed the pictures in a desk drawer rather than print the images in their community newspapers (Mallette, 1976, p. 75).

Don Black could not get his pictures published by his newspaper because editors were worried about shocking their readers. Black made pictures that showed a father delivering his own son. His pictures later ran in *People* magazine (Mallette, 1976, pp. 218–219).

Some newspapers stay away from pictures that show famous people looking silly or embarrassed. Many papers would not print pictures of President Ford who was caught tripping on several occasions by photographers. When presidential candidate, Edmund Muskie cried during a campaign, some editors did not print the picture. When President Reagan wiggled his fingers during a White House news photographers banquet, Rich Lipski of United Press International captured the gesture that many editors did not print ("Gotcha!," 1983).

One-finger gestures give editors more problems than Reagan's wriggling hands. Vice President Nelson Rockefeller was pictured by Don Black "giving the finger to Binghamton, N. Y. hecklers" in 1976. Harry Themal (1987) of the Wilmington, Delaware *Morning News-Journal,* recalled that editors were concerned that if Rockefeller's picture was published, children might "think it's all right to copy the gestures" (p. 11).

Themal was involved with another obscene gesture controversy at his newspaper. Ernest Parsons, a convicted double murderer, raised both of his middle fingers of his chained hands for Ronald Cortes' camera. The picture ran on the front page of the *Morning News-Journal.* Themal wrote that "The phone was already ringing as I stepped into the office. It didn't stop ringing for hours as caller after caller complained about the picture's being published on the front page." A man said that the picture was "absolutely tasteless. I found it embarrassing when my 7-year-old son brought in the paper and turned it to this picture. I've lost all respect for the newspaper." Another man said, "You shouldn't be glorifying an individual convicted of murder."

Although caught making an obscene gesture, many editors used the picture of
former Vice President Nelson Rockefeller responding to a crowd of hecklers (photo
by Don Black/*Binghamton Press* and *Sun-Bulletin*).

As an answer to the readers' wrath, editor Donald Brandt said that "the gesture is
not as obscene as the crime of which Parsons was found guilty . . . the photo made
an eloquent statement about the obscenity of the crime." Managing editor, Norm
Lockman said that the picture "showed Parsons utter contempt for society. It of-
fends us, too, but our photographer's depiction of this anti-social behavior says
volumes about this man" (p. 10).

Context-Excluded Images

Michael Smith, photo director for the *Detroit Free Press,* was accused of glorifying
a drug dealer by readers because of a photograph that was printed. Richard Carter,
reputed to be one of Detroit's major cocaine dealers, was shot to death in a hospital
bed. He was buried in a $16,000 casket "customized to look like a Mercedes-
Benz—complete with wheels, grill and headlights." George Waldman made a
picture of Carter that showed his body lying in the open casket. Although some

readers objected to seeing a corpse, most complained that the picture glorified the drug dealer. Smith said that the picture "says a lot about the drug culture in Detroit in 1988." Reader representative, Joe Grimm (1989) admitted that the picture did not make it clear enough that the casket "symbolized unabashed arrogance and ignorance of drug dealers who have contributed greatly to Detroit's toll of young shooting victims" (p. 31). The context of a picture, explained in a story or column, will diffuse much of the protest about a controversial picture.

AIDS research and care are highly emotionally charged issues. When covering the AIDS story, photographers usually concentrate their efforts on those unfortunate individuals who are close to death. Alon Reininger has traveled the world for many years to document the AIDS crisis. His portrait of Ken Meeks, who died shortly after the picture was taken, shows a man sitting in a wheelchair, lesions covering his arms, and staring at the camera with a hauntingly vacant look ("150 years," 1989).

During Nicholas Nixon's Museum of Modern Art show where he presented his work, "People with AIDS," a protest group handed out fliers. The flier stated that photographers who portray the emancipated bodies of AIDS victims show "people to be pitied or feared, as people alone and lonely." The gallery exhibit "perpetuates general misconceptions about AIDS without addressing the realities of those of us living every day with the crisis."

Many readers complained that the newspaper was glorifying the life of a drug dealer by publishing this picture (*Detroit Free Press* photo by George Waldman, September 17, 1988).

According to the New York activist group, ACT UP, the reality of a life with AIDS is more optimistic, but less visually dramatic. Because of "experimental drug treatments, [and] better information about nutrition and holistic care," AIDS patients are living longer (Grover, 1989).

Editors should never publish shocking pictures for their shock value alone. No responsible editor would contemplate such an action. The days when a publisher can make a large amount of money with a sensational picture on the front page are long over. Publishers reveal that a newspaper's profits are made from selling advertising, not papers. If anything, such a dependence would cause editors to be more conservative in their picture choices so as not to offend advertisers. Don Black and other photographers worry that editors are, in fact, too timid when it comes to pictures and stories that might shock or offend some readers. "Failing to run an important news picture for fear of reader response," Black says, "is indulging in a form of censorship" (Goodwin, 1987, p. 219). The public never learns the whole truth, however, when graphically visual images are devoid of a fuller context.

Images of Children in Dangerous Situations

Occasionally, an editor will hear complaints from readers who object to the showing of children playing unsafely. Human interest pictures of children jumping from a

Editors run the risk of reader wrath if they print pictures of children playing unsafely (photo by Paul Lester/*The Times-Picayune*).

second floor window onto several stacked mattresses, playing with fire or guns, or floating on hand-made rafts on a river, might give editors problems. The Florida Supreme Court recently ruled that a soft drink company "is not liable for damages suffered by a teenager who broke his neck and was paralyzed when he copied a stunt he saw in a Mountain Dew television commercial" (Van Gieson, 1989, p. D-9). The ruling could probably be applied to a parent's lawsuit if a child was injured copying an unsafe act printed in the newspaper. Responsible editors, however, will avoid such tragic confrontations.

EDITORS LIST THEIR ETHICAL CONCERNS

Bill Phillips (personal communication, March 27, 1990), director of photography and Bill Dunn, managing editor of *The Orlando Sentinel,* have come up with 16 areas of sensitivity "that should raise a flag on all desks—though not an automatic signal to kill." The 16 subject categories that might give picture editors trouble include:

- body shots,
- gore,
- grief,
- the physically and mentally afflicted,
- vulgar gestures,
- cheesecake and beefcake,
- otherwise sexually offensive pictures (includes see-through and sexy fashion photography),
- racial or ethnic stereotypes (includes those that inflame),
- pictures that embarrass or ridicule,
- invasion of privacy,
- trespass,
- posing news pictures,
- mechanically manipulated images,
- kids doing dangerous things,
- juveniles being arrested, and
- dead animals.

Inevitably, there will be other, unique issues that will test the ethics of photographers and editors. With a solid and sure philosophical foundation, an understanding of the many conflicting opinions, and an emphasis on journalistic credibility, decisions can be defended with confidence.

Chapter 8
Juggling Journalism and Humanism

A MURDER/SUICIDE INVOKES SIX PHILOSOPHIES

In the October 1989 issue of *FineLine,* editor Robin Hughes (1989) described a news picture that sparked controversy at the *Louisville Courier-Journal.* In "Anatomy of a Newspaper's Decision," Hughes reported editor and reader reactions to a staff photographer's photograph. The medium-distance picture shows an unidentified victim of a shooting spree by a disgruntled employee of a printing plant. The gunman killed 8 and wounded 12 with his AK-47 military assault rifle before he turned a pistol on himself.

The picture by staff photographer Durell Hall Jr. shows a victim lying on his back with arms outstretched. The image had been described by an editor as "a photo that had to be used" and by a reader as "obscene." The newspaper received more than 580 calls and letters, most opposed to the picture's use on the front page. The victim's family filed a suit "alleging that the newspaper intentionally and recklessly inflicted mental distress on the family and that publication of the photo was an invasion of their privacy." Several weeks later the suit was dismissed.

Although not invoked by name, editors and readers used all six of the major philosophies to support their positions. C. Thomas Hardin, photo and graphics editor, most likely used the Categorical Imperative philosophy to defend his printing of the image. When Hardin saw the picture, he knew that it was "a photo that had to be used. In 25 years, I don't remember a situation in our coverage area where an event was so tragic or public." Hardin continued, "Coupled with the national debate on automatic weapons, the use of the photo was validated." Hardin used the journalism principle of newsworthiness. A dramatic, local tragedy combined with a national concern for gun control, compels the editor to use the picture.

The Utilitarianism philosophy was probably voiced by the editor and two readers as a justification for printing the disturbing picture. Editor David Hawpe said that

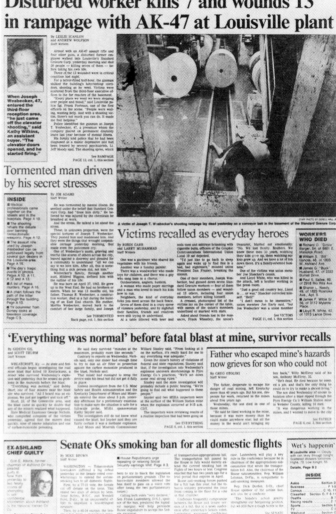

The front page of the *Courier-Journal* newspaper in Louisville confronted morning readers with the news of a tragedy in their community (photo courtesy of *The Courier-Journal*).

one of the reasons the picture was published was "the need to confront readers in our community with the full consequences of gun violence." Don Frazier, president of the Graphics Communications International Union, called the picture "obscene" and "was shocked to see it." he later conceded that "maybe the picture did raise the consciousness of some about gun violence like [the editor] said he meant to do." A widow of one of the victims wrote, "I would want people to remember that my husband died violently—senselessly—and I don't want anyone to forget it." All

three positions indicated that the public at large is served by the picture's powerful message.

Editors could have selected a less graphically violent picture for the front page, a largely Golden Mean position. Instead, the Categorical Imperative philosophy most often prevailed. "The photo did what I wanted it to do by showing the reality of what assault weapons are capable of," said Hawpe. "A less graphic photograph would not have been as effective."

Readers opposed to the picture were just as sure that their positions were correct. The Veil of Ignorance was probably invoked by a caller who asked, "How would you feel if it was your relative's body?" Most readers used the Golden Rule philosophy. One caller said, "Showing a body is in bad taste and insensitive to the victim's family and friends." Another man said, "I kept thinking what's this going to do to his family? Why did they have to show his face? They could at least put a shirt or a sheet over him."

Hawpe admitted that some callers "thought we ran the photo just to sell newspapers." Such a reaction comes from believing the publisher is guided only by Hedonistic concerns.

The editors should have known that reader protests would be harsh. Six of the requirements for a reader firestorm, detailed in chapter 4, had been met. The picture came from a staff photographer, was a local story, was printed on the front page, in the morning paper, and showed the victim's physically traumatized body.

Your own reaction to the photograph depends on your own ethical orientation. You might think that the picture is an example of hard-hitting journalism and tells the story well. On the other hand, you may feel that the photograph is much too gruesome to be published in a newspaper. Which reaction is correct?

WHAT IS YOUR ETHICAL PERSPECTIVE?

A photojournalist who believes in the principles of telling the truth, objectivity, and newsworthiness will take pictures at the scene no matter how gruesome the subject matter may be. If a journalist relies on professional principles alone, however, there is a danger that a subject might be exploited.

A photojournalist who believes that victims of violence should be left to bear their grief privately without the prying eye of a camera's lens will not take pictures at a funeral or accident scene. If a journalist relies solely on humanistic concerns, however, readers will be denied information that is perhaps in their interest to know.

A photojournalist who believes that the sensitivity of readers should be a first consideration will not publish such pictures. Newspaper readers never complain about gruesome pictures that are not published. However, a journalist runs the risk of filling the publication with "happy talk" features.

An exploration of a photographer's ethical philosophy helps to decide the best course of action during a controversial assignment. Unfortunately, a survey of editors and reporters found that out of 153 respondents, only one referred to a "formal system of ethics outside the profession—Christianity" when responding to ethical situations (Mills, 1983).

Stress Results in Burnout

A photographer who shoots too many stressful assignments that conflict with an ethical philosophy runs the risk of catching career burnout. About 14 photographers were included in a survey of Ohio journalists. More than 36% of the 252 journalists sampled "had suffered from burnout, either at present or in the past" (Endres, 1988, p. 9).

Many excellent and caring photographers have left the profession because of job-related stress. In a *News Photographer* article, Jerry Gay, a 1975 Pulitzer Prize award winner said that there is a need for balance in a photographer's life. A photographer concerned only for the next award-winning picture becomes, according to Gay, "insensitive to other people and their feelings, especially at home. 'They stop being people and start being as mechanical as their winder' " (Hertzberg, 1979, p. 12).

Editors and photographers should work together to reduce one cause of stress—contests. The importance of photographic competitions for raises and promotions should be greatly reduced. A monthly clip contest in which first, second, and third places are chosen without points being awarded would relieve much of the stress associated with traditional contests. Such a contest would award a photographer's effort and let others know what content is most respected by members of the profession.

In other fields, job stress receives ample publicity with company-sponsored support programs. The NPPA and media organizations should recognize the problems that come from stress and offer support groups to all journalists.

If a particular assignment violates a photographer's ethical code, photographers should have the right to bow out gracefully. Some shooters are best at taking sports or feature assignments. Other photographers have worked for the coroner's office and enjoy driving around town listening to the squawk of a police and fire radio scanner. A photographer should not have to cover an assignment that makes him or her uncomfortable. No reasonable editor will force a photographer to take a picture that is against a photographer's ethical philosophy. Such a statement should be a part of the NPPA Code of Ethics.

NEW TECHNOLOGICAL CONCERNS

When photographers and editors are asked to list their ethical concerns for the future, a dominant issue is the manipulation of subjects or images through computer, stage managing, or darkroom techniques. If a documentary photograph is altered through computer or more ordinary means, or if a subject is stage managed by the photographer, the publication has a responsibility to its readers to inform them of the manipulation. Computer manipulation cannot be detected by an unsuspecting and trusting public. A photojournalist who believes in high ethical standards will not manipulate a subject even slightly. For once a minor manipulation occurs, ethical principles fall like a house of cards. Soon the photographer will justify writing words on feet, double printing, lying about a subject's location, and moving pyramids.

A STRENGTHENED ETHICS CODE

In the journalism profession, unlike the legal or medical professions, there is a problem of enforcement. Although a photographer is often criticized and sometimes fired for a blatantly unethical violation, he or she cannot be barred from the profession. The NPPA should have a committee for the ethics of photojournalism. The committee would sponsor research, publications, lectures and workshops that would help spread positive ethical behavior. The committee could also investigate instances of questionable ethics with the power to censure offenders. An unethical photographer could be banned from entering the monthly clip contest for a determined number of months or even banned from the NPPA. The public could then be informed that such behavior is unacceptable and not representative of the membership as a whole.

The "Code of Ethics" that all members of the NPPA must sign should include additional sentences:

- No photojournalist will intentionally add to a victim's grief for monetary or award-winning gains.
- No photojournalist will intentionally violate a subject's privacy for monetary or award-winning gains.
- No photojournalist will intentionally stage manage a subject or use traditional darkroom or computer technology to alter the meaning of an editorial picture.
- No editor will use traditional darkroom or computer technology to alter the meaning of an editorial picture.
- No editor will subject a photojournalist to the pressure of forced contest participation.
- No editor will demand that a photographer take a picture that is against that photojournalist's personal ethical code.

The new ethics code should be printed and sent to all members of the NPPA. The time has come for photojournalists to re-dedicate themselves to ethical behavior by signing the new code.

Despite the renewed interest in ethical issues, there is evidence that the profession has a way to go. In a survey mailed to managing editors of newspapers across America, the respondents were asked to rank order the test elements given to prospective reporters. The top two test concerns were spelling and grammar. Ethical considerations were at the bottom of the list. Only 15% of the editors reported that "their tests contained material of an ethical nature" (Gwin, 1988, p. 104). Ethical issues need to be higher in the minds of those who hire journalists.

It is the duty of photographers with more experience to advocate ethical ideals to students and those new to the photojournalism profession. It is not enough to say that because ethical behavior is an individual decision, photojournalism ethics cannot be taught. Ethical behavior is taught by helping a photographer understand the underlying philosophies that shape a decision, by the ideals contained in a Code of Ethics, and through a discussion of specific situations.

The goal of a photojournalism ethics discussion is not to make right and wrong rules for every conceivable situation. Such a goal is not possible. Real situations are as complex as life itself and the responses are equally infinite. The goal is to help make sure that evaluations of photographers' actions are generally in agreement. When there is disagreement, the conflicting arguments should be based on sound ethical principles.

PHOTOJOURNALISM: A LESSON IN HUMANITY

A photojournalist is a mixture of a cool, detached professional and a sensitive, involved citizen. The taking of pictures is much more than F-stops and shutter speeds. The printing of pictures is much more than chemical temperatures and contrast grades. The publishing of pictures is much more than cropping and size decisions. A photojournalist must always be aware that the technical aspects of the photographic process are not the primary concerns.

A mother crying over the death of her daughter is not simply an image to be focused, a print to be made, and a picture to be published. The mother's grief is a lesson in humanity.

If the photojournalist produces a picture without a thought for her tragedy, the lesson is lost. But if the photographer cares for her loss, is made more humane, and causes the readers to share in her grief, photojournalism has reached its highest potential.

Despite its frustrations and low moments, the lesson of humanity is why photojournalism is an extremely rewarding profession. For that reason, photojournalism is worthy of the best thought and actions possible by its participants.

Appendix A: NPPA Code of Ethics

The National Press Photographers Association, a professional society dedicated to the advancement of photojournalism, acknowledges concern and respect for the public's natural-law right to freedom in searching for the truth and the right to be informed truthfully and completely about public events and the world in which we live.

We believe that no report can be complete if it is not possible to enhance and clarify the meaning of words. We believe that pictures, whether used to depict news events as they actually happen, illustrate news that has happened or to help explain anything of public interest, are an indispensable means of keeping people accurately informed; that they help all people, young and old, to better understand any subject in the public domain.

Believing the foregoing we recognize and acknowledge that photojournalists should at all times maintain the highest standards of ethical conduct in serving the public interest. To that end the National Press Photographers Association sets forth the following Code of Ethics which is subscribed to by all of its members:

1. The practice of photojournalism, both as a science and art, is worthy of the very best thought and effort of those who enter into it as a profession.
2. Photojournalism affords an opportunity to serve the public that is equalled by few other vocations and all members of the profession should strive by example and influence to maintain high standards of ethical conduct free of mercenary considerations of any kind.
3. It is the individual responsibility of every photojournalist at all times to strive for pictures that report truthfully, honestly and objectively.
4. Business promotion in its many forms is essential, but untrue statements of any nature are not worthy of a professional photojournalist and we severely condemn any such practice.
5. It is our duty to encourage and assist all members of our profession, individually and collectively, so that the quality of photojournalism may constantly be raised to higher standards.
6. Is is the duty of every photojournalist to work to preserve all freedom-of-the-press rights recognized by law and to work to protect and expand freedom-of-access to all sources of news and visual information.
7. Our standards of business dealings, ambitions and relations shall have in them a note of sympathy for our common humanity and shall always require us to take into consideration our highest duties as members of society. In every situation in our business life, in every responsibility that comes before us, our chief thought shall be to fulfill that responsibility and discharge that duty so that when each of us is finished we shall have endeavored to lift the level of human ideals and achievement higher than we found it.
8. No Code of Ethics can prejudge every situation, thus common sense and good judgement are required in applying ethical principles.

Appendix B:
Toward a Philosophy of Research in Photojournalism Ethics

Rich Beckman
University of North Carolina

The research path in photojournalism ethics is neither straight nor narrow. It is strewn with pitfalls so large that sound methodology alone cannot be your guide. The purpose of this discourse is to help you avoid the primordial ooze that awaits unsuspecting researchers who venture out unprepared into the field of photojournalism ethics.

Is There Ever a Definitive Right or Wrong?

This is always a dilemma for ethicists and should be for researchers. Your moral judgment may be right for you or your newspaper, but it is wrong to deduce that your moral judgment, or that of your survey pool, is ever right for everyone. It is therefore particularly important to qualify your conclusions based on the demographics of your pool. This is a particular problem in photojournalism research because often the situation in question will involve more than one person and therefore more than one perspective. The photographer may feel he or she acted in an ethical manner, yet the subject might feel that the photographer acted unethically. The real problem is that they may both be right.

Have You Considered the External Influences and Circumstances?

This can be a particular problem when you are doing research in areas of print journalism. When you are judging a photograph or having others judge a photograph, are you judging the ethics of the photographer or the ethics of the picture editor? What policies guide the photographer and who decided to publish the picture in question? Has the photographer been told to photograph everything possible and leave the editing and ethics decisions to the editor? How should a photographer react to this directive? Was the photographer influenced by the actions of the competing newspaper's photographer who took a similar picture? Can you, the researcher, make a sound decision about the photographer's behavior when you were not at the scene and have not experienced the mood and external influences that may have guided the photographer to take or not take a certain picture? Does it matter when the picture was taken? Did the photographer make a decision to take the picture

rather than to help the subject or did the photographer take the picture after the rescue squad had already arrived? What about unpublished pictures? If an editor decides that a picture should not run, does that absolve the photographer of questionable ethical practices? Part of the researcher's role is to sort through this maze before bringing the issue forward for debate. There are numerous examples in the literature of researchers who failed to present adequate information about an event to allow their survey participants to offer an educated opinion.

Are You Using a Consistent and Quantifiable Measurement Scale?

Are there degrees of ethical behavior? Is it fair to ask your respondents to judge a particular set of circumstances as highly ethical versus ethical or as a numerical value on an ethical scale of 1–10? Is it even necessary to attempt to quantify your results or can the researcher draw adequate conclusions from answers to open-ended questions? I don't believe something can be highly ethical or barely ethical and I have never seen an adequate set of definitions which differentiates between degrees of ethical behavior. If you plan to use such a scale, be certain to include definitions of your categories.

Is It Valid to Generalize the Specific?

Some researchers examine actual events but generalize them within their study or survey. The question will read "A photographer is photographing the victims of a car accident" or "A photographer crosses a police line." This assumes that all car accidents are the same or that all police departments treat photographers the same way. This type of generalized research can be valid, but the results should not be applied to any specific occurrence, even the one the original questions may have been derived from. Perhaps we need to include a research docudrama disclaimer, "the study is based on actual events, but . . ."

Have You Tested for Cultural Bias?

What influences have had a part in formulating the ethical standards of the participants you are studying and the members of your survey subject pool? If I was raised in the city and you were raised in a rural area; if I were raised as a Catholic and you were raised as a Baptist; if I grew up in Brazil and you grew up in Brooklyn; if I was a child of the 1960s and you were a child of the 1980s; if my father was a policeman and your father was a journalist; how might these external factors influence our ethical views? Some or all of these, as well as other socioeconomic and demographic statistics, may skew our data. How do we know we have an unbiased pool if we do not even know what things influence our ethical decision-making processes? It may be important to modify how you measure for bias in a survey or interview pool. Do you need to know where your subjects fall on a societal scale of ethical/unethical behavior? Do you need to pretest every subject and then factor their ethics rating against their responses? Although it is not possible to account for every possible

cultural bias that your pool may contain, it is your responsibility, as a researcher, to subject your study to the greatest possible rigor.

What Do We Hope to Accomplish by Doing Research in Photojournalism Ethics?

The best we can hope for, in my opinion, is to identify issues that should be brought forth for debate and discussion. Most photojournalists and picture editors receive their ethics training on deadline and may not have the time or historical perspective necessary to appropriately address the complexities of the situation. There is more to ethics than "use your best judgment" although many publications use this directive with their photographers. The researcher's role is not to hand down judgments from his or her ivory tower, but to lend historical and philosophical perspectives to the arguments, gather data that supports or questions hypotheses, ask new questions about old beliefs, and interpret the results of research as it applies to the existing body of knowledge and the norms of the profession.

A REVIEW OF SELECTED LITERATURE

The ethical behavior of photographers and the use of their images has been a topic of debate for many years. In 1890, in *The American Annual of Photography and Photographic Almanac,* Henry Harrison Suplee wrote an article entitled "The Ethics of Hand Cameras" in which he advocated resistance to the nuisance of uninvited public snapshooting and in 1899 in the *American Journal of Photography* there is an article entitled "The Casuistry of Photographic Ethics" that discusses how snapshooters invaded the privacy of others in public places.

Much of the recent literature is case-study oriented and relies on expert opinion rather than quantifiable data. There have been attempts to research areas involving visual ethics that use traditional communication research methodologies. These studies form a foundation for additional research that will help decision makers formulate policy and judge individual images and events. The following review provides an insight into the available source materials for practitioners and researchers. They are included for your consideration and to demonstrate potential areas of disagreement when researching this field.

One of the best sources for juried research articles on visual ethics is the semiannual *Journal of Mass Media Ethics* that began publication in 1986. Articles on visual ethics appear regularly and the fourth issue of the *Journal,* published in Spring/Summer 1987, was a special issue on photojournalism ethics.

Journal of Mass Media Ethics
Vol. 1, No. 1
Fall/Winter 1985–86

"Codes Should Address Exploitation of Grief by Photographers"
George E. Padgett

Summary

The author argues that the media has no right to bring moments of private grief to the public forum of the newspaper page or evening newscast. The article points a finger at organizations that award these pictures with the field's highest honors, including the Pulitzer Prize, and the failure of present media codes of ethics to adequately provide adequate guidelines for dealing with grief situations.

The author warns that "if the press does not clean up its act relative to the issue of privacy, the courts may decide to step in at some point in the not-too-distant future. While there is no precedent for the regulation of grief exploitation as an invasion of privacy, the vehicle for doing so already exists in common law privacy. A sub-section of privacy law prevents the publication of private matters, particularly when such publication violates ordinary decencies."

Comment

I agree with many of the author's complaints and every editor, reporter, and photographer should read this article. I am still not convinced, however, that the answer lies in any one code of ethics or any one set of rules. For example, the author believes that "the pain and tears of those who survived (the 1984 California McDonald's massacre) had no place in the national news" and that "while the massacre at Beirut was news of national and international significance as were those American soldiers whose lives were lost, the funeral services and the tears of family members were not."

I would argue that the tears of the living are a more potent weapon against the wrongs of society than the blood of the dead. I would argue that the pictures from California might serve to convince my readers that the importing and manufacturing of semi-automatic weapons should be banned. I would argue that those servicemen belonged to all Americans and that my readers wanted to be at the funeral services and share in that grief, if only through a picture. I would argue that it is usually not the presence of the media at the event as much as it is the irresponsible behavior of one or more members of the media at the event that causes the problem.

There are, no doubt, photojournalists who invade the privacy of their subject's grief, who make sensitive situations worse and who give the profession a black eye. But there are also many photojournalists who are sensitive, caring human beings, who struggle with the ethics of their profession and have shed many a sympathetic tear after a difficult assignment.

Every grief situation is different. No one guideline will cover them all. We should continue to discuss these situations in our papers, and at our universities and seminars in order to establish precedents that will help guide us to be responsible journalists who are sensitive to our subjects and honest with our readers.

Journal of Mass Media Ethics (special issue on photojournalism ethics)
Vol. 2, No. 2
Spring/Summer 1987

"Video Ethics: The Dilemma of Value Balancing"
Robert Steele

Summary

This article resulted from a participant–observation study at two anonymous major-market television stations for 2½ months. The writer immersed himself in the day-to-day activities of local television news gathering and dissemination. He conducted in-depth, private, taped interviews with many photojournalists and journalists about their work, their attitudes, and their ethical beliefs. The thrust of the study was to gain insight into the structure of ethical reasoning.

Comment

This study provides an interesting look into the psyche of the television news photographer and explores some of the value judgments he or she faces while shooting on location. The researcher attempts to categorize certain patterns of ethical reasoning under such labels as veil of ignorance and utilitarianism and to isolate influences that cause certain behavior patterns, including an interesting overview of the role of competition, peer pressure, and the role of producers. This study is a good overview of the issues and provides future researchers with numerous paths to explore.

The author concludes that the individuals he interacted with were generally acting in ways they felt were ethical. Researchers who wish to expand on this study should be wary of the participant–observation methodology. Even unethical subjects might tend to act ethically when working under the researcher's microscope.

"TV News Photographer as Equipment: A Response"
Jeffrey Marks

Summary

This article is written in response to the study in the Steele article just discussed. It is a call for the inclusion of the photojournalist as an equal member of the production team so that his or her voice can be heard in the editorial decision-making processes.

Comment

The premises of this response are that photojournalists are usually not as well educated through formal schooling as reporters and that managers often treat photographers as pieces of equipment and fail to include them in the ethical decision-making process. Although these are presented under the subhead "A Few Generalities," it would have been helpful to footnote them to some quantitative data. The recommendations that the author provides to rectify this situation are excellent and

should be considered by station managers, regardless of whether their staff demographics parallel the author's profile.

"Coalesce or Collide?
Ethics, Technology, and TV Journalism 1991"
Don E. Tomlinson

Summary

This article explores how new technology, particularly pixel manipulation and digital sound sampling, could open the field of journalism to a new genre of electronic ethics violations. The author explores the motivating factors of advocacy journalism, competition, career advancement, and ego gratification through four fictional case studies as driving forces toward the questionable use of these new technologies.

Comment

It is interesting that this article could now be re-written to replace each of the fictitious case studies with actual ones. This is true not only for the broadcast industry that the author explores but for the still photography industry as well. The once clear distinction between form and substance has indeed been blurred by technology as the author states.

I would have preferred if the author had also included a discussion within the article on positive influences that might result from these technologies. It is also important to remember that these are not new ethical dilemmas, it is just becoming technically easier to trip into the existing ethical pitfalls. The article is a little hard to read because of the overabundance of quotes within the text, many of which could have been paraphrased or left for the "Notes" at the conclusion of the article.

"Ten-Fifty P.I.:
Emotion and the Photographer's Role"
Gary Bryant

Summary

This article presents the personal feelings, insights, and techniques of a newspaper staff photographer who covers spot news events as a regular part of his job. He discusses the credibility of the media, the perceived insensitivity of photojournalists at news scenes, the importance of news photographs as historical documents and teaching tools, and the societal good that has come the publication of many spot news pictures.

Comment

The value of this article is that it demonstrates how much thought photojournalists actually give to the ethics of spot news coverage. It belies the hard core, emotionless image of the news photographer and demonstrates that a camera is not always an impenetrable emotional shield.

I would argue with the author when he states "I feel that we, the press and photojournalists, have done a very good job in educating the public about our job roles and our viewpoint." In most markets this is still not true. Many newspapers have not developed effective channels of communication for their readers and the educational role of the newspaper ombudsman is often not well defined.

"Digital Retouching:
Is There a Place For It In Newspaper Photography?"
Shiela Reaves

Summary

The author attempts to design an early framework for the discussion of ethical problems brought about by the advent of digital retouching technology. Representatives from *The Register* (Santa Anna, CA), *The Chicago Tribune,* and *USA Today,* and three former presidents of the National Press Photographers Association, Gary Settle, C. Thomas Hardin, and Rich Clarkson were interviewed for this article.

The subjects agreed that any manipulation of news photographs would be unethical, but disagreed about using the technology on feature art and illustration. The article provides a glimpse of how the technology speeds up the production process and how newspapers are using it effectively without ethical violations.

Comment

The article is a good general discussion of the technology and successfully places a number of ethical questions before the reader. Unfortunately it fails to bring forth specific examples of questionable use of the technology for discussion by the panel of experts. The author briefly allows Rich Clarkson to defend the use of the technology to alter images in *National Geographic* but fails to solicit opinions from others about this controversial use of the technology.

The author also fails to adequately define the term *feature photograph*. In some cases it refers to photo illustrations and in others to the traditional definition of found moments. The text is hard to follow because of the constant intermixing of source people. It would have been better to let the reader learn the opinion of each expert rather than space short quotes throughout the article.

I also question the author's conclusion that, "Now anyone in any department of a newspaper could decide on changes in photographic images by simply having access to the computer system." This statement is an oversimplification of the digital retouching process and not a very realistic scenario.

"Against Photographic Deception"
Edwin Martin

Summary

This interpretive essay explores the subtleties of deception in photography and photojournalism. The author explores a variety of levels of viewer interpretation and photographic deception and concludes that any degree of direction on part of the photographer, when publishing within a context of expected truth, without a disclaimer, is a clear form of lying.

The essay compares numerous cinematic techniques to the working ethic of the photojournalist and argues that the symbolic implications of the photograph depend in part on what it is a photograph of—not simply on how it looks—and therefore depends on the literal accuracy of the print.

Comment

Although I do not totally agree with the author's strict literal interpretation of a photograph being dependent on its context or with his evaluation of the sophistication of the viewer, I do think this is an excellent article that should be required reading in this day of editorial illustrations and posed environmental portraiture.

I admire the author's quest for reality, but question whether any picture can meet his standards. Can a two-dimensional picture ever accurately convey reality? Can a camera, even with a normal lens, ever accurately replicate the spatial relationship of object as perceived by the human brain? Can any one moment captured on film convey to a viewer how the subject actually felt? I agree that directing is different than recording but I question whether newspapers should contain cinema verite freeze frames.

"Private Lives, Public Places:
Street Photography Ethics"
A. D. Coleman

Summary

This essay explores the author's personal ethical guidelines for street photography, which he defines as, "photographs made of people on the street or in other public places without the consent of the subject." It discusses the Clarence Arrington photograph by Gianfranco Gorgoni for the *New York Times* and relates to a photo opportunity that the author prevented from occurring.

The essay also explores, through example, the potential misuse and misrepresentation of stock photographs by publications seeking conceptual editorial illustrations.

Comment

The author's two examples effectively illustrate his point, but one involves a picture shot in a hospital, which is certainly not "street photography" and also not legal without permission and appropriate releases.

The author concludes by stating, "The assumption that you waive your rights to

control of your image and declare yourself to be free camera fodder by stepping out of your front door is an arrogance on the part of photographers; it has no legal basis. The excesses committed in its name are legion, and extreme." This is a statement that invites further research in this important ethical area.

"Dying on the Front Page:
Kent State and the Pulitzer Prize"
Lesley Wischmann

Summary

This essay by a friend of Jeff Miller, the victim pictured in John Filo's Pulitzer Prize winning spot news photo from Kent State, is an angry plea for photojournalists to consider the rights of the victims they photograph. The essay recalls the pain that this photograph has caused for the author and why she feels it misrepresents what actually happened. The author also includes comments from the victim's mother who disagrees with her opinion.

There is also discussion within the essay of other famous spot news photos that the author feels misrepresented actual events or that invaded the privacy of the moment and should not have been taken.

Comment

It is always important to consider the views of the reader, particularly those present at the scene of such events. It is also important to read the ethical views, as they relate to photojournalism, of a nonjournalist, nonacademic author, for it is all too easy to get lost in the cloak of professionalism.

Many photographs, however, are painful to look at, they are intended to be. I was very familiar with John Filo's photograph as a student at Ohio State University during the early 1970s. On May 4, many of my fellow journalism classmates and I would drive to Kent State to attend annual memorial services for the victims. That photograph was a meaningful symbol to us. It did not matter that Mary Vecchio was not a student or that she did not know the victim. It only mattered that she was a human being watching another human being who was murdered for what he believed.

I am certain that the pain of the author is real. But in this instance, I believe that the picture has served a greater good, and should have been published. The author also notes that the picture was used to advertise a television special on the shootings at Kent State and suggests that "exploitative photographs should never be used to advertise a product." This is an interesting question that deserves further discussion.

"News Photography and the Pornography of Grief"
Jennifer E. Brown

Summary

This article examines a variety of issues that relate to the shooting and publication of grief photographs. It explores the decision-making process in determining if a photo

is fit to print, the problem of photographic cliches, the treatment of local versus national and international news events, the victims' right to grieve privately, the effect of privacy law on the publication of grief photos, and how such photos fare in photojournalist competitions.

The author does not draw any specific conclusions on these issues other than that "every day, photographs must be evaluated anew, with photographers and editors considering the important elements of taste, privacy, and news value."

Comment

The author attempts to do too much in this overview. The issues are introduced and sometimes referenced with an applicable quote, but never discussed in sufficient detail to make a contribution to the existing body of knowledge.

Over 20 sources are referenced for this six-page study, which makes for a disjointed and difficult to read article. The author offers no interpretation of these numerous quotes and fails to state any hypothesis or conclusions. This report shows a lot of work, especially from an undergraduate student, but she would have been more successful had she been advised to choose one area to explore within this broad topic.

"Balancing Good News and Bad News:
An Ethical Obligation?"

Mary-Lou Galician
Steve Pasternack

Summary

As the introduction states, "this paper focuses on the ethical and moral implications of findings from the authors' national survey of television news directors' policies, practices, and perceptions of good/bad news."

The four major research areas in this survey are:

1. assessment of various mass media in terms of good news and bad news;
2. assessment of participants' own local television station practices regarding selection of good news and bad news;
3. whether established policies guide selection and presentation of good and bad news; and
4. perceptions about balance, newsworthiness, and effects of good news and bad news on television and whether broadcast journalists have an ethical obligation in the daily mix of good and bad news.

The paper follows a traditional research format that includes an introduction, the methodology, findings, and an extensive discussion.

Comment

As the authors note, the 31% return rate limits the generalizability of the results even though great care was taken to reduce bias within the sample.

The hypothesis of this study is that the ratio of bad news to good news on newscasts is greater than the actual societal ratio of such events and that this raises ethical and moral questions regarding the selection process. Unfortunately, the study revealed a large group of gatekeepers who do not consider these categories during the selection process and many who objected to the categorization of news along a good–bad scale.

The authors dismiss this view as reactive or defensive, but I think it deserves further study and discussion. I would have liked the authors to define the terms *good* and *bad* as they relate to news within this study. Is it good news if interest rates fall or does it depend on whether you are a borrower or an investor. I think we could agree on some events that are universally good or bad, but that we would also find a large number of news events that are universally ambiguous.

The question this study begets, which I am not prepared to answer, is whether researchers should apply quantitative methodologies to qualitative ethical questions.

"Consumer Magazines and Ethical Guidelines"
Vicki Hesterman

Summary

This study surveyed top-level management at 49 large-circulation consumer magazines in six areas of potential ethical conflict. The areas are:

1. freedom to choose editorial content without pressure from the advertising staff;
2. acceptability of set up photos or composite or fictional characters;
3. acceptability of gifts, tickets, and travel;
4. allowable outside activities for the editorial staff;
5. entering of nonjournalistic contests; and
6. acceptable means for obtaining a story.

The author notes, based on the survey results, that editors differ greatly in their interpretation of what is ethical and that "arriving at any kind of a common code for magazines with different purposes may be difficult."

Comment

The participants in this survey were promised anonymity. We know that news magazines were not included in the sample, but otherwise, we do not know anything about content or demographics, other than a rough estimate of average circulation. Without this information it is hard to judge the relevance of the data unless we are willing to assume that a uniform code of ethics should apply to all large consumer magazines regardless of content, communication goals, and audience demographics.

The answer to one question, however, should cause some raised eyebrows among visual communicators. When asked; "Do you ever publish photographs that are set up without labeling them as photo illustrations?"; only 50% of the participants answered "No, we only use actual shots." It is hard to interpret what this really means because that was the only negative response among the multiple choice answers. There should have been an answer "no" for people who use illustrations and label them correctly. In any case, 50% of the respondents use illustrations and do not label them as illustrations. Whether this is 100% of the publications that use illustrations as the survey reports or some smaller percentage, it is still a lot of people abusing the trust of their readers.

Journal of Mass Media Ethics
Vol. 3, No. 2
Fall, 1988

"Ethical Implications of Electronic Still Cameras
and Computer Digital Imaging in the
Print Media"
Douglas Parker

Summary

The author conducted interviews with 11 photographers, editors, and educators and complied them to formulate a discussion of ethical issues photojournalists face with the emergence of electronic still cameras and digital imaging.

The discussion focuses around five question areas outlined by the author:

1. Will manipulation of images increase?
2. Will still photographers become disillusioned with their profession and with editors?
3. Will still photographers have less input into what type of image appears in the paper?
4. Will the public's trust in newspapers decrease as manipulation of photos increases?
5. What will be the legal status of images that exist only in computers?

The article includes an explanation of the technology and discussion based on controversial examples of its use as well as theoretical areas of potential ethical conflict.

Comment

This is an excellent discussion by people in the field, many of whom already have access to the equipment, and have had to make ethical decisions about the extent to which they would use it.

The author concludes his article with a series of disturbing questions: "If the leading experts cannot agree on what is or is not ethical, what constitutes acceptable manipulation or enhancement? How will they be able to set standards for the next

generation when virtually all news gathering will be done electronically? The experts should draw the battle lines now, because the future is here . . ."

I believe this is the wrong attitude for our profession to take. The battle lines were drawn long before digital imaging and long before electronic still cameras. They were drawn long before the 35mm camera ever became the tool of the photojournalist. Technology does not create new ethical issues. The reader does not care if you spend 2 days or 2 minutes formulating a lie. It is still a lie and still a violation of their trust. The standards we have set and the issues that we argue will continue to evolve based on our actions and societal norms. There is no need to return to the mountain for a new set of commandments.

The Association for Education in Journalism and Mass Communication is an international association comprised of educators, universities, and affiliates. The organization's annual convention is an excellent forum for the discussion of issues in the field. During the past 20 years, many papers have dealt with the issue of visual ethics. The following list includes those papers that were sponsored or cosponsored by the Visual Communication Division or the Radio-Television Journalism News Division. More information may be available from the authors or from the Association's national office at the University of South Carolina. Many sessions have been recorded and are available on cassette tape.

AEJMC Convention Papers

1972

Research Paper Session
Presiding: Lorry E. Rytting, University of Utah
"Ethical Judgments About Selected Photojournalism Situations"
Fred Parrish, University of Florida

Invited Panel
"Government Pressures on Reporters and Editors"
Presiding: John Rider, Southern Illinois-Edwardsville
Panel: Roy M. Fisher, University of Missouri
 Theodore F. Koop, Radio, Television News Directors Association
 George Reedy, Marquette University

1973

Research Paper Session
Presiding: James Hoyt, University of Wisconsin
"Judging People in the News—Unconsciously: The Effects of Varying Camera Angles and Bodily Activity for Visuals"
Lee M. Mandell and Donald L. Shaw, University of North Carolina

1975

Professional Freedom and Responsibility Session
Presiding: Stephen Lamoreux, Colorado State University
"Professionalism in Photojournalism"
Perry Riddle, *Chicago Daily News*

Research Paper Session
Presiding: Stephen Lamoreux, Colorado State University
"Reader and Audience Reaction to Photos"
Robert E. Gilka, National Geographic Society

1977

Professional Freedom and Responsibility Session
Presiding: Perry Riddle, *Chicago Daily News*
"Press Responsibility: The News Photographer's Concern"
Sandra Eisert, *Washington Post*

Research Paper Session
Presiding: James Fosdick, University of Wisconsin-Madison
"The Questionable Photographic: A Study of J-School Students as Gatekeepers"
William Baxter and Rebecca Quarles, University of Georgia
"Women in Photojournalism: A Survey and Professionalization Comparison"
Karen Slattery, University of Wisconsin-Madison

1978

Research Paper Session
Presiding: William Baxter, University of Georgia
"Street Photography from the Subject's Viewpoint"
Emily Nottingham, Indiana University

Research Paper Session
Presiding: Dan Drew, University of Wisconsin-Madison
"Television and Terrorism: Professionalism Not Quite the Answer"
Herbert Terry, Indiana University

1979

Open Paper Session
James Fosdick, Presiding
"The Prying Eye: Ethics of Photojournalism"
Whitney R. Mundt and Joseph Broussard, Louisiana State University

Student Paper Session
Presiding: I. Wilmer Counts, Indiana University
"Farm Security Administration Photography: Propaganda or Documentary?"
Fred Stanfield, University of Georgia

1980

Research Paper Session
Presiding: Karin Ohrn, University of Iowa
"The Editor's Manipulation of Photographs: An Experimental Study of the Effects of Varying Production Methods"
James Fosdick and Pam Shoemaker, University of Wisconsin-Madison
"Ethical Issues for Photojournalists: A Comparative Study of the Perspectives of Journalism Students and Law Students"
Mary Remole and James Brown, University of Minnesota
Discussant: C. Zoe Smith, Marquette University

Research Paper Session
Presiding: John C. Doolittle, Indiana University
"Broadcast Executives' Attitudes Toward Fairness, Equal Time, Ascertainment, and Communications Act Revision"
James R. Smith, SUNY-New Paltz

Professional Freedom and Responsibility Session
Presiding: Bill Thorn, Marquette University
"The Professional Perspective of a Two-Time Pulitzer Prize Photographer"
Stanley Forman, *Boston Herald American*

Research Paper Session
Presiding: Rich Beckman, University of North Carolina-Chapel Hill
"A Crisis for Photographers: Clinton, Tennessee, 1956"
June Adamson, University of Tennessee
Discussant: James Fosdick, University of Wisconsin-Madison

Joint Session
Presiding: Charlene Brown, Indiana University
"The Right of Privacy vs. The Right to Gather News: Access to Records and Places"
Panelists: Aryeh Neier, NYU, Formerly, ACLU
 Dwight L. Teeter, University of Texas-Austin
 Michael Gartner, *Des Moines Register and Tribune*

1981

Mini-plenary Session
"Photographers' Access to News Events and the Courts"
Moderator: Rich Beckman, University of North Carolina-Chapel Hill
Panelists: Don Middlebrooks, Steel, Hector and Davis, Miami, FL
 William O. Seymour, NPPA and University of West Virginia
 Johannes F. Spreen, Sheriff, Oakland County

Research Paper Session
Presiding: C. Zoe Smith, Marquette University
"Changing in the Wording of Cutlines Fail to Reduce Photographs' Offensiveness"
Fred Fedler and Paul Hightower, University of Central Florida, and Tim Counts, University of South Florida

Teaching Standards Session
"Broadcast News Course Content: Techniques, Issues and Ethics"
James R. Smith, SUNY-New Paltz

1982

Mini-plenary Session
"Media Ethics in Hostage Situations"
Presiding: Sarah Toppins, University of Illinois
Speaker: T. Joseph Scanlon, Carleton

Mini-plenary Session
"Ethical and Legal Issues in Visual Communications"
Presiding: Carolyn Cline, University of Texas-Austin
Speakers: Sandra Eisert, *San Jose Mercury News*
 Michael Kautsch, University of Kansas
 Lorraine Reed, Council of Better Business Bureaus

Research Paper Session
"Viewer Response to Contrivance in Journalistic Photography"
Michael Diehl, University of Texas-Austin

Research Paper Session
Presiding: James A. Wollert, Memphis State University
"The Use of Anonymous Sources and Related Ethical Concerns in Journalism"
K. Tim Wulfemeyer, University of Hawaii-Manoa
"The Real-Life Referent as a Standard for News Perspective Bias"
Gretchen S. Barbatsis, Michigan State University

Teaching Session
"Teaching Students Ethics"
Presiding: Karin Ohrn, University of Iowa
Speakers: Sandra Eisert, *San Jose Mercury News*
 Will Counts, Indiana University

1983

Professional Freedom and Responsibility Session
"Legal and Ethical Considerations Concerning the Coverage of Mt. St. Helens
and Other Tragedies"
Presiding: C. Zoe Smith, Marquette University
Speakers: George Wedding, *San Jose Mercury News*
 Steve Small, *The Columbian*

Research Paper Session
"Newspaper Subscribers' Responses to Accident Photos: The Acceptance Level
Compared to Demographics, Death Anxiety, Fear of Death and State Anxiety"
James M. Roche, Indiana University

1984

Research Paper Session
Moderator: K. Tim Wulfemeyer, University of Hawaii-Manoa
"Factors of Believability of Television Newscasters"
Discussant: Tony Atwater, Michigan State University

1985

Research Paper Session
Moderator: Ken Kobre, University of Missouri-Columbia
"Photojournalism and the Infliction of Emotional Distress"
Michael Sherer, University of Nebraska
"Photography and Reality: A Matter of Ethics"
Julianne Newton, University of Texas-Austin

Teaching Standards Session
"Ethics in Photojournalism"
Tom Defayo, *The Commercial Appeal*, Memphis, TN

1986

Professional Freedom and Responsibility Session
"Ethics in Broadcast Journalism: Myths, Realities, Ideals"
Moderator: Donald McBride, South Dakota State University
Panelists: Doug Fox, WFAA-TV, Dallas, TX
 Tim Wulfemeyer, University of Hawaii-Manoa
 Bill Overman, KFDX-TV, Wichita Falls, TX
 Paula Walker, KOTV, Tulsa, OK

Professional Freedom and Responsibility
"Ethics in Broadcast Journalism: Deciding What's Right"
Moderator: John Broholm, University of Kansas

Research Paper Session
"TV News Directors and Photographers: Matters Professional"
Moderator: Dwight Jenson, Syracuse University

"Visual Excellence and Photographic Professionalism in Local Television News"
Conrad Smith and Tom Hubbard, Ohio State University
"Television News Directors' Attitudes toward 'Good News' and 'Bad News': A National Survey"
Mary-Lou Galician, Arizona State University and Steve Pasternack, New Mexico State University
"The Changing Profiles of Broadcast News Directors"
Vernon A. Stone, Southern Illinois University
Discussants: Tim Wulfemeyer, University of Hawaii-Manoa
 John C. Doolittle, American University
 Sandra H. Dickson, University of West Florida

Professional Freedom and Responsibility Session
"The Electronic Darkroom—Will It Digitize Ethics?"
Craig L. Denton, University of Utah

Research Paper Session
Moderator: Craig Denton, University of Utah
"Images of Democracy: An Analysis of Photos Published During and After
Argentine Military Rule"
Jeffrey A. John, Wright State University
Discussant: Ed Scheiner, Michigan State University

1987

Research Session
"Broadcast News—Issues and Ethics"
Presiding: John Doolittle, American University

"Gray Area in the Blue Skies"
Craig Mitchell Allen, Ohio University
Discussant: Max Ustler, University of Kansas
"R. Budd Dwyer: A Case Study in Newsroom Decision Making"
Patrick R. Parsons and William Smith, Pennsylvania State University
Discussant: Mark D. Harmon, Xavier College
"The Ferraro Financial Furor: How the Television Networks Covered It"
Jeanne M. Norton and Luther W. Sanders, University of Arkansas-Little Rock
Discussant: Tony Atwater, Michigan State University

Professional Freedom and Responsibility Session
"Ethics in Broadcast Journalism"
Presiding: Sarah Toppins, American University
Panel: John Spain, WBRZ-TV, Baton Rouge, LA
 Ernie Schultz, Radio-Television News Directors Association
 Tim Wulfemeyer, San Diego State University

Research Paper Session
"Clones, Codes and Conflicts of Interest in Cartooning: Cartoonists and Editors
Look at Ethics"
Presiding: Doug Covert, University of Evansville
Speakers: Daniel Rife, University of Alabama
 Donald Sneed, San Diego State University
 Roger Van Ommeren, South Dakota State University

"Portraits of a Public Suicide"
Robert L. Baker, Pennsylvania State University
Discussant: Tom Hubbard, Ohio State University

Professional Freedom and Responsibility Session
Invited Panel: "Responsibility and Field Work Procedures in Documentary Pho-
tography"
Presiding: J. B. Colson, University of Texas-Austin

"Community Documentation"
Michael Short, Documentary Photographer, Tarascan Indians, Mexico
"A Mainstream Small Town in Northern Mexico"
Julie Newton, University of Texas-Austin
"Transitions in Cowboy and Oil Cultures in West Texas"
Rick Williams, Documentary Photographer, Albany, TX

1988

Special Topics Session
"The Teaching of Photojournalism Ethics"
Paul Lester, University of Central Florida
Discussant: Rich Beckman, University of North Carolina

Research Paper Session
"Ideology and Press Photographs: A Framework for Analysis"
Keith Kenney, Michigan State University
"Gender Stereotypes in Sports Photographs"
Wayne Wanta and Dawn Legett, University of Texas-Austin

Mini-plenary Session
"Native Americans and the Press: Accurate Coverage or Stereotype?"
Presiding: Sharon Murphy, Marquette University
Speakers: Frank Blythe, Native American Public Broadcasting Consortium, Lincoln, NE
Richard LaCourse, LaCourse Communications, Yakima, WA
Mark Trahant, *The Arizona Republic*, Phoenix, AZ
Armstrong Wiggins, Indian Law Resource Center, Washington, DC

Invited Panel
"After Dwyer: Sensitivity in News Photography, a Year Later"
Presiding: Robert L. Baker, Pennsylvania State University
Speakers: James Vesely, *Sacramento Union*, and former chairman, APME
Photojournalism Committee
John Hall, *The Oregonian*

Mini-plenary Session
"Covering the Candidates: Private Lives of Public People"
Presiding: William L. Winter, American Press Institute
Panel: John Jacobs, *San Francisco Examiner*
Rollin Post, KRON-TV, San Francisco
Michael Traugott, The Gallop Organization and the University of Michigan

1989

Refereed Paper Session
Presiding: Sandra Utt, Memphis State University
"Still-Video Photography: Tomorrow's Electronic Cameras in the Hands of Today's Photojournalists"
Kurt Foss and Robert Kahan, University of Missouri

Refereed Paper Session
Presiding: Judith M. Buddenbaum, Colorado State University
"Digital Imaging Technology is More Than Meets the Eye: The Promise and
Perils of Easy Manipulation of News Photos"
Danal Terry and Dominic L. Lasorsa, University of Texas-Austin

Refereed Paper Session
Presiding: Tony Rimmer, California State University-Fullerton
"What's Ethical and What's Not in Electronic Journalism: Perceptions of News
Directors"
K. Tim Wulfemeyer, San Diego State University
Discussant: James D. Harless, Ohio State University

1990

Invited Panel
Presiding: Michael Murrie, Southern Illinois-Carbondale
"Who Owns the Pictures?"
Tom Bier, Chairman, Radio Television News Directors Association
Tom Bitney, Manager, News Graphics, Minneapolis *Star-Tribune*
Steve Blum, CONUS Communications, Minneapolis
Steve Murphy, News Director, WOWT-TV, Omaha, NE

Mini-Plenary
Moderator: Nancy Green, president/publisher, *Springfield News-Leader*
"When Hell Breaks Loose—Crises We All Share"
Nancy Sharp, Fiona Chew, Joan Deppa, Lynne Flocke, Dona Hayes, Frances
Plude and Maria Russell, Syracuse University
Marion Lowenstein, Stanford University
Elizabeth Dickey, University of South Carolina

Mini-Plenary
Moderator: Roy Flukinger, University of Texas-Austin
"Journalism Ethics: Up Against the Berlin Wall"
Karen-Annette Franz, University of Minnesota
Theodore Glasser, Stanford University
Carolyn Wakeman, University of California, Berkeley
James Ridgeway, *The Village Voice*
Alec Miran, Executive Director of Special Events, CNN

Invited Paper Session
Moderator: Roy L. Moore, University of Kentucky
"Ethics and Law: Who Draws the Line Where?"
"Digital Manipulation of Electronic Photography: How Far is Too Far?"
Howard Bossen, Michigan State University
"Legal Issues in Electronic Alteration of Photographics"
Michael D. Sherer, University of Nebraska-Omaha

Refereed Paper Session
Moderator: Jim McNay, San Jose State University
"Analysis of Visual Reference Associations in Television News Coverage of the

1988 Presidential Election Campaign"
Jeffrey John, Wright State
"Television News Re-enactments: Setting the Stage for the Computer Manipulation of Journalism's Moving Images"
Don Tomlinson, Texas A&M University
Discussant: Doug Carr, St. Bonaventure

Invited Panel
Moderator: Stanley Wearden, Kent State University
"Teaching Resources for Ethics Classes"
Rich Beckman, University of North Carolina
Vicki Hesterman, Point Loma Nazarene
Ralph Izard, Ohio University
Bob Steele, Poynter Institute

Invited Panel
Moderator: Ted Hartwell, Minneapolis Institute of Art
"The Arts, the Media and the Public Interest: Robert Mapplethorpe and Related Issues"
Roy Flukinger, University of Texas-Austin
Diane Helleckson, *St. Paul Pioneer Press*
Jay Walljasper, *Utne Reader*

Refereed Paper Session
Moderator: Jim McNay, San Jose State
"A Method for Studying Bias and Ideology in Journalistic Photographs"
Keith Kenney, University of South Carolina
Discussant: Frank Biocca, University of North Carolina

AEJMC also publishes *Journalism Quarterly, Journalism Monographs,* and *Journalism Educator,* which provide a scholarly forum for the publication of research and teaching articles. The following studies are from these journals.

Journalism Quarterly
Vol. 38, No. 4, Autumn 1961

"The Staged News Photograph and Professional Ethics"
Walter Wilcox

Summary

This study of the ethics of staged news photos was based on a survey of photojournalists, managing editors, television newsmen, and a sample of the upper strata of the public as measured by educational attainment.

Participants were asked to rate the behavior of the photographer in each of 10 examples (all versions of actual events) as either definitely unethical, doubtful, or no ethical violation.

The author found the four groups to be in "remarkable agreement" with the most pronounced agreement occurring at the extremes of the ethical–unethical continuum. Disagreement was greatest in those situations that involved hard news and that also were "somewhat complex."

Comment

If everyone who has done research on visual ethics since 1961 had taken the time to read the introduction of this article, we would have a stronger foundation of data to build upon. Therefore, I take the space to quote the first paragraph of the article.

> The study of professional ethics in a systematic fashion poses a number of formidable problems. First, the notion of ethics itself is subjective and, in a marked degree, dependent upon notions of morals and of law. Second, the subject impinges heavily upon personal moral values and the translation of these values into professional conduct, where a number of additional, and sometimes competing, values are encountered. Third, an ethic—defined as the rule governing application of personal and social morals to a professional act—has as its basis the moral values of society, which in turn, are constantly shifting. Thus, it can be said that, for the purposes of systematic study, the professional ethic is not independent of other variables, and must be treated as a manifestation of a rather complex set of values.

Although the case situations in this study are, hopefully, no longer applicable, the methodology and philosophy of this research are as sound today as they were 30 years ago.

Journalism Quarterly
Vol. 60, No. 2, Summer 1983

"Ethical Newsgathering Values of the Public
and Press Photographers"
Craig H. Hartley

Summary

This comparative study of ethical values is based on results from a random sample survey of National Press Photographers Association members who work at publications and people listed in the Austin, TX telephone directory. Participants were asked to judge 19 hypothetical situations as either highly ethical, ethical, unethical, or highly unethical.

The study included questions of privacy, decency, faking, dispositions of negatives in court proceedings, legality versus ethics, acceptance of freebees, and the presence of photographers affecting news events.

In 17 of the 19 situations presented the difference between the photojournalists and the public exceeded the .05 significance level set for the study.

Comment

There are three things that bother me about this study. First, what is the difference between ethical and highly ethical or unethical and highly unethical? Second, some of the situations lack specific details that I think would effect the response of the participants. For example, situation 15 states, "Photographer ruins one of two remaining frames of film in another photographer's camera." What was the reason for this bizarre occurrence and how did it occur? And situation 18 states, "Photogra-

pher decides not to photograph hobo killed by train, despite being sent out to do this task." Did the photographer feel that the scene was too gruesome or that it wasn't newsworthy? His reason for this action would be important to know. Third, the author states in his interpretation of results that, "Many (photographers) shifted responsibility for their actions to the editor by saying they had a job to do, or it was the editor's decision. This is not valid reasoning." At many papers this is very valid reasoning if the photographer desires to keep his or her job. It may not be ideal, but it is reality.

Although 17 of the 19 cases showed a statistically significant difference among the two groups of respondents, it is important to realize that about half of these differences occurred on the same side of the axis and were merely a difference in the degree of ethical or unethical behavior that the respondents perceived. The author would have been well served by reviewing the Wilcox study prior to re-inventing the wheel.

Textbooks

An important vehicle for educating students about visual ethics is the college textbook. The following list includes many of the textbooks used in visual communication survey courses and beginning photojournalism courses at accredited schools of journalism and technical schools around the country.

Photojournalism, The Visual Approach
Frank P. Hoy
Prentice-Hall, 1986

Chapter 20, entitled "Ethics," provides the best coverage of photojournalism ethics among the textbooks that were examined. It includes visual and written examples and a discussion of the photographer's and editor's viewpoints.

I do disagree with Hoy's definition of the "cornerstone of journalism ethics," within the text and question whether we, as educators, should teach ethics to students with the degree of certainty that the following selection implies.

> The photojournalist's role on the scene is dictated by the cornerstone of photojournalistic ethics—to get the picture despite any obstacles.
>
> In general, it is not the photojournalist's job to decide whether to photograph or not. He or she is just too close to the drama and tragedy to know whether the photograph is in bad taste or is in reality an important news story that the public should know about. . . . Later the editor (or the publication's attorneys, if need be) can decide on whether the photo is invasion of privacy, libel, or even 'in good taste.'
>
> Yet, often the first thought of the beginning photojournalist—and rightfully so—is to sympathize with the subject and to decide not to photograph. But the responsibility is clear—if it is news, a photojournalist has the obligation to report it regardless of personal reaction. Here the old adage 'shoot first and question afterwards' is a good policy.

I am aware that this is the policy at many newspapers, but there has been sufficient argument over its merits to question whether it should be stated as an accepted policy throughout the field to photojournalism students.

Photojournalism: The Professionals' Approach
Kenneth Kobre
Curtin & London, 1980

Chapter 13 is entitled, "Photographing Within The Bounds of Laws and Ethics," but deals almost entirely with the legal considerations of privacy, libel, the courts, and copyright. The brief section of the chapter that discusses ethics is good, and will be updated and expanded in a new edition.

Photojournalism
Arthur Rothstein
Amphoto, 4th Edition, 1979

There may, at some time, be an updated version of this book. Amphoto had planned publication in 1986 and again in 1987, but both were cancelled. There is a 1983 printing, which is also listed as the fourth edition.

The last chapter, entitled "Privileges and Restrictions" gives a very brief and general overview of the topic area.

Exploring Black & White Photography
Arnold Gassan
Wm. C. Brown, 1989

The last chapter in this book, entitled "Ethical and Legal Aspects," is only three pages long and does not cover ethical considerations of photojournalists.

Handbook of Photography
Ronald P. Lovell, Fred C. Zwahlen, Jr., and James A. Folts
Delmar Publishers, 1987, Second Edition

Chapter 11 is titled, "Photography, Ethics and Law," but deals almost entirely with the legal aspects of privacy, libel, copyright, and ownership.

Photojournalism: Making Pictures for Publication
Philip C. Geraci
Kendall/Hunt Publishing Co., 1978, Second Edition

This book, which is out of print, does not contain any specific discussion of ethics and there is no listing for ethics in the index.

Photojournalism, Photography With A Purpose
Robert L. Kerns
Prentice-Hall, Inc., 1980

Chapter 11, entitled "Business Skills, Legal Aspects and Community Relations," discusses libel, invasion of privacy, model releases, photographing money, and documents and the copyright law, but does not discuss applicable ethical considerations.

Photojournalism, Principles and Practices
Clifton C. Edom
Wm. C. Brown Company, 1980, 2nd Edition

Chapter 17 is entitled "A Matter of Ethics" and provides a philosophical discussion of the topic but does not include case studies or examples of pictures that have caused debate within the field.

Other Books

There are two books that I am aware of that are dedicated to the topic of visual ethics. One is *New Pictures Fit to Print . . . or are They?* by Curtis D. MacDougall and the other is *Image Ethics, The Moral Rights of Subjects in Photographs, Film, and Television,* edited by Larry Gross, John Stuart Katz, and Jay Ruby.

MacDougall's book was published by Journalistic Services, Inc. in 1971. It is a shockingly honest discussion of ethical considerations in news photography. This book is an excellent historical reference, based entirely on case studies. There is commentary from many of the journalists who took the pictures and were involved in the picture editing and publication decisions. It is valuable to know from whence we came and it is all here—lynchings, disasters, Lindbergh, and wars. I recommend checking the library or used book stores if you are not familiar with this book.

Image Ethics, from Oxford University Press, 1988, provides a much more theoretical approach to the issue of ethics and also includes an excellent annotated bibliography. Most of this book deals with film, but the issues are easily paralleled in television and still photography. Most of the chapters confront the moral responsibility of preconceived visual representation, but public photography and documentary film-making are also discussed.

As you might expect from a compilation, this book wanders amidst the amorphous realm of moral convictions. Some of the chapters leave the reader feeling that artistic license supersedes moral responsibility, while others share with the reader the deepest sense of ethical consideration.

Most of this book does not directly relate to the situations that most broadcast news and publication photographers encounter on a daily basis, but the philosophical discussions are relevant and provide a good foundation for further research.

References

Adaskaveg, M. (1985, August). Of police and press. *News Photographer*, pp. 8-12.

Ahlhauser, J. (1990). A history of photojournalism ethics. In P. Lester (Ed.), *NPPA special report: The ethics of photojournalism* (pp. 2-5). Durham, NC: NPPA.

AP darkroom reception is mixed. (1990, April). *Presstime*, pp. 70-71.

Associated Press News Wire. (1989, November 13). Detroit, MI.

Baker, R. (1988, Summer). Portraits of a public suicide: Photo treatment by selected Pennsylvania dailies. *Newspaper Research Journal*, 21.

Barney, R. D., Black, J. J., Van Tubergen, G. N., & Whitlow, S. S. (1980, May). *Journalism ethics and moral development: An early exploration.* Paper presented before the International Communication Association, Acapulco, Mexico.

Barrett, B. (1988, May 9). Business ethics for sale. *Newsweek*, p. 56.

Bell, M. (1990 April 29). Kent State symbol still bitter today. *The Orlando Sentinel*, pp. A-1, A-8.

Bethune, B. (1983, November). Under the microscope. *News Photographer*, p. R-1.

Bird, M. (1923, June). Our psychic investigation in Europe-II. *Scientific American*, pp. 379-380, 428-429.

Black, J. (1922, October). The spirit-photograph fraud. *Scientific American*, pp. 224-225, 286.

Blackwood, R. (1983). The content of news photos: Roles portrayed by men and women. *Journalism Quarterly, 60,* 710-714.

Bossen, H. (1985, Summer). Zone V: Photojournalism, ethics, and the electronic age. *Studies in Visual Communication,* 30.

Boundaries of 'personal space.' " (1986, March). *News Photographer*, p. 24.

Brill, B. (1986, September). Town protests staged picture, "hooker image." *News Photographer*, pp. 4-8.

Brink, B. (1988, June). Question of ethics. *News Photographer*, pp. 21-33.

Brown, J. (1987, Spring/Summer). News photographs and the pornography of grief. *Journal of Mass Media Ethics,* 80.

"Caption." (1989). *Masterpieces of American Photography 1899-1982,* Orlando, FL: Cornell Fine Arts Museum.

Chaney, S. (1989, October). How technology can alter photographs to deceive readers. In *Solutions today for ethics problems tomorrow, A special report by the Ethics Committee of the Society of Professional Journalists, 1989* (p. 17). Greencastle, IN: Society of Professional Journalists.

Chapnick, H. (1982, August). We all know pictures can lie. *Popular Photography*, pp. 40-41.

Christians, C., Rotzoll, K., & Fackler, M. (1983). *Media ethics.* New York: Longman.

Clark, R. (1987, November 22). The underside of journalism. St. Petersburg *Times*, p. D-1.

Coleman, A. D. (1988, August 18). Private lives, private places: Street photography ethics. *Journal of Mass Media Ethics,* 60-66.

Colton, S. (1989, April 14). Iwo Jima flag-raising shot was not posed. *Chicago Tribune*, p. 67.

Contest instructions, *47th Annual Pictures of the Year.* (1989). Durham, NC: NPPA.

Cook, F. J. (1971). *The nightmare decade.* New York: Random House.

Cookman, C. (1985). *A voice is born.* Durham, NC: NPPA.

Cooper, K. (1947, August 9). AP men urged to get character closeups. *Editor & Publisher*, p. 48.

Coulson, D. (1988, July). *Editors' attitudes and behavior toward journalism awards.* Paper presented to the 76th Annual Convention of the Association for Education in Journalism and Mass Communication, Portland, OR.

Crisostomo, M. (1989, December). Walking a fine line. *News Photographer*, pp. 22-24.

Cunningham, R. (1989, November). A photographer defines boundaries. *The Quill*, p. 8-10.

Edmunds, S. (1966). *Spiritualism: A critical survey.* London: Aquarian Press.

Edom, C. (1980). *Photojournalism.* Dubuque, IA: Wm. C. Brown.

Edwards, R. (1979). *A theory of qualitative hedonism.* Ithaca, NY: Cornell University Press.

Elliot-Boyle, D. (1985-1986, Fall/Winter). A conceptual analysis of ethics codes. *Journal of Mass Media Ethics,* 25.

Elson, R. (1968). *The world of Time, Inc: The intimate history of a publishing enterprise, 1941-1960.* New York: Atheneum.

Emery, M. C., Schuneman, R. S., & Emery, E. (Eds.). (1970). *America's front page news 1690-1970.* New York: Doubleday.

Endres, F. (1988, Fall). Stress in Ohio newsrooms. *Newspaper Research Journal,* 9.

Ephron, N. (1978). *Scribble scribble notes on the media.* New York: Alfred Knopf.

The ethics and etiquette of photography. (1907, July 11). *The Independent,* pp. 107-109.

Evans, H. (1978). *Pictures on a page.* New York: Holt, Rinehart and Winston.

Evans, M. (1989, November). An open question: "Emphatically accurate photos." *News Photographer,* pp. 26-28.

Faber, J. (October, 1977), How the NPPA came into being. *News Photographer,* p. 27.

Faber, J. (1978). *Great news photos and the stories behind them.* New York: Dover.

Faber, J. (1983, July). Sacrificial protest of Quang Duc. *News Photographer,* p. 10.

The face and faith of Poland. (1982, April). *National Geographic* (A special supplement).

Farouk, E-B. (1982, February). Egypt's desert of promise. *National Geographic,* pp. 190-220.

Fitzgerald, M. (1988, November 5). Pretty as a picture. *Editor & Publisher,* p. 16, 34–35.

Flag raising on Iwo Jima. (1980, January). *News Photographer,* p. 13.

Flukinger, R., Schaaf, L., & Meacham, S. (1977). *Paul Martin victorian photographer.* Austin, TX: University of Texas Press.

Fowler, T. (1990, March). *Coverage of hurricane Hugo.* Paper presented at the AEJMC Southeast Colloquium, Charleston, SC.

Frassanito, W. (1978). *Antietam: The photographic legacy of America's bloodiest day.* New York: Charles Scribner's.

Fulton, M. (Ed.). (1989). *Eyes of time: Photojournalism in America.* New York: Graphic Society.

Geiselman, A. (1959, August 15). Take pictures of tragic scene or flee from irate onlookers? *Editor & Publisher,* p. 13.

Gelfand, L. (1989, January). Is color the culprit? *News Photographer,* p. 12.

Gernsheim, H. (1969). *The history of photography.* New York: McGraw-Hill.

Glasser, T., & Ettema, J. (1989, Summer). Common sense and education of young journalists. *Journalism Educator,* 18-25, 75.

Goldman, K. (1989, October 30). TV network news is making re-creation a form of recreation. *Wall Street Journal,* p. A-4.

Goodwin, E. (1983). *Groping for ethics in journalism.* Ames, IA: Iowa State University Press.

Gordon, J. (1980, July). Judgment days for words and pictures. *News Photographer,* p. 25.

Gordon, J. (1981, November). Fired. *News Photographer,* pp. 31-36.

Gordon, J. (1983, July). A question of ethics. *News Photographer,* pp. 11-17.

Gordon, J. (1986, March). Grief photo reaction stuns paper. *News Photographer,* pp. 17-25.

Gotcha! (1983, August). *News Photographer,* p. 22.

Grimm, J. (1989, January). Two tough questions. *News Photographer,* p. 31.

Grover, J. (1989, Summer). Visible lesions. *Afterimage,* pp. 10-16.

Grow, J. M. (1989, December). Anniston weather photos. *News Photographer,* p. 55.

Guidelines. (1989). *NPPA Directory* (p. 36). Durham, NC: NPPA.

Gwin, L. (1988). Prospective reporters face writing/editing tests at many dailies. *Newspaper Research Journal,* 9, 101-111.

Hansen, G. (1989). *Denial of disaster.* San Francisco: Cameron.

Hartley, C. (1982, January). Photographers, public view practices. *News Photographer,* p. 24.

Hartley, C. (1983, Summer). Ethical newsgathering values of the public and press photographers. *Journalism Quarterly, 60,* 301-304.

Heimsohm, W. (1982, October). The enhancemet effect. *American Photographer,* pp. 94-107.

Helping hands at fire calls. (1983, July). *News Photographer,* pp. 18-19.

Henderson, L. (1989). A selected annotated bibliography on image ethics. In L. Gross, J. Katz, & J. Ruby (Eds.), *Media ethics* (pp. 91-107). New York: Oxford University Press.

Henning, A. (1932). *Ethics and practices in journalism.* New York: Ray Long & Richard Smith.

Hertzberg, M. (1979, February). Stress. *News Photographer,* p. 12.

Hesterman, V. (1988, November). By the numbers. *News Photographer,* pp. 21-24.

Hicks, W. (1973). *Words and pictures.* New York: Arno Press.

Hodge, B. (1989, January). Change in the reader and viewer. *News Photographer*, pp. 14-15.

Holland, D. (1989, November). Photographer's hassling by cops costs town $24,000. *News Photographer*, p. 4.

Horrell, C. W. (1955). *Analysis of the recommendations for the education of newspaper photojournalism students.* Unpublished doctoral dissertation, Indiana University, Bloomington, IN.

Houdini, H. (1924). *A magician among the spirits.* New York: Harper.

Hoy, F. (1986). *Photojournalism, the visual approach.* New York: Prentice-Hall.

Hughes, R. (1989, October). Anatomy of a newspaper's decision. *FineLine*, p. 3.

Hulteng, J. (1984). *The messenger's motives.* Englewood Cliffs, NJ: Prentice-Hall.

Hvidston, C. (1983, February). Of privacy and board members. *News Photographer*, p. 5.

"'Inside Story' inside photos." (1982, June). *News Photographer*, pp. 29-32.

Izard, R. (1985). *Background of survey* (Journalism Ethics Report, 1984-85). Society of Professional Journalists, Sigma Delta Chi ethics committee, Greencastle, IN.

Jaubert, A. (1986). *Making people disappear.* Washington, DC: Pergamon-Brassey's International Defense Publishers.

Jay, B. (1984). The photographer as aggressor. In D. Featherstone (Ed.), *Observations* (pp. 7-23). Carmel, CA: The Friends of Photography.

Johns, D. (1984, July). All about boo-boos. *News Photographer*, p. 8.

Jones, W. T., Sontag, F., Beckner, M. O., & Fogelin, R. J. (Eds.). (1969). *Approaches to ethics.* New York: McGraw-Hill.

Jussim, E. (1989). American photojournalism from 1880 to 1920. In M. Fulton (Ed.), *Eyes of time photojournalism in America* (pp. 36-73). Boston: New York Graphic Society Book.

Knightley, P. (1976). *The first casualty.* New York: Harcourt, Brace Jovanovich.

Knocking on death's door. (1989, February 27). *Time*, p. 49.

Kobre, K. (1980). *Photojournalism the professionals' approach.* Boston: Focal Press.

Kochersberger, R. (1988, Summer). Survey of suicide photos use by newspapers in three states. *Newspaper Research Journal*, 9.

Lambeth, E. (1986). *Committed journalism an ethic for the profession.* Bloomington, IN: Indiana University Press.

Lasica, J. D. (1989, June). Photographs that lie. *Washington Journalism Review*, p. 24.

Lee, E. (1989, September/October). Rob Lowe cover: Spoof or dangerous deception? *SixShooters*, pp. 8-9.

Lester, P. (1988, Spring). Front page mug shots: A content analysis of five U.S. newspapers in 1986. *Newspaper Research Journal*, pp. 1-9.

Lester, P. (1989). *The ethics of photojournalism: Toward a professional philosophy for photographers, editors and educators.* Unpublished doctoral dissertation, Indiana University, Bloomington, IN.

Lester, P. (Ed.). (1990). *NPPA special report: The ethics of photojournalism.* Durham, NC: NPPA.

Lesy, M. (1976). *Real life Louisville in the twenties.* New York: Pantheon.

London editor dismissed for royal mistake. (1989, November 21). *The Orlando Sentinel*, p. A-2.

Long, J. (1989, November). Fakes, frauds and phonies. *News Photographer*, pp. 13-14.

Los Angeles Times. (November 18, 1978). p. 1.

MacDougall, C. (1940). *Hoaxes.* New York: Macmillan.

MacDougall, C. (1964). *The press and its problems.* Dubuque, IA: Wm. C. Brown.

MacDougall, C. (1971). *News pictures fit to print . . . or are they?* Stillwater, OK: Journalistic Services.

Mallette, M. (1976, March). Should these news pictures have been printed? *Popular Photography*, pp. 75, 120.

Miller, S. (1975). The content of news photos: Women's and men's roles. *Journalism Quarterly, 52*, 70-75.

Mills, R. D. (1982, July). *Newspaper journalists' perceptions of ethical decisions.* Paper presented at the annual meeting of the Association for Education in Journalism, Athens, OH.

Mills, R. D. (1983). Newspaper ethics: A qualitative study. *Journalism Quarterly, 60*, 589-594, 602.

Moeller, S. (1989). *Shooting war.* New York: Basic Books.

Moore, N. (1978, June). Drowning photos provoke a furor in Findlay. *News Photographer*, p. 54.

Morse, M. L. (Ed.). (1987). *The electronic revolution in news photography.* Durham, NC: NPPA.

Mott, F. (1962). *American journalism.* New York: Macmillan.

NBC puts an end to re-enactments of news events. (1989, November 21). *The Orlando Sentinel*, p. A-4.

Nelson, H., & Teeter, D. (1982). *Law of mass communications*. Mineola, NY: The Foundation Press.

Newhall, B. (1982). *The history of photography*. New York: The Museum of Modern Art.

NPPA Directory. (1989). Durham, NC: NPPA.

O'Connor, M. (1986, January). Fix-it with Scitex. *How*, pp. 44-49.

Ohrn, K. (1980). *Dorothea Lange and the documentary tradition*. Baton Rouge: The Louisiana State University Press.

On posing features. (1989, November). *News Photographer*, pp. 50-52.

150 years of photography pictures that made a difference. (1988, Fall). *Life* (whole issue).

150 years of photojournalism. (1989, Fall). *Time*, p. 2.

One person's gallery—Foolers by Cliff Yeich. (1985, July). *News Photographer*, pp. 8-9.

Orwell, G. (1949). *1984*. New York: Harcourt, Brace and World.

Padgett, G. (1985-1986, Fall/Winter). Codes should address exploitation of grief by photographers. *Journal of Mass Media Ethics*, 50-56.

Pentagon probing consultant fees. (1988, November 4). *The Orlando Sentinel*, p. A-11.

Photographer's pledge. (1982, March 25). *New York Times*, p. A-25.

Photographers give their guidelines. (1986, August). *News Photographer*, p. 24.

Photographers' caption error is devastating. (1986, September). *News Photographer*, pp. 54-57.

Pierce, B. (1983, November). Photographing violence. *Popular Photography*, p. 126.

Pollack, P. (1977). *The picture history of photography*. New York: Harry Abrams.

Pulitzer photos from Rhodesia are now subject of controversy. (1978, April 22). *New York Times*, p. 5.

Rawls, J. (1971). *A theory of justice*. Cambridge, MA: Belknap Press of Harvard University Press.

Ray, F. (1961, October). The case of the rearranged corpse. *Civil War Times*, p. 19.

Readers object to gruesome page 1 photo. (1982, January). *News Photographer*, p. 2.

Reaves, S. (1987, January). Digital retouching. *News Photographer*, p. 31.

Reaves, S. (1989, October 6). Ethics: Report airs editors' debate on principles of pixels. *The Electronic Times*, Section 2, p. 1.

The riot beat. (1976, August 14). *Newsweek*, p. 78.

Ritchin, F. (1984, November 4). Photography's new bag of tricks. *The New York Times Magazine*, p. 49.

Rosenberg, J. (1989, March 25). Visual enhancement of photos. *Editor & Publisher*, p. 47.

Rothstein, A. (1961, September). The picture that became a campaign issue. *Popular Photography*, pp. 42-43.

Rothstein, A. (1986). *Documentary photography*. Boston: Focal Press.

Salamone, D. (1988, April 11). Coping with tragedy's aftermath. *The Orlando Sentinel*, p. B-1.

Sanders, B. (1986, February). A matter of image. *News Photographer*, p. 8.

Sherer, M. (1986, August). Bibliography of grief. *News Photographer*, pp. 23-38.

Sherer, M. (1986a, March). A problem of trespass. *News Photographer*, pp. 14-15.

Sherer, M. (1986b, March). Conduct is a key consideration. *News Photographer*, p. 26.

Sherer, M. (1987, January). Short course: Invasion of privacy. *News Photographer*, pp. 18, 22.

Shoot or help? (1980, February). *News Photographer*, p. 19.

Sipchen, B. (1989, October 28). Hot shots *Rolling Stone* shows off its family album. *The Orlando Sentinel*, pp. E-1, E-3.

Spitzer, C., & Franklin, J. (1988, April 13). Rescuing rescue workers from stress. *The Orlando Sentinel*, p. E-4.

Squires, C. (1988, October). Seeing history as it happened. *American Photographer*, pp. 32-63.

Steele, R. (1987, Spring/Summer). Video ethics: The dilemma of value balancing. *Journal of Mass Media Ethics*, 10-11.

Stein, J. (1988, August 18). Seeing stars: Privacy and the press. *The Orlando Sentinel*, pp. E-1, E-6.

Stettner, L. (1977). *Weegee*. New York: Alfred Knopf.

Strongman, T. (1987, January). More guidelines for invasions of privacy. *News Photographer*, pp. 20, 68.

Strothers, B. (1989, November). Troubles with re-creating news. *News Photographer*, p. 25.

Symbol of depression dies at the age of 79. (1983, September 17). *New York Times*, p. 8.

Szarkowski, J. (1980). *The photographer's eye*. New York: The Museum of Modern Art.

Taft, R. (1938). *Photography and the American scene*. New York: Macmillan.

Tasteless breach. (1986, March). *News Photographer,* p. 27.

Tell, J. (Ed.). (1988). *Making darkrooms saferooms.* Durham, NC: NPPA.

Thall, L. (1988, November). Screen test. *Photomethods,* pp. 36-37.

Themal, H. (1987, October 17). News photo provokes hundreds of complaints. *Editor & Publisher,* p. 11.

Van Gieson, J. (1989, December 1). Injury suit over TV ad tossed out. *The Orlando Sentinel,* p. D-9.

Vaughan, V. (1989, April 29). Ethical dilemma comes if news event also is a junket. *The Orlando Sentinel,* p. A-16.

Walkie-talkie rescue: Screams from below. (1983, October). *News Photographer,* p. 4.

Warning. (1986, October/November). *4Sight,* pp. 7-11.

Weather 'photo opportunity' becomes near-tragedy. (1989, September). *News Photographer,* pp. 6, 10.

Weaver, D., & Wilhoit, C. (1986). *The American journalist.* Bloomington, IN: Indiana University Press.

What ever happened to ethics. (1987, May). *Time,* pp. 14-29.

Whose picture is it anyway? (1987, June). *American Photographer,* pp. 75-79.

Why tamper with perfection? (1989, November). *News Photographer,* p. 14.

Wilcox, W. (1961). The staged news photograph and professional ethics. *Journalism Quarterly, 38,* 497-504.

Wilson, J. (1989, November). Photographer, famous photo's subject hold reunion in Havana, Cuba. *News Photographer,* p. 6.

Zuckerman, L. (1989, February 27). Knocking on death's door. *Time,* p. 49.

Author Index

Subject Index

197